THE ART OF SEEING

THE ART OF SEEING

the best of Reuters photography

ULLI MICHEL

REUTERS

Published by **Pearson Education**

London • New York • San Francisco • Toronto • Sydney • Tokyo • Singapore
Hong Kong • Cape Town • Madrid • Amsterdam • Munich • Paris • Milan

PEARSON EDUCATION LIMITED

Head Office:
Edinburgh Gate
Harlow CM20 2JE
Tel: +44 (0)1279 623623
Fax: +44 (0)1279 431059

London Office:
128 Long Acre
London WC2E 9AN
Tel: +44 (0)20 7447 2000
Fax: +44 (0)20 7240 5771
Website: www.business-minds.com

First published in Great Britain in 2000

© Reuters 2000

The right of Ulli Michel to be identified as Editor of this Work has been asserted by him in accordance with the Copyright, Designs and Patents Act 1988.

ISBN 0 273 65011 4

British Library Cataloguing in Publication Data
A CIP catalogue record for this book can be obtained from the British Library

10 9 8 7 6 5 4

Designed and Typeset by Ian Roberts, Pearson Education
Printed and bound in Great Britain by Rotolito, Italy

The Publishers' policy is to use paper manufactured from sustainable forests.

FOREWORD

In 1985 Reuters entered the news pictures business. From its black-and-white origins, the Reuters News Pictures Service has become the world's leading and most technologically advanced picture agency.

Back in those days, once back at the darkroom, it often took an hour for a photographer to develop the film, edit, make a print, and transmit it to an editing centre that could relay it to clients.

A huge amount of equipment was necessary for this. Often, it would have been easier to charter a cargo plane than to battle with irate airline ground staff while attempting to board an aircraft with what seemed to be a mixture between a rock star's equipment and a mad professor's laboratory. Travelling through hostile environments carrying this strange load made you wonder what kind of a profession you were in.

Since that time technological advances have revolutionized the industry: digital cameras and ultra-light laptops have truly changed our work practices. For example, during the World Cup finals in France in 1998 Reuters capitalized on its investment in digital camera and transmission technologies – and, as Brazil scored the opening goal of the tournament against Scotland, newspapers and magazines were amazed to receive images of the moment only seven minutes after the ball had hit the back of the net.

These new technologies mean that on any particular day Reuters photographs from around the world are seen by millions of online, newspaper, and magazine readers. The Internet itself has also impacted upon the business: the fast-evolving world of Internet news demands pictures that meet constantly updated deadlines for ever-changing online pages. We are moving towards the age of the real-time pictures service.

However, it is obviously not just speed-to-market that is important for a news service or its clients. The Reuters News Pictures Service embodies the core values of the world's largest information and news provider. Our clients trust our content; they know that the image in front of them has not been altered electronically and that the events recorded in the picture are genuine.

Not only that, our clients can always be assured as to the quality of the images we can offer. Being a Reuters photographer is about skill and commitment and the thrill of being in the fast lane of a fast business, where news never stops and there is always a deadline somewhere in the world. In this environment dedication to the job is paramount.

Our photographers have to be in the right place at the right time, and even then they have to exhibit real vision and talent as they may have to get a certain angle to record a split-second moment and capture an image that is the definitive, truly newsworthy photo. These are perhaps the essential characteristics for the best photojournalists: a nose for a story, an eye for a photo, and a finger on the button.

The work of our photographers has been honoured with many prizes, and you will find in this book one of this year's winning World Press Photo images. Yannis Behrakis' picture of a Kosovo Albanian funeral (p.54) was part of his winning portfolio in the General News category.

But other photos can stand out for different reasons. Diana, Princess of Wales – probably the most photographed woman of the past century – chose John Pryke's picture of her (p.100) as her favourite image of herself.

The picture of US senator Bob Dole falling at an event whilst on the Presidential campaign trail (p.83) shows that the old maxim, 'being in the right place at the right time' still stands. Reuters photographer Rick Wilking was in the right place at the right time, and was the only photographer to get this shot.

Not every news photo has to show conflict or tragedy; this book does include images that show the horrors of war, natural disasters, and the collapse of political regimes, but it also covers the birth of new countries, the triumph of sporting heroes, human and scientific endeavour, diverse cultural phenomena, and moments of simple visual beauty.

Many of the pictures show the benefit of careful preparation. For years Jim Hollander attended the San Fermin festival in Pamplona, Spain, better known as the 'Running of the Bulls'. His stunning photograph here (p.7) is the result of his dedication. Dedication of a different type is seen in the work of Luciano Mellace, a veteran Italian photojournalist, who was commended by Pope John Paul II for his lifetime achievements in covering the Vatican (p.101).

To get these familiar or award-winning images our photographers work right at the coalface, where the action is, and often expose themselves to danger. In a 15 year period, four of our photographers have paid the price of their lives. Hos Maina and Dan Eldon were killed by a mob in Mogadishu and Roberto Navas lost his life when he was caught in an exchange of gunfire during the El Salvador civil war. Our staff photographer and Vietnam War legend Willie Vicoy was killed in an ambush by rebels in the Philippine Islands. This book is dedicated to them.

I would like to thank all those photographers who have helped to make the Reuters News Pictures Service what it is today. Thanks also go to the photographers who have contributed to The Art of Seeing, and to Ken Mainardis, Elaine Herlihy and Martin Drewe for their help in putting together the book.

Editing this book has proved both an exhilarating and a painful process: seeing great images, by hundreds of Reuters photographers, gathered together for the first time was moving; the task of selecting those for inclusion in this book proved extremely difficult. For those we did select we went back to the photographers, where possible, to obtain a first-hand insight into the professional practice, the emotions and events, behind each image. We hope this provides a context for each photo that will help aid your understanding of what makes a great news photograph.

ULLI MICHEL
GLOBAL NEWS PICTURES EDITOR, REUTERS

THE ART OF SEEING

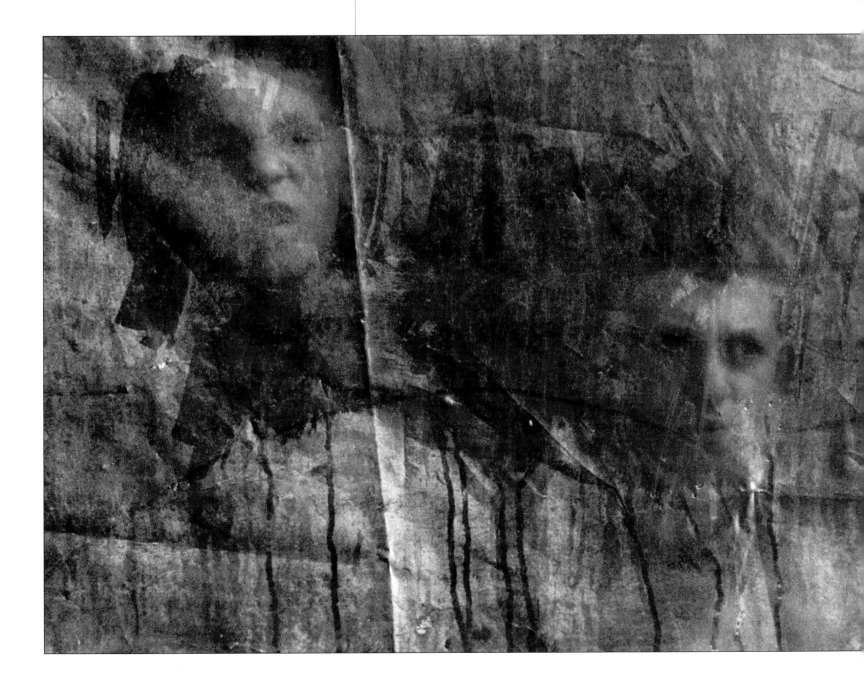

Breaking the sound barrier
23 July 1999

John Gay

I am currently assigned as the Imaging Systems Officer for VF-2 (an F-14D squadron) with the US Navy. I primarily work with reconnaissance camera sets, TARPS (Tactical Air Reconnaissance Pod System), that hang under the Tomcat. I also manage a targeting pod system known as LANTIRN (Low Altitudes Navigation Targeting Infrared Night). Both of these systems are critical assets to the air wing and are very high visibility when the squadron deploys. I was previously enlisted in the Navy for almost ten years as a photojournalist. I still shoot, but not as part of my assigned tasks. All my photography is now just for fun, but I do still market my work through the Navy.

The USS Constellation left San Diego on 18 June 1999, and had just completed a ten day exercise off the coast of Hawaii. When I took the shot we were en route to Japan and Korea when, as part of an Air Power demonstration, pilots were practising fly-bys of the ship. The day before I had observed the practice, but didn't shoot. I got a good feel for the altitude of the jets and their proximity to the ship. On the second day of the demonstration, I loaded a camera and fitted a 80-300 zoom and positioned myself in 'vultures row' (a part of the superstructure that sits about 75 feet off the water).

Taking a spot meter reading off a jet on the flight deck, I determined my exposure. The air was very humid that day so I knew I would see lots of condensation off the wings. Setting the camera in full manual and zone focusing, I panned the jets as they passed. As they fly by at 650 to 700 knots, you don't have much time and must spot the jets way off in the distance to track them in. The F/A 18 shot was only one frame. I saw the pilot, who I later learnt was Lieutenant Ron Candiloro, dropping in altitude to gain speed when he was about three miles out, so I knew his pass would be impressive. Waiting and anticipating when the jet will break through the barrier is the hardest part. Just prior to breaking the barrier, vapours flicker off the wings as air passes a little quicker over curved surfaces.

As the jet gets closer to the sound barrier this flicker increases in frequency and size, until the pressure created by the forward sound waves squeezes the moisture in the air, forming a ball of cloud right over the aircraft. You generally only get one shot because the condensed air at low level altitude will slow the jet down once it breaks through the barrier. The cloud is instantaneous and leaves as quickly as it comes.

Once I pushed the shutter for this shot I knew I had captured an impressive photo. The jet was just above my eye-level and about 200 yards off the port side of the ship. I processed the film on board and scanned the image, sending it off to the Chief of Naval Information for distribution.

from previous page
Ethnic Albanian refugee children, Skopje, Macedonia.
24 March 1999
Damir Sagolj

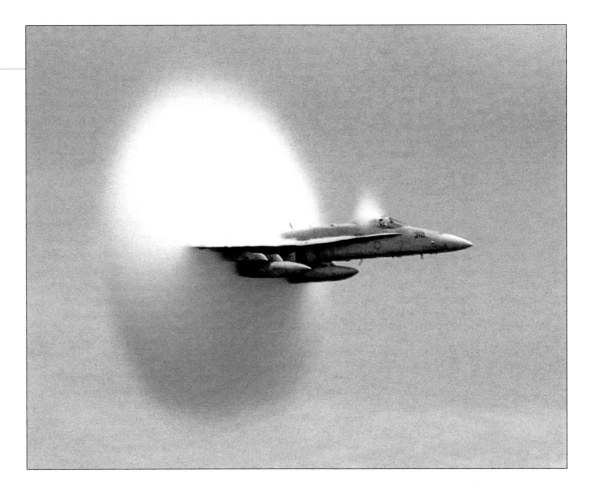

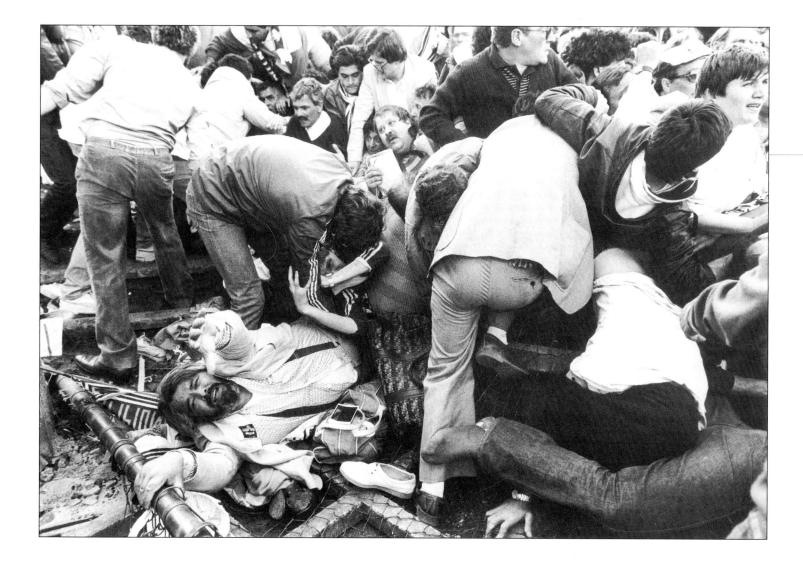

The events of 29 May 1985 will not only remain forever in my mind, but I am sure they will remain in the minds of football fans the world over. On that night 39 football fans lost their lives when a riot broke out in the old Heysel Stadium in Brussels, Belgium.

I had just joined the new Reuters News Picture Service in April 1985 and was based in Brussels. I was used to covering major sporting events in Canada and, after living in Europe just shy of 8 weeks, I was even used to the way European football was covered. But nothing could have prepared me for the riot that broke out before the game that evening.

Having been assigned to cover the European Cup Final between Liverpool, of England, and Italy's Juventus I headed to the ageing Heysel Stadium, setting up a portable darkroom, and arranging the telephone connection to Reuters' European headquarters, which was in Brussels at that time. Reuters only had two photo passes for the game. One was for the field, which I took, and the other was for an elevated position in the stands. I went out on the field to get ready for the game and noticed things were getting a little out of hand at the north end of the stadium, between some of the fans on the lower levels of the stadium and the Belgian police.

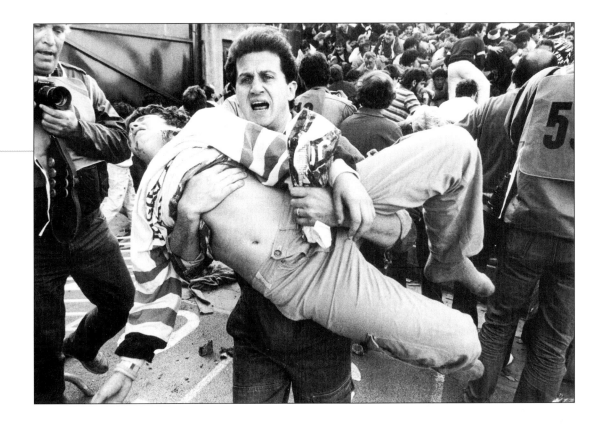

**The Heysel Stadium
disaster**
29 May 1985

Nick Didlick

It was shortly after this that I wandered down to the south end of the field to take up a field position to cover the game. There I saw one of those scenes you really have to witness as it is hard to put into words: the thousands of fans that were jammed to capacity in the stands at the south end parted like a human wave as fighting broke out. Liverpool supporters separated from Juventus supporters and left a no-man's-land in the middle.

I walked up to the stands, where Juventus fans were pinned against a fence, just as part of the wall collapsed, spilling the fans onto the pitch. People everywhere were screaming for help. I took some black and white shots and ran back to the darkroom to give my film to the picture editor, Steve Crisp, telling him that all hell had broken loose in the stands and that many people had been killed.

This time I loaded colour film in my cameras and dropped my long lenses on the field so I could move freely and quickly through the crowd which now was becoming hostile to the few photographers on the scene. The riot was in full flow now, with only a few policemen protecting the trapped and injured Juventus fans.

I moved quickly through the crowd, pausing only for a few seconds to take a picture before moving on again. Photographers standing in the crowd became targets for some of the bricks that were being thrown by fans. Other fans were weeping or asking for help, and throwing their arms around photographers begging them not to take pictures of the bodies that were lying in a heap in the stands.

I quickly shot two rolls of colour film and dashed back to the darkroom so that the images could be shipped to the office for processing, printing and transmitting. Then I returned to the field to shoot the aftermath of the riot, expecting the game to be cancelled or postponed because of the number of people killed. Unbelievably it went ahead, though no-one had much stomach for it.

My pictures took the front page of every Fleet Street newspaper, most European papers, and many others around the world.

Running the bulls, Pamplona
13 June 1993

Jim Hollander

The running of the bulls takes place at 8am precisely on every morning of the week long Fiesta de San Fermin, held in the city of Pamplona in northern Spain. It is an exhilarating, mad dash of several thousand runners sprinting somewhere along the 900 metre course in front of six 'toros bravos', or fighting bulls. These are not lumbering beef animals but wild, fighting bulls with very long, sharp horns. They of course have never been on a city street before, and are scared and dangerous. They are between four and five years old and weigh between 500 and 600 kilos each. The bulls thunder through the course in several minutes while the runners scatter as their individual physical panic sets in and the bulls close the gap. Every runner, no matter how experienced, feels the panic and the adrenaline pumping.

I first attended the fiesta at age 13 and ran the bulls at 14. I remember that first run … some steers flashing by me and then madly chasing them up the cobblestoned streets for a few metres. Some inexplicable spirit entered me and I kept at it for the next 13 years, running the bulls a total of about 90 times. This all ended abruptly in 1977 when several huge Miura bulls saw me fall from the sky after I was tossed several metres into the air by an accompanying steer. Two of these bulls came within inches of goring me even though I had enough adrenaline-induced sense to stay on the ground covering my head. If I rose ever so slightly I would have caught a horn somewhere.

The following morning I began photographing the spectacle from the perspective of my own experience, but with the help of a cane. I gave up running the bulls that day, but in the ensuing years have continued photographing the fiesta and each morning's run, often trying different angles or locations to shoot from in order to capture the excitement and danger of this event. To label this madness a sport is misleading – it is a frantic individual dash with death. As a photographer one has split seconds to see the bulls and hopefully catch some significant action. Much in the end depends on luck. There are so many people running,

and such panic, that one doesn't know where the bulls actually are until the sprinting crowd parts and the bulls are just metres away and charging. If someone falls in front of you, you might be able to get it on film, or it might totally block your view and you get nothing. Some action could take place three metres away and you might not even see it. The day this photo was taken I positioned myself at the entrance to the bullring which marks the finish of the run.

In this area the street narrows and dips slightly downhill, which forces the bulls to slow down ever so slightly and enables some of the more experienced runners to get in closer to the animals. These runners often lead the bulls, or one individual bull, down into the 'chute', through the doors and into the morning sun filling the bullring. I put a remote camera at ground level right and shot with a cable release as I stood with other press photographers on a safety barricade made of wooden planks.

I was shooting with another camera, looking to get a picture facing into the light-filled 'chute' as the animals passed. Standing on the barricade does not eliminate all dangers for the photographers, but makes one feel a bit safer than the runners who, as panic spreads, climb onto the barricade and pile into the photographers as they seek safety. The young man pictured had had enough and, as his panic took over, he took a falling leap right into my lens (and knocked it off its clamp) just as the morning sun rose above the far end of the bullring and flooded the doorway with yellow-red, swirling dust. What makes this photo special to me is the delicate moment behind as a very experienced runner lightly jumps over another fallen runner, right in front of the horns of a bull.

This photo won several awards including the Best Sports Action Picture in the University of Missouri Picture of the Year contest in 1993. It was widely published, and featured in Life Magazine and the New York Times.

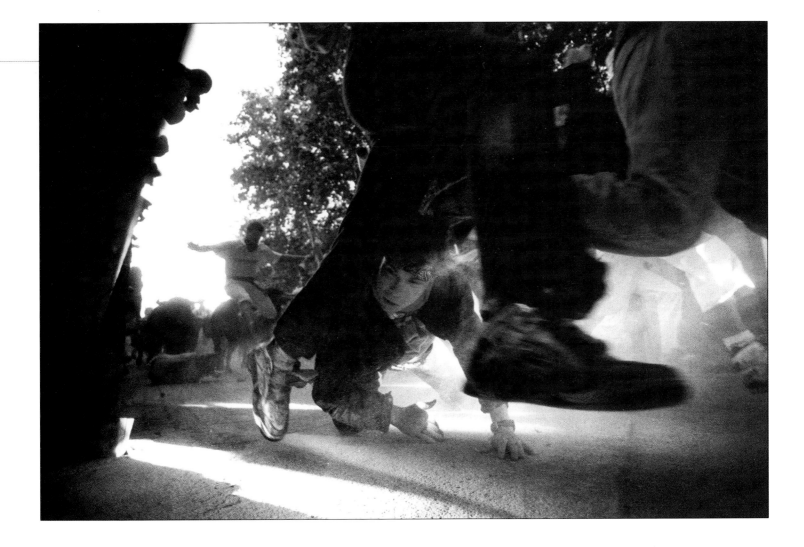

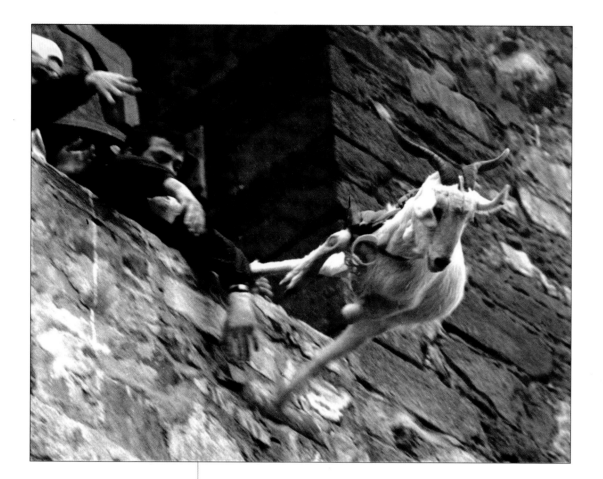

The annual 'goat throwing' festival, northern Spain
25 January 1997

Desmond Boylan

I showed up at the small village of Manganese de la Polvorosa, in northern Spain, to photograph the annual 'goat throwing' festival. I timed my arrival to the last possible moment before the goat, 'Marcela', was thrown from the bell tower – since the (several hundred) villagers can be very aggressive towards the press who appear at their festival, following the controversy caused by criticism from British tabloids and animal rights groups.

I mixed with villagers and chose my position, with my camera, inside a plastic bag, loaded and ready to shoot. I only raised the camera when the youths that throw the goat appeared on the top of the bell tower of the church – making sure everybody around me was busy looking at the bell tower and not at me. The goat takes about a second and a half to fall to the ground, and from my position I could see most of its descent, so I managed three frames – of which only one was good. The goat is caught at the bottom of the tower, in a blanket held by villagers. After I had my shot I changed position fast to get pictures of the goat being carried away unhurt. Some villagers were aggressive towards me – but much less so than perhaps they would have been, had they seen me readying my camera before the goat was thrown.

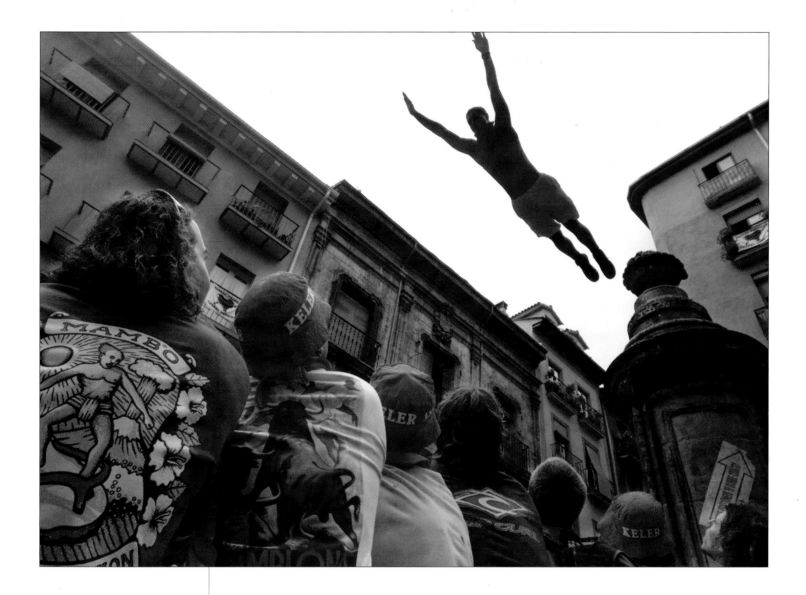

Fiesta, Pamplona
06 July 1999

Jim Hollander

A reveller at the Fiesta de San Fermin leaps off a stone column into the waiting arms of friends and other revellers, as the festival gets underway. Many foreigners, often very drunk, climb the tower and take a leap of faith as the festivities continue throughout the day. The famous running of the bulls began the day after this.

Javier Sotomayor
04 August 1997

Ralf Stockhof

This picture of Cuban high jumper Javier Sotomayor was taken during the World Athletics Championships in Athens. I always try to look at a subject from a different angle and had to get up on the roof of the Olympic Stadium to get this shot of his run up.

Sotomayor won the gold medal with a jump of 2.37 metres.

Thomas Enqvist
22 January 1999

Mark Baker

Sweden's Thomas Enqvist raises his arms in celebration after defeating Australia's Pat Rafter in their third round match at the Australian Open in Melbourne. Enqvist defeated the number three seed, and local favourite, in four sets: 6-4, 4-6, 6-4, 6-4.

Margaret Thatcher
12 October 1994

Ian Waldie

The Tory conference in Bournemouth in 1994 was the first major job I had done for Reuters, and making the cabinet ministers and their leader John Major look interesting or different was proving difficult! Margaret Thatcher was famous for not giving a damn about the way she was portrayed by the press. This began as a simple photo and was taken purely on a basis of composition. When the negative was scanned, however, it was clearly apparent that Mrs Thatcher was looking considerably paler than the rest of her cabinet colleagues. There were several theories in the press room and on Fleet Street as to why she seemed so pale in the photo, but not in real life. The most feasible I think is that the make-up she was wearing simply fluoresced or reflected the flash I was using at the time, and because she is so close to her cabinet colleagues who (hopefully) were not wearing make-up, the difference in skin tones was made much more evident.

Party conferences are an annual event, and my boss, David Viggers, asked me if I would come to Bournemouth from my stringing patch in Scotland to cover the conference. The conference was covered by my colleague Dylan Martinez and myself – and I just happened to be in the conference hall when Thatcher sat with her former cabinet ministers. A case of right time, right place … with a huge slice of luck thrown in.

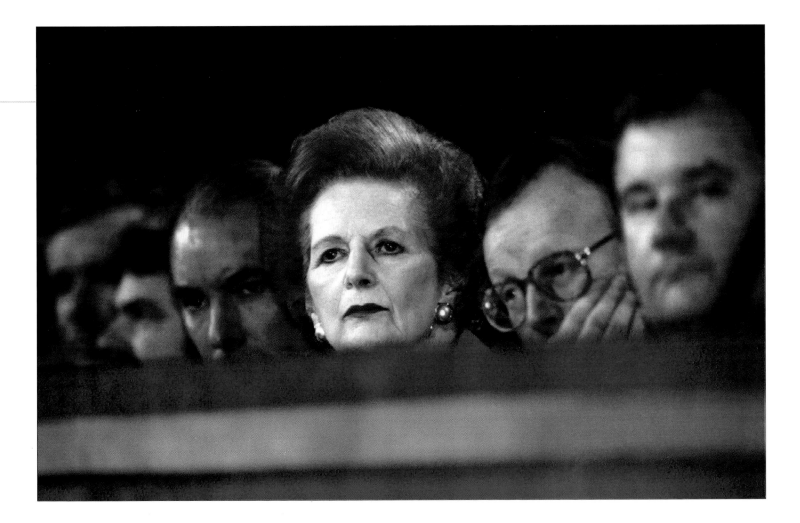

The Clintons
20 August 1999

Larry Downing

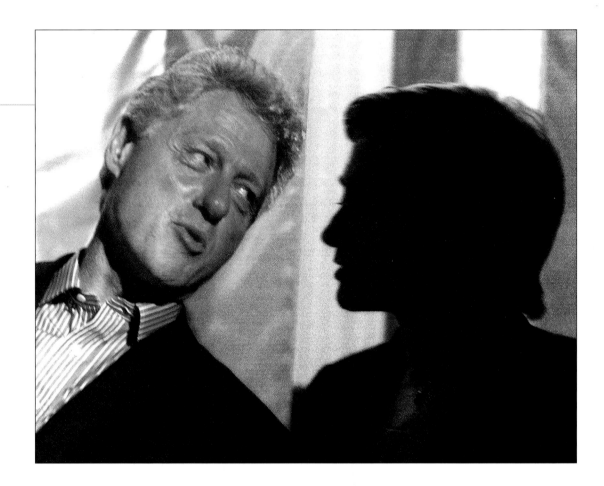

This photograph was taken at a political event in New York State while the first family was on vacation. As the president and first lady sat on stage waiting to speak I noticed that the spotlight on the couple fell off sharply next to the president. For most of the event both of them were lit up evenly but the first lady adjusted her chair slightly and became lost in the shadows for a brief few moments. The picture represents my interpretation of the previous two years of the Clinton Administration – the fact that, on certain issues, Hillary may have been left in the dark.

Shouting match, Juventus vs. Milan

17 November 1996

Claudio Papi

This picture was shot while I was covering the Juventus–Milan Serie A soccer match. Referee Pierluigi Collina had already warned the goalkeeper for unsportsmanlike conduct for holding up play earlier in the match. When, once more, the goalkeeper delayed kicking the ball back into play I saw Collina approach him. Instead of carding the goalkeeper he shouted in his face furiously!

I had already transmitted four action pictures and I went back to re-edit my film. It was the last frame on the roll and I decided to transmit it since it was not the average soccer picture. It later won first prize in the sports category of the CHIA Italian newsphoto awards.

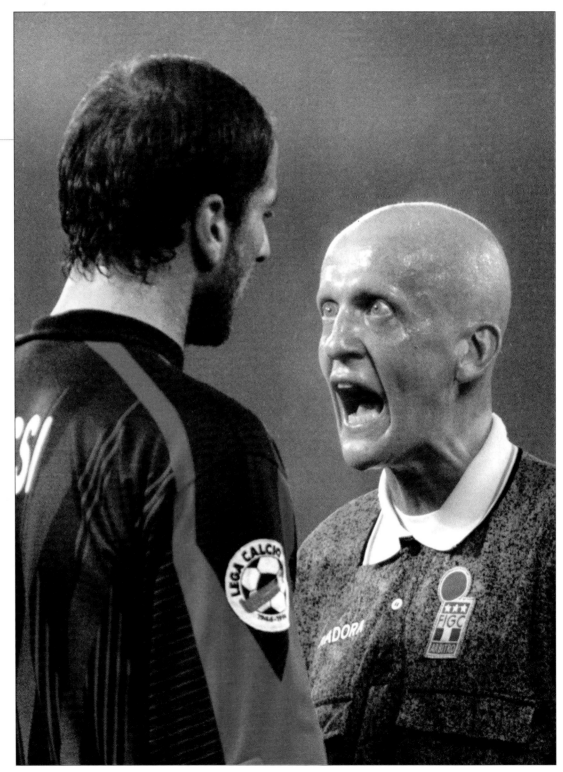

**A Nigerian fan,
World Cup 1998**
19 June 1998

Oleg Popov

A Nigerian fan, his face painted in his country's colours, awaits the appearance of his team on the pitch for a World Cup match against Bulgaria in Paris.

I was positioned next to the Nigerian fans, who sang and danced through the match. Only this man was quiet.

Bulgaria failed to win a match at the tournament; Nigeria's 'Super Eagles' beat them 1-0 and qualified for the second round as winners of their group. They were knocked out in the next round, losing 4-1 to Denmark.

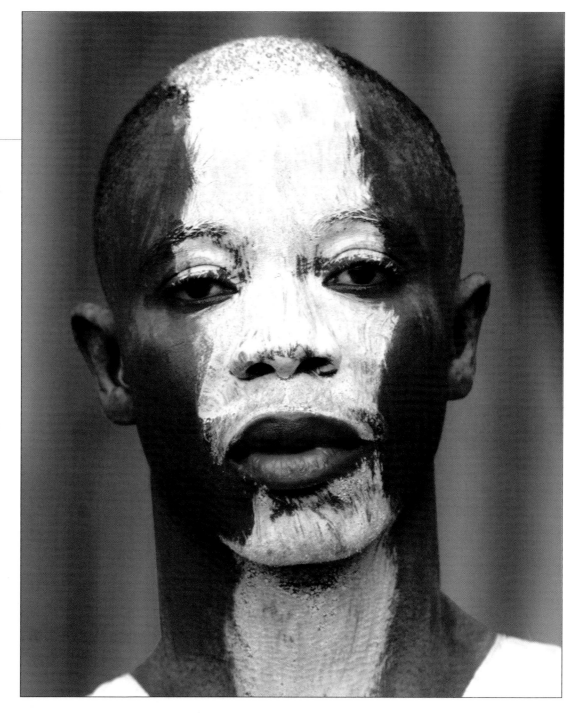

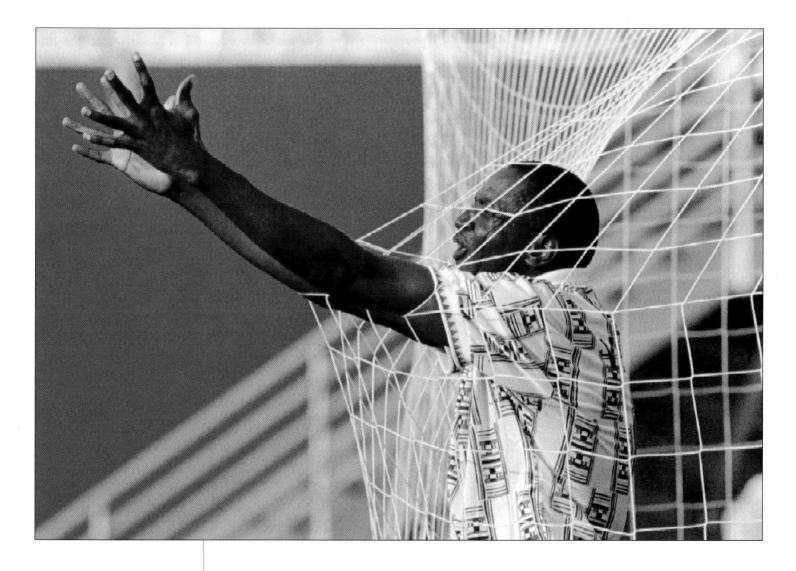

A Nigerian celebration, World Cup 1994
21 June 1994

Oleg Popov

Bulgaria had the dubious honour of losing their first and last games of the 1994 World Cup in the US. The first was a 2-0 defeat to Nigeria, during which this photo of Nigeria's Yekini – celebrating his first goal in the net of the Bulgarian team – was taken. The last was a 4-0 defeat to Sweden in the third place play-off.

However, the Bulgarians enjoyed their most successful World Cup ever: prior to 1994 the Bulgarian team had never won a match in the competition; in 1994 they came fourth, beating Argentina and Germany along the way, before being knocked out in the semi-finals by Italy.

Brazil won the World Cup, beating Italy in the final, in the first tournament ever to be won on penalties.

Nelson Mandela's release from prison
11 February 1990

Ulli Michel

I had been waiting for this moment: the release of the world's most famous political prisoner, Nelson Mandela. And I will never forget that February afternoon outside Victor Verster Prison in Paarl.

Mandela had made it very clear that, after being locked up for 27 years, he wanted to walk out of prison.

Photographers, reporters and camera crews were expecting him to address them from a position close to where we were standing. As he walked his last 200 metres to freedom, I started taking pictures through the 500mm lens on my camera.

In a flash, thousands of supporters engulfed Mandela. The great man disappeared in a sea of well-wishers and the moment was over. I had only the time to expose half a roll of film before he couldn't be seen anymore.

On my way back to Cape Town, where I developed my film, I wasn't sure I had the picture I needed and I was very nervous. Looking through my film on the light table, my lupe stopped at frame number 12.

There it was: Nelson Mandela on his way to freedom and to becoming South Africa's first black president.

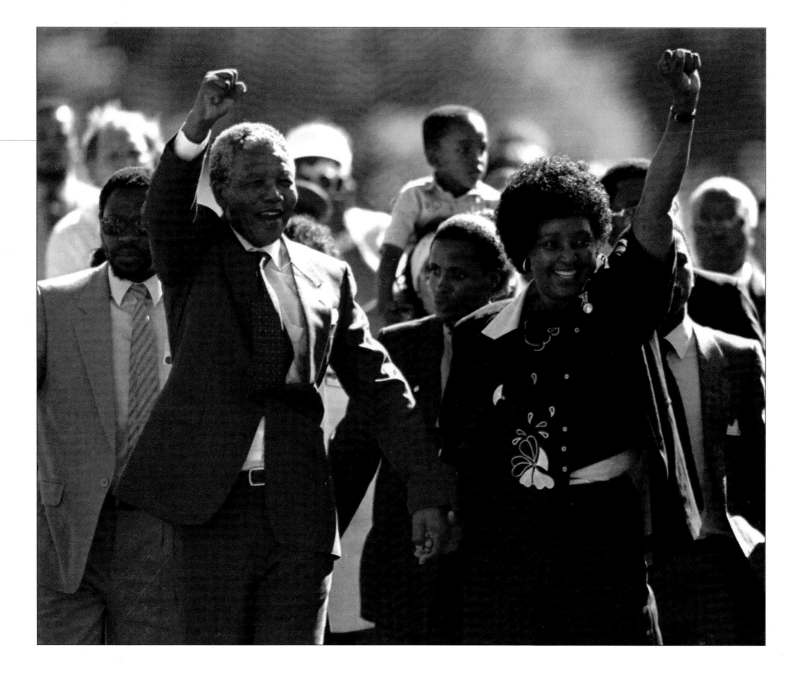

The Philippine general election, 1986
07 February 1986

Claro Cortes

In February 1986 I had been assigned to shoot general election scenes of the historic Philippine presidential polls. Incumbent strongman Ferdinand Marcos was challenged by Corazon Aquino, widow of assassinated opposition leader Benigno Aquino Jr. Voters from all walks of life came in throngs. Professionals, students, workers and the clerics went to the polls to cast their ballots. I went to a polling station very close to the office so I could file early pictures for the clients' deadlines. The world was eagerly following developments in the Philippines at that time.

The polling station, which was a public school, was really crowded. I went from room to room looking for a good shot until a group of Catholic nuns looking for their names in the voters' list caught my eye. I followed them, clearly letting them see my presence to make them more relaxed about the fact that I was tailing them. I snapped images of them registering, and receiving and filling in their ballots. I knew I would have something nice after I saw them sitting in adjacent booths. What makes this image great is its simplicity. The nuns in their white habits framed by the makeshift dividers created a graphic pattern which helps the composition. Luckily, we were still using black and white films back then – as I feel this was truly a black and white picture!

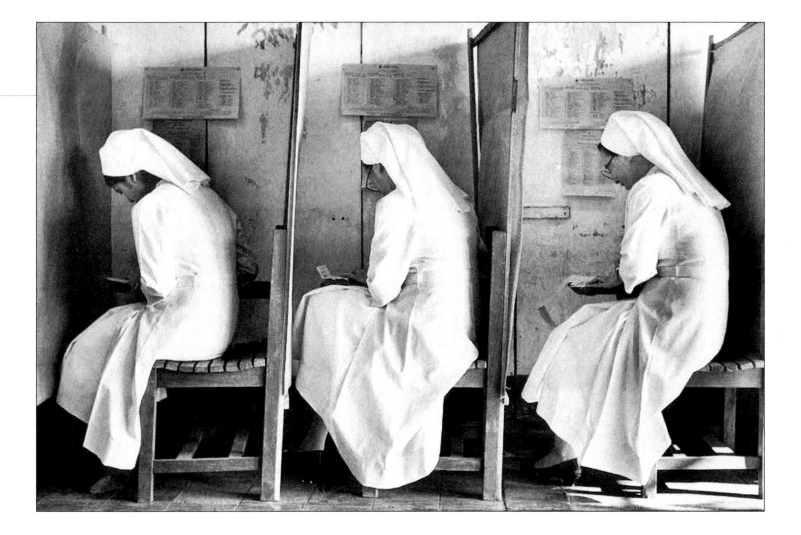

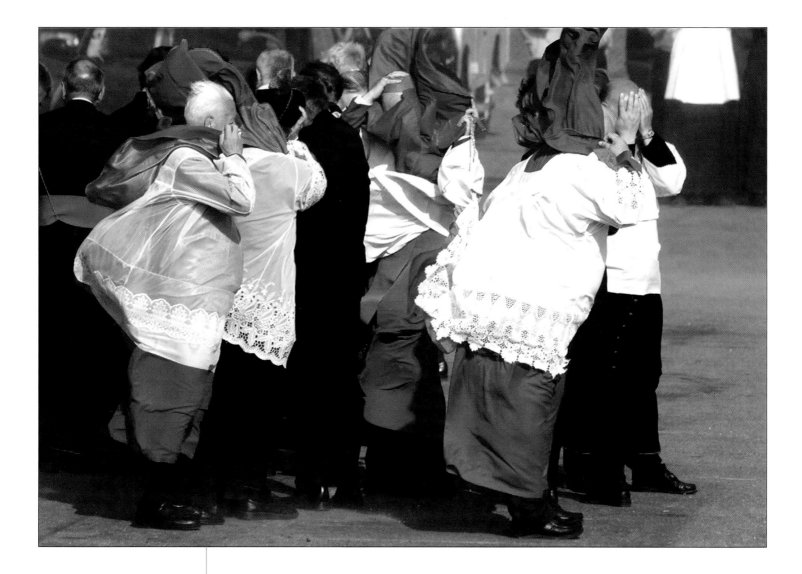

Polish bishops await the Pope
06 June 1999

Jerry Lampen

Polish bishops wait for the arrival of Pope John Paul II in Elblag, Poland. As I was waiting in the Tarpan (open Land Rover) for the pontiff to arrive by helicopter my eye caught these bishops who were part of the welcome committee. When the helicopter arrived, the rotor wash sent into the air sand and dust – and the robes of the waiting bishops. It was a split second shot and thanks to the fact that I was keeping an eye on them I caught the action.

The picture was published as picture of the week in the German quality magazine Focus and also featured in Time Magazine. It was also awarded second prize in the foreign news category of the Dutch Picture of the Year competition.

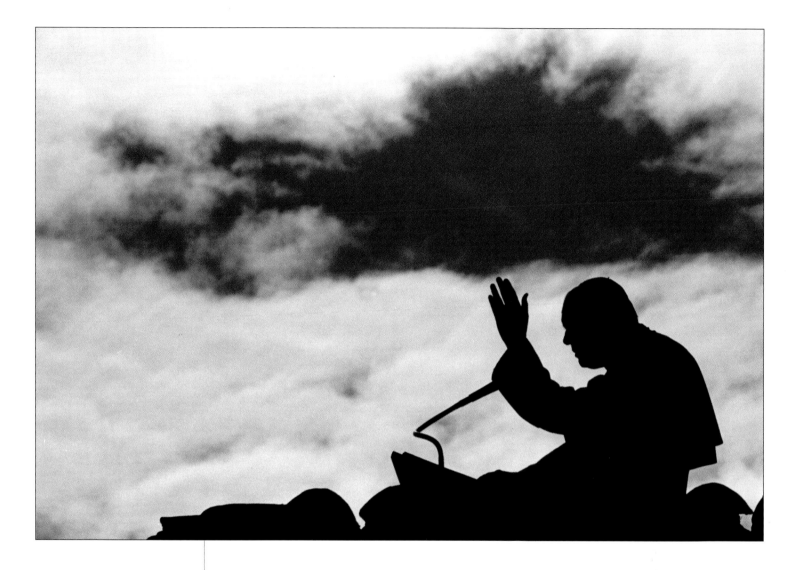

The Pope remembers earthquake victims, Assisi
03 January 1998

Paolo Cocco

I took this picture when the Pope went to Assisi to conduct a service commemorating the victims of an earthquake in central Italy. The Pope toured the affected area and met those who had been made homeless. Then he presided over a ceremony and prayer from the Basilica of St Francis, where four people, including two Franciscan friars, had died when the ceiling, on which the famous frescos were painted, gave way and fell to the ground.

I was using a Canon 500mm lens and Fuji 400ASA negative film. It was near the end of the ceremony and the Pope was blessing people gathered outside the Basilica. I had already shot from head on, so was walking around to find a different angle. I saw the clouds gathered, decided to silhouette the Pope against them, and waited for the right moment.

I like this photo because it's a very simple and yet strong image; everyone can recognize the Pope, even if it's only his silhouette.

Sex and drugs and rock and roll
22 May 1995

Kieran Doherty

Sometimes the best photographs happen when an official photo-call is over. Rock star Tommy Lee and his wife Pamela Anderson had been at the launch of a new soft drink, 'Virgin Energy', which was claimed to have aphrodisiac qualities. When they left they climbed into their limo and were hidden behind the smoked glass. I ran through traffic on the busy road to the moving vehicle and tapped on the window. Tommy Lee wound down the window and reacted with good humour by attacking me with a stretched condom.

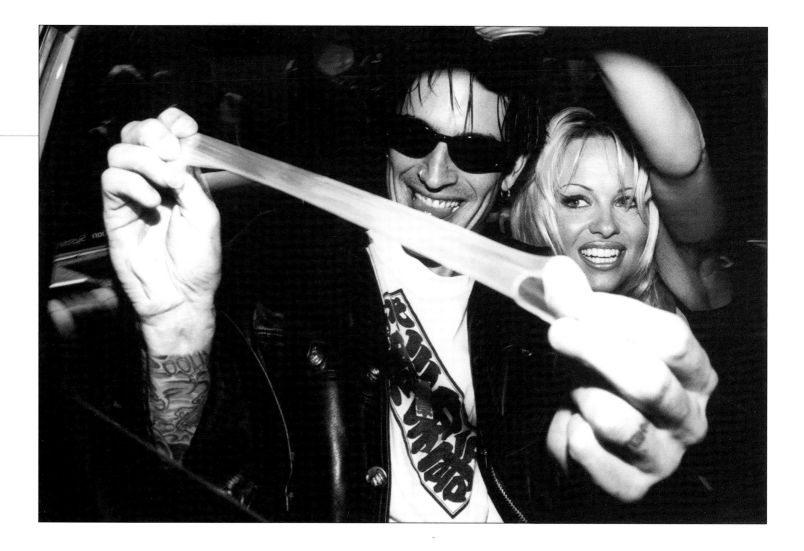

Evander Holyfield
28 June 1997

Gary Hershorn

This photo shows Evander Holyfield walking back to his corner, in a fight in Las Vegas, after Mike Tyson had bitten off a portion of his ear. It was truly one of the most bizarre moments to have ever taken place during a sporting event. A headbutt from Holyfield which went unpenalized by the referee, and which had opened a cut on Tyson's face, incensed the latter so much that he took matters into his own hands.

I was in my usual ringside position shooting through the ropes when Tyson bit Holyfield's ear. No one at ringside had a clue what had happened when Holyfield started jumping up and down and holding his ear. When we saw blood and a small piece of flesh on the mat it became apparent that part of the ear had been bitten off. When Tyson was disqualified all I remember doing was jumping up on the apron of the ring and thinking I had to get a picture of the ear.

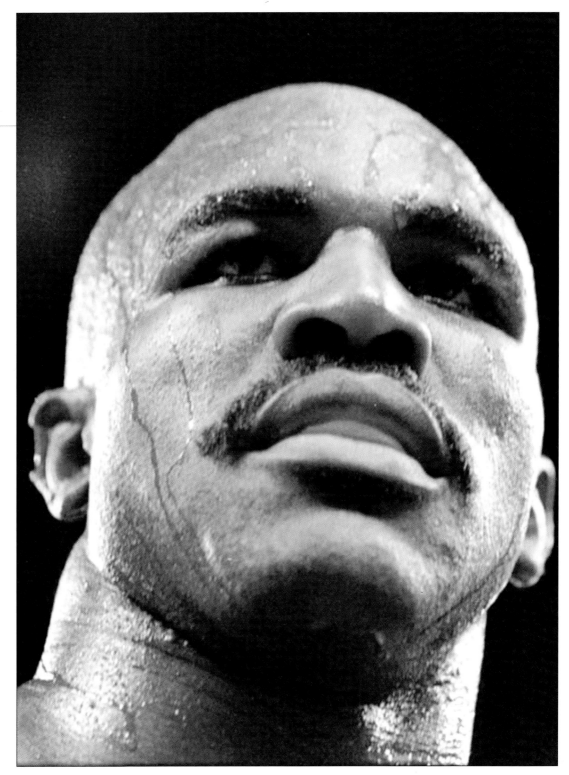

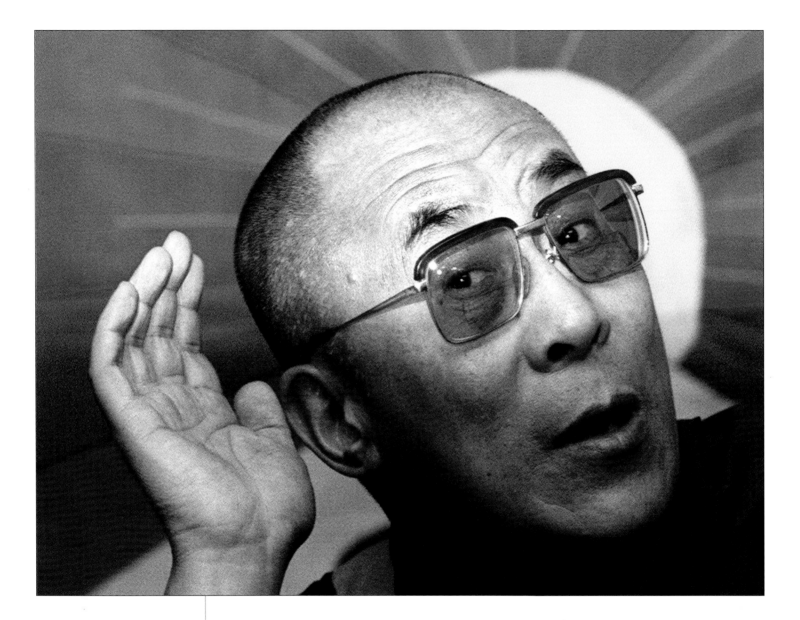

The Dalai Lama
13 June 1993

Heinz Peter Bader

This photograph was taken as the Dalai Lama strained to listen to journalists' questions during a news conference a day before the opening of the United Nations World Human Rights Conference in Vienna. The Dalai Lama was officially invited to Austria after his exclusion from the UN conference.

THE ART OF SEEING

Tibetan herders playing open-air billiards
09 August 1999

Natalie Behring

A group of Tibetan herders play a game of billiards as a flock of goats and horses graze on the pasture above them near Xiangpi Mountain, in China's western Qinghai province. Qinghai is part of the Qinghai-Tibet Plateau, also known as the 'Roof of the world', where ethnic Tibetans make up 21 per cent of the population.

I took this photo while on a trip sponsored by the World Bank. About 20 journalists were invited to see a site where China plans to relocate ethnic Tibetans and Muslims in a Han (Chinese) area. While we were driving through the countryside, I saw several situations similar to the one shown in this picture, but since we were in a caravan of trucks, the driver refused to stop and let me take pictures. Luckily, on the way back to the provincial capital, I saw the billiard table from the car, and the driver agreed to take a quick break. I just ran out of the car and snapped a few pictures.

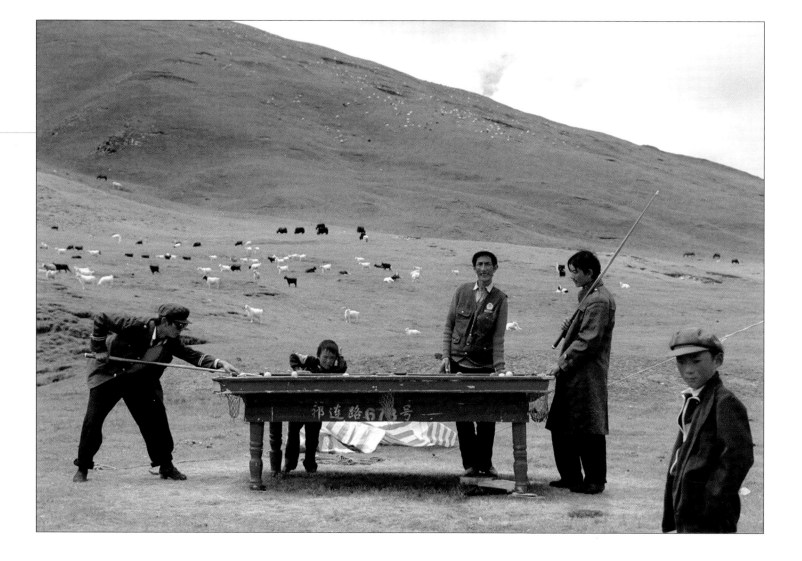

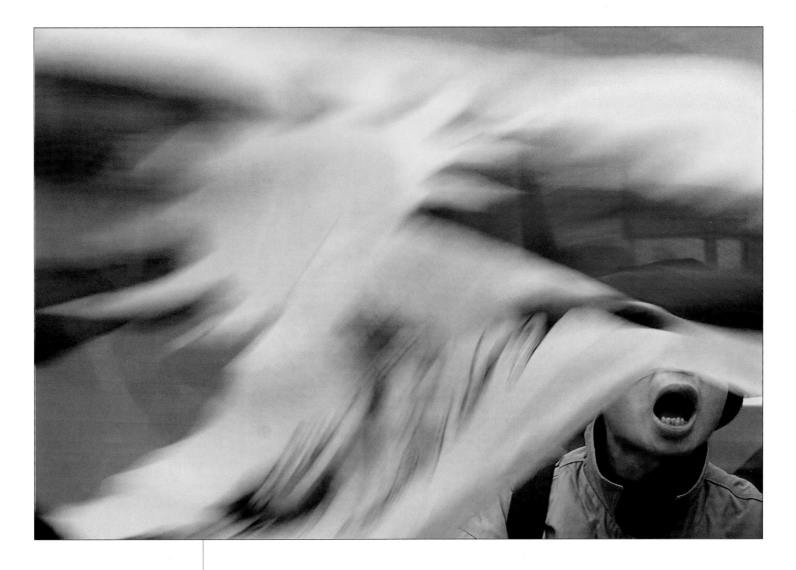

Anti-Chinese demonstrations, Whitehall, London
21 October 1999

Dylan Martinez

This photo was taken whilst Chinese premier Jiang Zemin was meeting with UK Prime Minister Tony Blair inside No. 10, Downing Street, during a very controversial official visit to the UK. Pro-Tibet and other anti-Chinese demonstrators were out in force. Some 200 or so protestors shouted for a free Tibet and waved flags and banners. I didn't have much time as I had to get back to snap Zemin leaving No. 10. In the midst of the crowd I noticed this colourful flag and the man waving it and waited for him to shout. I took about a dozen frames on a slow shutter and, once I saw on the back of my camera that I had this image, I hurried back to Downing Street.

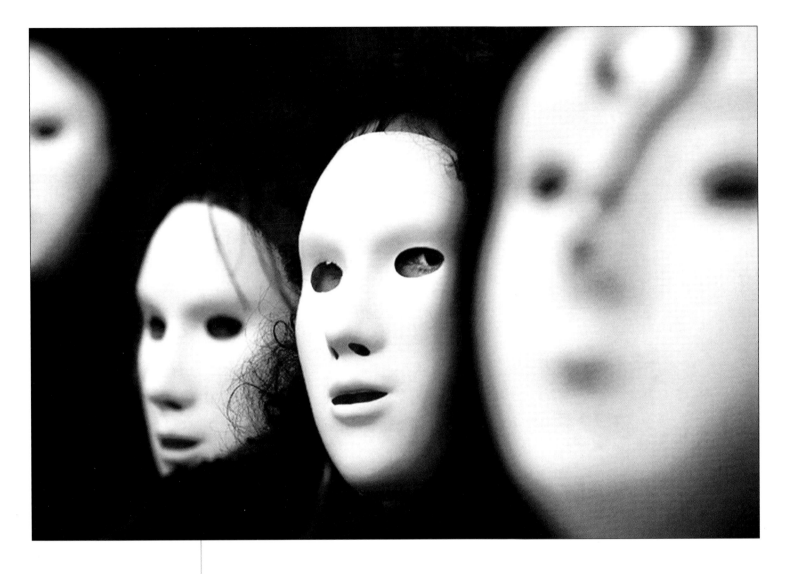

**Anti-Pinochet
demonstrators,
Trafalgar Square,
London**
17 January 1999

Kieran Doherty

Demonstrators against former Chilean dictator, General Augusto Pinochet, gathered in Trafalgar Square and wore these masks to represent those missing over the years when he was in power. The Spanish judge Baltasar Garzon was due to arrive in London to attend the House of Lords hearing regarding Pinochet's extradition the following day. Through wearing the masks the demonstrators created a haunting and even eerie atmosphere. For photographic impact the masks needed to be compressed – an effect I achieved by shooting side-on. For me the momentary glimpse of the eye peering through the mask brought this picture to life.

General Pinochet had been placed under house arrest during a vist to Britain, following an extradition request from Spain for crimes against humanity. He was detained for a total of 18 months, as teams of lawyers debated the case, before being allowed back to Chile on grounds of ill health.

A masked ball

16 July 1999

Miro Kuzmanovic

Singers perform on a giant stage on Lake Constance during a rehearsal of Giuseppe Verdi's opera 'Ein Maskenball' (A Masked Ball), which featured as part of the annual Bregenz festival. The design of the stage on the lake shows 'Death' reading the book of life.

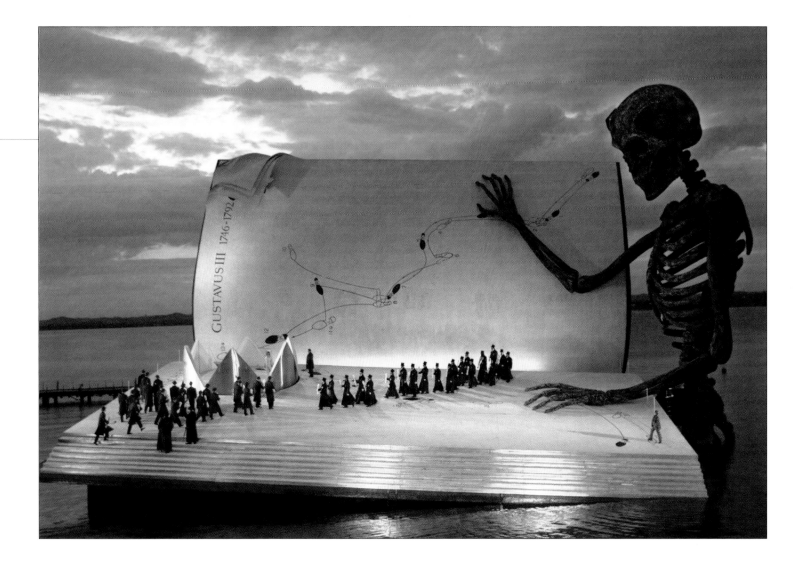

Rwandan Hutu refugees
17 December 1996

John Parkin

A Rwandan Hutu refugee helps her daughter with a drip at a local hospital in Goma, Zaire.

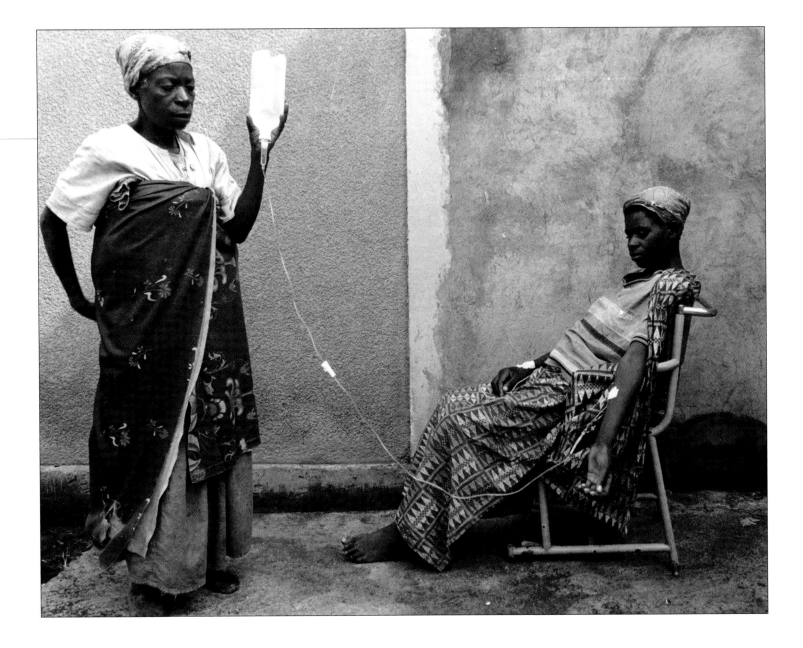

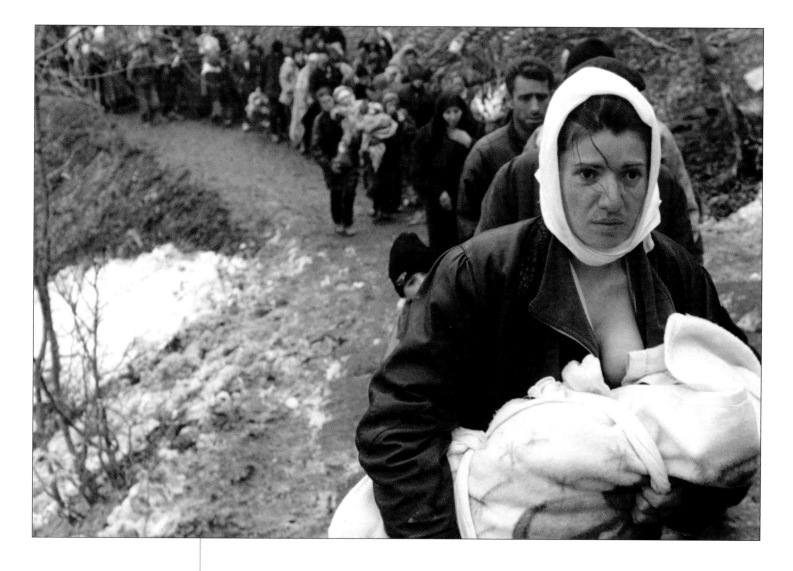

Exodus from Kosovo
30 March 1999

Damir Sagolj

An ethnic Albanian woman feeds her baby as she and another 2,000 refugees walk up a muddy dirt track on Likej Mountain after they were allowed to enter Macedonia in the mountainous region near the border crossing of Blace. More than 2,000 Kosovo refugees entered Macedonia after crossing the mountains in the south of Kosovo overnight. The refugees were blocked by the Macedonian army for several hours and spent the night in the forest, but were later allowed to enter Macedonia after UNHCR officials put pressure on the Macedonian government.

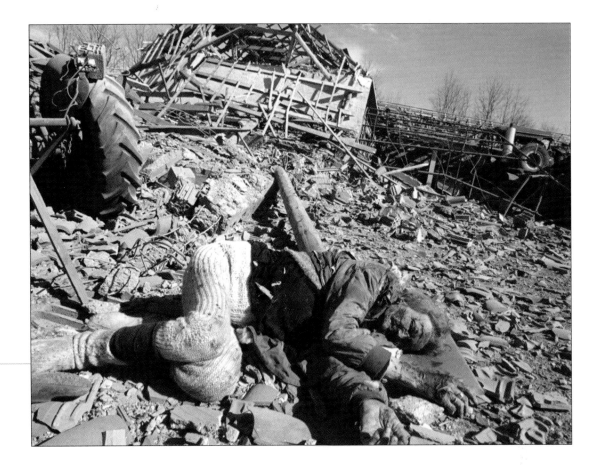

**An Albanian victim of
NATO bombing, Kosovo**
14 April 1999

Goran Tomasevic

My most important work for Reuters so far has been in Kosovo. After several assignments in 1998 and 1999, I was in Pristina just before the start of the NATO bombing. The Yugoslav authorities ordered all journalists to leave, especially those working for foreign news organizations. I did not want to go and had no intention of doing so. This was happening in my country and I wanted to stay – so I did! I was one of very few photographers, and indeed journalists, who remained. For the first few days I encountered problems as people constantly questioned me about what I was doing. But after a while they stopped bothering me and I was able to work undisturbed.

On 14 April 1999 I heard that NATO missiles had hit some refugees. I took my car and went to the village of Mejia. The air smelt of burnt flesh and I could see the charred corpses of many people strewn over the ground. In all 64 people were killed, and 20 more injured. The Serb police were scared and confused and did not hinder my work. The rumble of NATO planes could still be heard overhead and we had to keep taking cover in case they returned.

A Kosovar refugee pleads with Macedonian soldiers
01 April 1999

Yannis Behrakis

When NATO air strikes started on 26 March 1999 Serb troops forced hundreds of thousands of ethnic Albanians out of Kosovo. In some cases the Serbs put thousands of Albanians onto trains and deported them to Macedonia.

However, the Macedonian authorities refused entry to Kosovar refugees, and for ten days ethnic Albanian refugees streaming out of Kosovo were stranded in a no-man's-land between the two states. And still the number of deported refugees grew by thousands every day. This woman pleads to Macedonian soldiers to let them enter Macedonia. Conditions in refugee camps were desperate, and getting worse as more arrivals continued to flood in. This photograph was taken at the notorious Blace camp, where people were struggling to find food or water.

I was in Macedonia covering the Kosovo refugee crisis, and had been at the border crossing of Blace every day. However, after the second day the Macedonian army denied access to the camp to all journalists. I managed to get into the camp by giving cigarettes and other goods to some Macedonian policemen. I then got this shot, of a woman in front of about 10,000 refugees, appealing to Macedonian policemen to let them over the border into Macedonia.

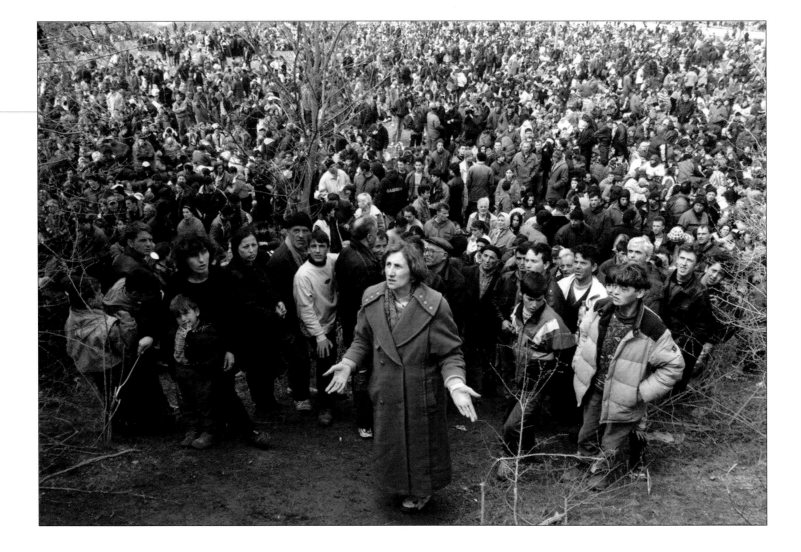

Kosovar refugees fight for Red Cross provisions
29 April 1999

Yannis Behrakis

In the Kosovar refugee camp at Blace, some local Red Cross workers
finally started distributing bread and other aid to people who had been
several days in the open without food or warm clothes. The extent of the
desperation and hunger of the refugees became clear when they started
fighting between themselves to reach the provisions.

The Macedonian army had sealed the perimeter of the camp, and were
not allowing journalists in. I got in by disguising myself as a refugee,
covering myself and my cameras with a long blanket and walking slowly
through the army lines into the camp.

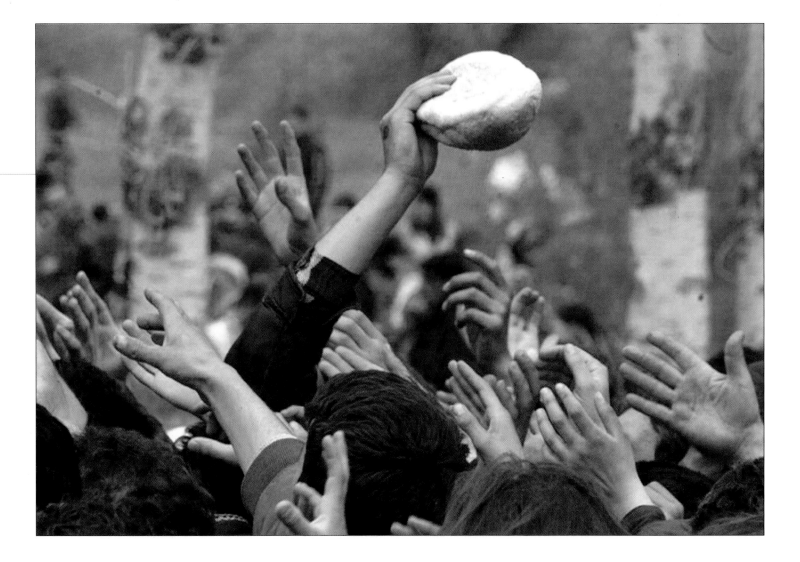

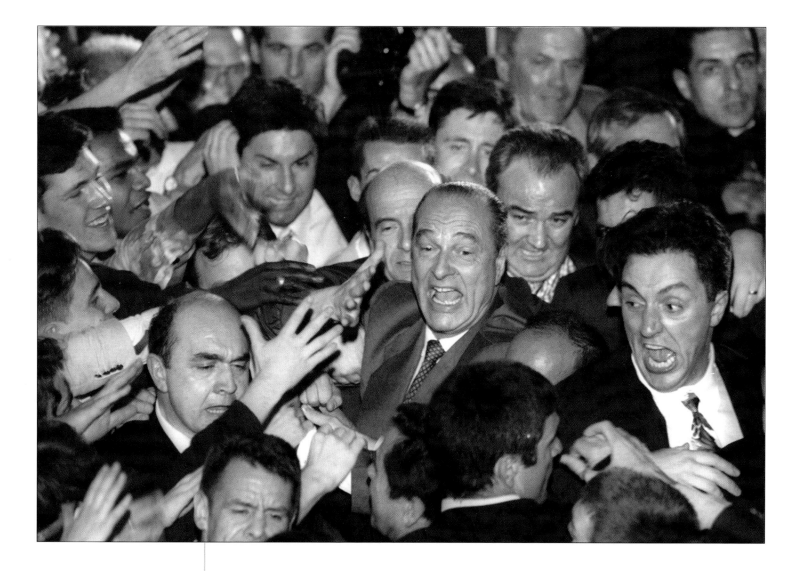

Jacques Chirac is elected French President
07 May 1999

Jack Dabaghian

After covering the election during the day, getting shots of voters at polling stations etc., each Paris photographer was assigned to the headquarters of a political party in order to photograph supporters' reactions and the eventual winning candidate. I was selected to be at the rally for the Republican Party headquarters that night. At about 8pm, after preliminary results had come in, it became clear that Chirac had won. I then started looking for an angle from which I could capture his arrival back at his campaign HQ. Moving through the cheering supporters was impossible. After discovering the route by which Chirac would arrive I decided to climb onto the first floor of the building housing his headquarters. When he did arrive his supporters became hysterical, clambering over security fences. His bodyguards and close party members could do little to help. Everybody was being pushed and crushed, screaming for air and space. I was comfortably installed on my balcony capturing the historical moment – and watching other photographers unable to work.

During the following days I realized my picture was in every single newspaper and magazine. I had captured the picture that encapsulated the spirit of celebration following Chirac's victory.

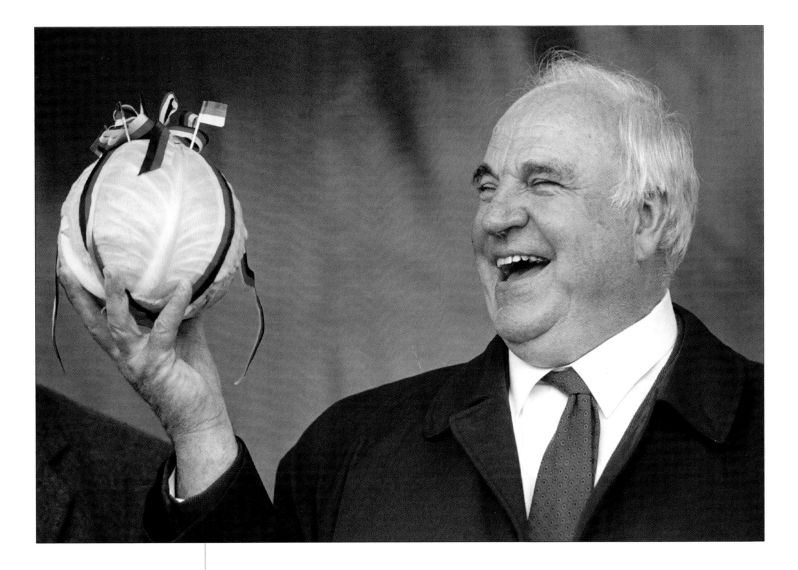

Helmut Kohl election campaigning
29 July 1998

Christian Charisius

In July 1998 Germany's former Chancellor Helmut Kohl was campaigning for federal elections in four popular holiday resorts on Germany's North Sea coast. In one of these towns, Buesum, the mayor unexpectedly offered Kohl a cabbage decorated with small German flags, because the Buesum region is an important and well-known area for the growing of cabbages – but also because Kohl means cabbage in German. Kohl was surprised by the mayor's present and took in good heart the pun on his name.

I decided to cover Kohl's first stop on his traditional one-day journey through the North Sea region so that I could return to Hamburg, work on the pictures and file them on time. I wanted to be as close as possible to the former Chancellor when he mingled with the crowd, which he usually did on these occasions. Waiting for the end of his speech directly in front of the stage, I found myself laughing while watching this scene through the viewfinder of my camera.

Before 1989 the Berlin Wall was the symbolic divide between East and West. Then, in that year, peoples of the East rose up, fleeing westwards to freedom through Czechoslovakia and Hungary. The movement culminated in Berlin when Berliners from both sides of the wall overcame the oppressive shadow it cast to tear it down and unite Germany and Europe once again. I got to Berlin on 9 October 1989 and was assigned to stay at the Brandenburg gate until something happened. I waited with the 'Wessis' or 'Westies' until 4am, taking pictures of the partying on the wall. Having crept off for a two hour nap I returned at 6am. The situation had changed: the East German soldiers had thrown the revellers off the wall and stood atop it themselves, glowering at their Western brethren. A sledgehammer emerged from the crowd. Eagerly, and still under the eyes of the soldiers, the crowd hammered against the wall. First just small chunks of concrete flew, but they got bigger and bigger as a hole opened. The soldiers directed a high-pressure water hose through the gap, but the hammerers just got wet and continued to pound. I kept taking shots, avoiding getting my gear wet and trying to capture the whole scene: soldiers, hammer, water, flying concrete, magic. It was the first hole in the wall, the first opening to the East, to an old people but a new way of life and a new way of thinking.

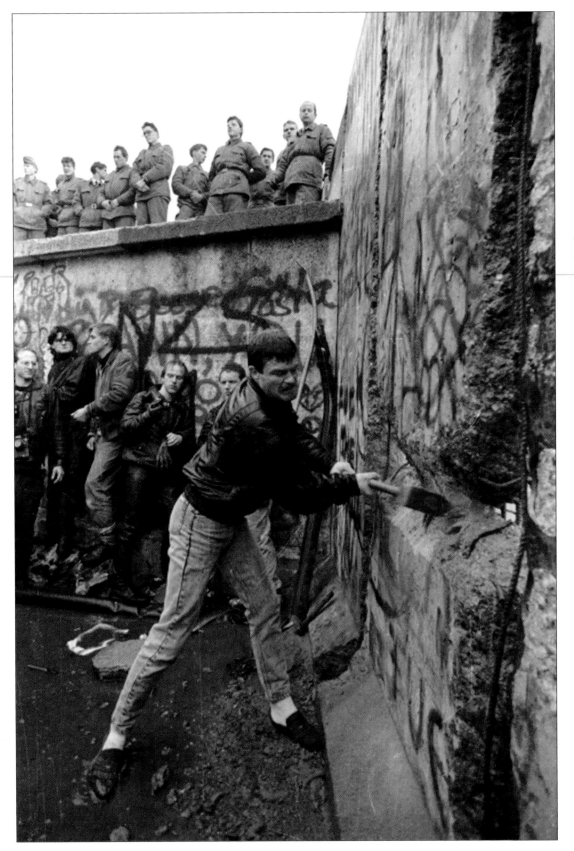

The Berlin Wall falls
10 October 1989

David Brauchli

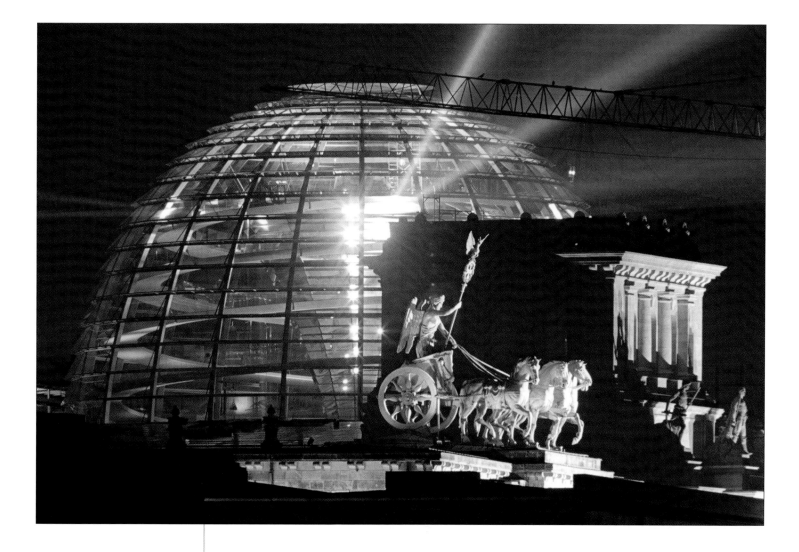

The New Reichstag, Berlin
26 September 1998

Fabrizio Bensch

The Brandenburg Gate and the Reichstag building – the seat of the German parliament – are both of great symbolic and historic import to all Germans. The Reichstag was burnt under the Nazis, and was badly damaged during World War II when the Red Army hoisted the Soviet flag above it. After the division of Germany the parliament moved to Bonn. But the Reichstag reacquired its intended use with the reunification of the country. As the gateway between East and West the Brandenburg Gate had been seen as the symbol for the division of Germany, but when the Berlin Wall came down on the night of 9 November 1989 it came to represent union and opportunity.

On the night before I took this photo general elections to the Bundestag (the German lower house) had taken place. They ended the era of Helmut Kohl and saw in a new Chancellor, Gerhard Schroeder. It was then that the lighting in the dome of the new Reichstag was switched on for the first time.

My aim in capturing the Quadriga on the top of the Brandenburg Gate together with the illuminated dome – which I took with an extremely long telephoto lens – was to capture an image of Germany past and present.

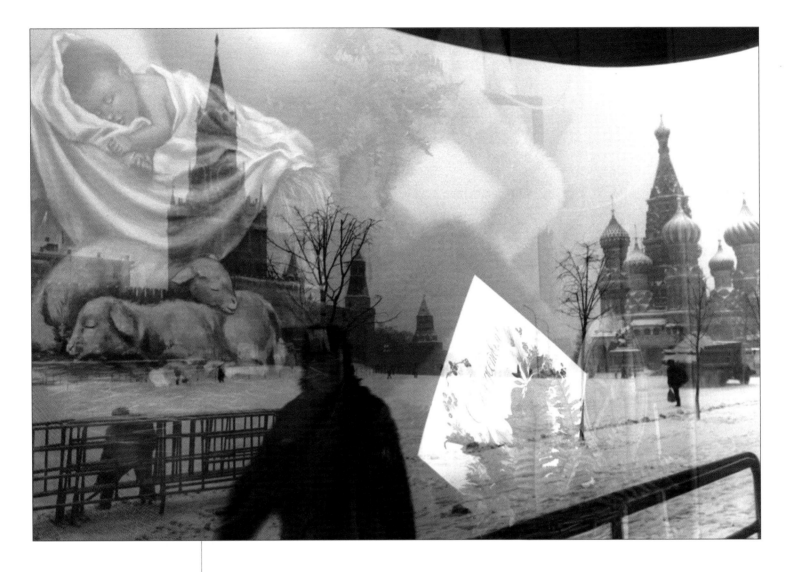

Moscow at Christmas
23 December 1996

Grigory Dukor

The Kremlin and St Basil's cathedral are reflected in a store window displaying Christmas decorations.

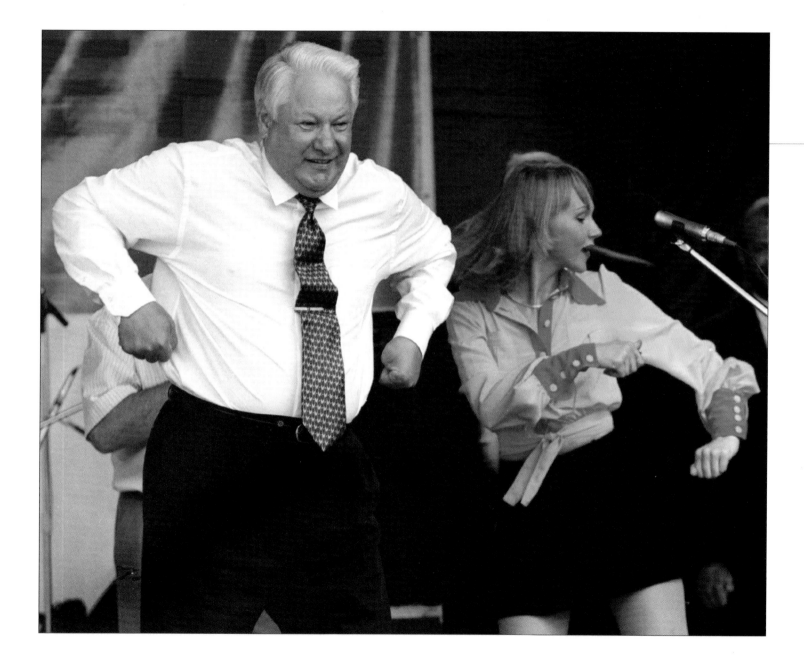

Boris Yeltsin dances in Rostov
10 June 1996

Viktor Korotayev

After addressing a crowd of (mostly young) Russians in a stadium in the southern city of Rostov, Russian President Boris Yeltsin suddenly returned to the stage and started to dance with entertainers who were performing for the audience. The event happened during the 1996 presidential election campaign, when Yeltsin was running for re-election. At that stage in the campaign Yeltsin was level in the polls with Communist party leader Gennady Zyuganov, but went on to win and serve his second term, until his abrupt resignation on 31 December 1999.

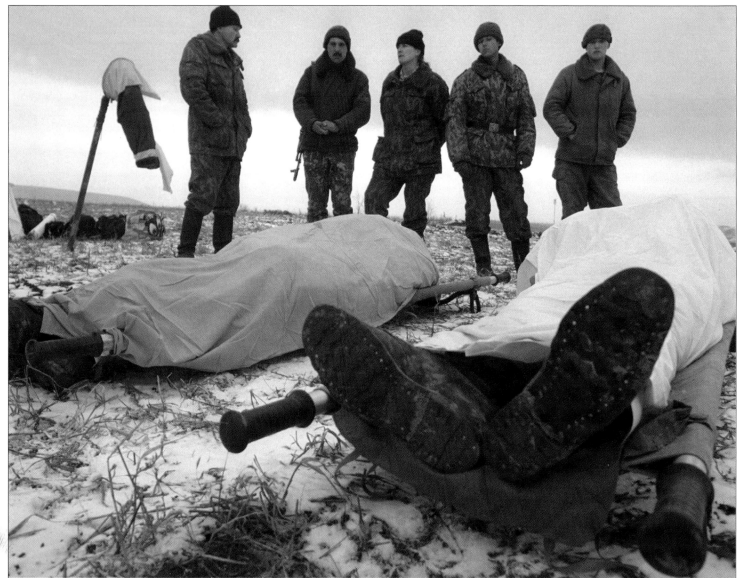

Russian soldiers killed in Chechnya
30 November 1999

Vladamir Velengurin

Russian soldiers say a last farewell to their comrades killed in Chechnya. These two paratroopers were killed during an attack on the strategically important Chechen town of Argun. They were riding on an armoured personnel carrier which came under grenade fire. Two days before this I had photographed them smiling and laughing with their friends. A couple of minutes after I took this frame their bodies were taken away by helicopter.

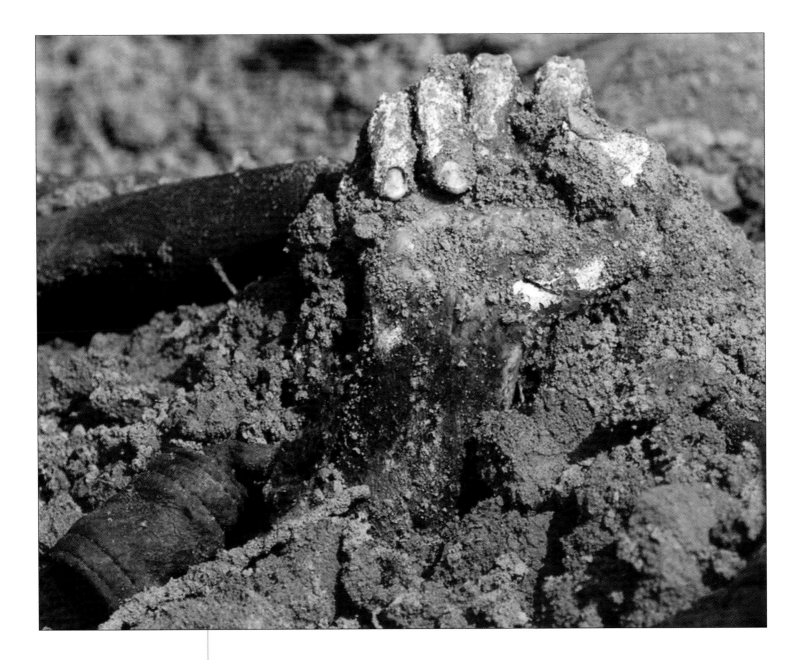

Uncovering a mass grave in Kosovo
26 June 1999

Peter Mueller

I had received information that German army investigators had discovered a mass grave in the small village of Zagradska Hoqa, outside Prizren, in western Kosovo.

It was only my second week in Kosovo, but I had already come to recognize the smell of bodies – a smell that greeted us as the grave was opened. The first thing that became visible as soldiers continued to uncover the grave was this fist of a dead ethnic Albanian man. He was buried alongside three others.

To me the clenched fist is an expression of the cruel and miserable struggles during the Kosovo conflict.

Coffins stick out of the ground in a massive cemetery that was deluged in water and mud when a river in the northern Peruvian city of Trujillo burst its banks. The flooding dislodged earth and sent 123 corpses floating into the surrounding neighborhoods. In Peru mudslides and flooding from El Nino rains caused over 200 deaths and left more than 200,000 people homeless.

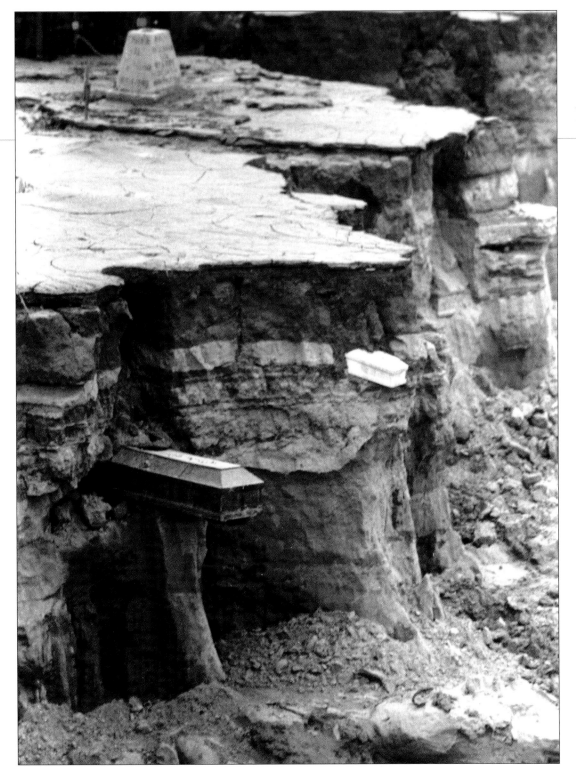

Floodwaters damage a cemetery, Peru
12 February 1998

Silvia Izuierdo

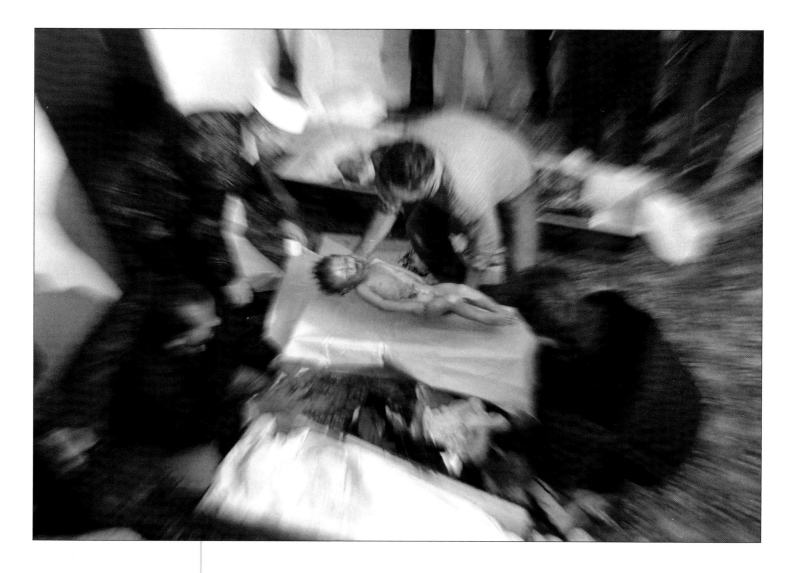

The funeral of ethnic Albanians killed by Serbs
23 October 1998

Yannis Behrakis

Ethnic Albanians lower the body of two-year-old Mozzlum Sylmetaj into his coffin during a Moslem funeral preparation ceremony in the village of Gercina, west of Pristina and near the Kosovo–Albania border. Serbian border troops had killed him, along with his father, six-year-old brother, twelve-year-old cousin, and their Albanian guide. Hundreds of ethnic Albanians attended their funeral.

The family had been trying to return to their village – following the agreement of the Holbrook–Milosevic deal – after spending a month as refugees in Albania, fleeing fighting between Kosovo Liberation Army (KLA) and Serb forces. The Serbs claimed they had been with KLA guerillas, and were killed in an exchange of fire with border troops.

I had learnt of the funeral the night before, and drove through Kosovo to the village in a bullet-proof Land Rover. The funeral presented some very strong scenes. When the relatives started preparing the bodies for the burial I walked up a staircase and shot pictures from above, staying away from other people in the room so as not to be too intrusive. I shot this picture with the existing light in the room, using the zoom effect in my 28-70 lens to give more power to the picture.

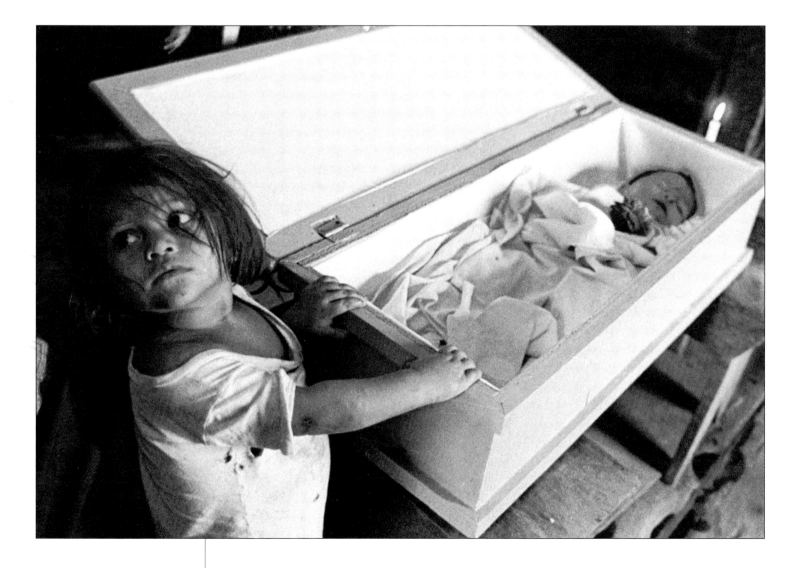

Infant victims of Contra rebels, Nicaragua
August 1988

Lou Dematteis

In this photo, a two-and-a-half-year-old child looks up from the coffin holding the body of her six month old brother, killed during an attack by Contra rebels on an isolated farm co-operative in Jinotega Department, in the rural countryside of Nicaragua, three-and-a-half hours from the capital, Managua. I took the photo as part of Reuters' ongoing coverage of the brutal war, which was waged by US-backed Contra rebels against Nicaragua's Sandinista government.

I heard about the attack on the farm co-operative late one evening while I was in Managua. Contra rebels had attacked in the pre-dawn darkness earlier that day. I left early the next morning in a four-wheel-drive vehicle. The muddy dirt road to the co-operative was in very bad shape and was also very dangerous as ambushes by the Contras were a common occurrence. After I reached the scene I found out that several people had been killed and a number of buildings burned to the ground. I entered an undamaged house and found the coffin with the infant we see in the photo.

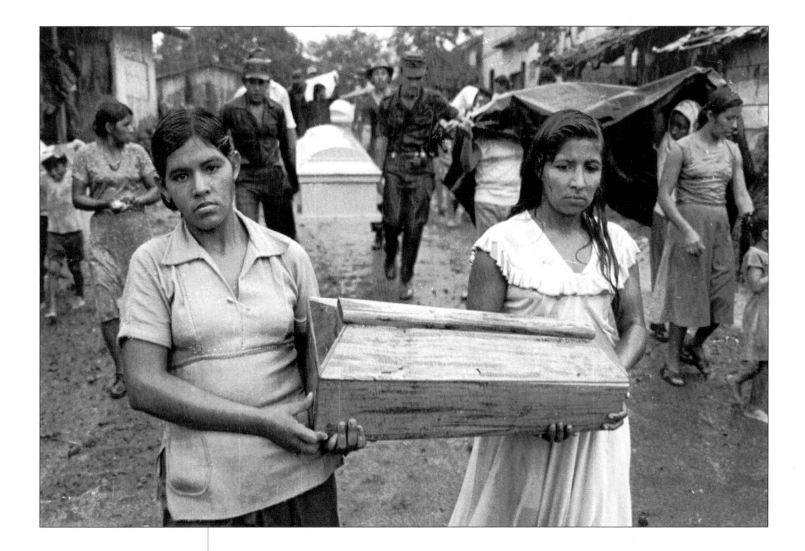

**Burying victims of a
Contra landmine,
Nicaragua**
04 July 1986

Lou Dematteis

Two women walk in a funeral procession carrying a coffin holding the body of a child killed along with 31 other unarmed civilians – men, women and children – when the truck they were riding in struck a Contra land mine. The truck was carrying a 50-gallon barrel of gasoline that exploded and many of the victims were burned beyond recognition. I arrived before the coffins for the victims did and I saw the charred remains of the victims on a warehouse floor. It was the single most difficult event for me to photograph in my five and a half years of covering the war in Nicaragua. The photograph of the funeral procession was taken in the pouring rain.

The landmine explosion took place on the morning of 3 July 1986. That evening, the Nicaraguan Army informed journalists in Managua of the explosion, and said they would lead a convoy of journalists wishing to travel to the area the next day. We left for the town of San Jose de Bocay, about four and a half hours from Managua, early in the morning. It was raining very hard throughout the day, making the journey over the muddy and dangerous roads even more difficult. On our way, we passed an army convoy bringing coffins into the town for the 32 victims. We entered the town and found the victims laid out in the warehouse. Then the coffins arrived, the victims were placed into them and the funeral procession began.

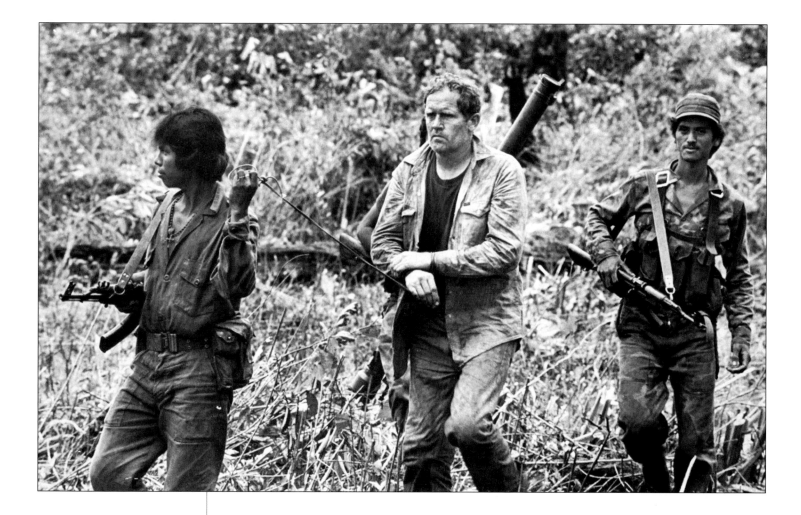

The capture of a CIA mercenary, Nicaragua
07 October 1986

Lou Dematteis

Sandinista soldiers lead US mercenary Eugene Hasenfus through the jungle after shooting down his Contra supply plane. Hasenfus was in the secret pay of the United States Central Intelligence Agency, which was illegally supplying the Contra rebels. He survived by parachuting out of the plane before it crashed. The downing of the plane and Hasenfus's capture provided the Sandinistas with hard evidence of the extensive, illegal US-funded Contra supply operation and triggered what became known as the Iran/Contra investigations. This photo is perhaps the best known image of all those resulting from the coverage of the wars in Central America in the 1980s.

I first heard about the downing of the Contra supply plane via a phone call from the US on the morning of 6 October 1986. The plane had been reported missing from its base in El Salvador, where the CIA's secret re-supply mission was situated. The rumour was that an American aboard the plane had survived the crash and been captured. The area where the plane went down was in the middle of the jungle of Rio San Juan Department, in south-eastern Nicaragua, and the only way to get there was by helicopter. I immediately left with some other journalists and drove to the Sandinista Air Force base nearest to the crash site. We spent the night outside the base and early the next morning convinced the officials there to allow us to travel with them by helicopter as they went out into the jungle to pick up the prisoner and bring him back to Managua.

The bombing of the US Embassy, Nairobi
07 August 1999

George Mulala

It was the first day of my holidays. I drove into town at about 10am, parked my car close to the office for security, and walked to the bank.

I was about 30 metres from the office when I heard a huge 'boom'. This was not like a tyre burst or a car accident, but very deep and very loud. It made the doves that live upon the surrounding rooftops noisily flap away as glass in all the buildings shattered.

I turned and ran straight back to the office to pick up my cameras. Sirens, horns and all sort of noises were beginning to infringe upon the silence that had followed the blast. All power was out, so at the office I ran up and down 12 flights of stairs to get my cameras. Outside, I grabbed a taxi and ran to the scene.

The carnage in front of me was terrible: I am used to photographing conflict but this was worse than I had ever seen before. Anything I had encountered when covering genocide in Rwanda, the Somalian crisis or the civil unrest in Burundi all faded by comparison. It was the US embassy that had been bombed, and I had to stand far away to take in the full impact and extent of the destruction. The bomb killed more than 250 people and injured a further 5,000. When volunteers brought out this injured man, I lifted my camera and, with a 200mm, took the image.

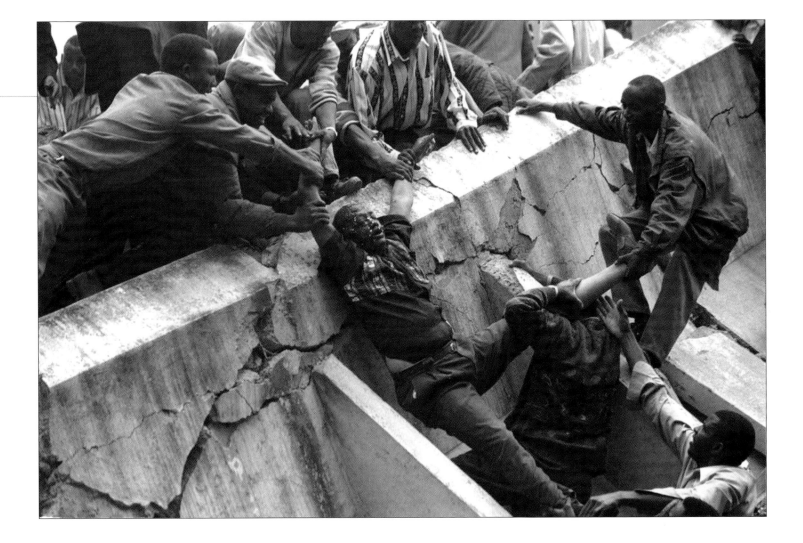

The bombing of Baghdad
17 January 1991

Patrick de Noirmont

Noise everywhere. Explosions, shootings and banging at the door. I jumped out of my bed and opened the balcony to see anti-aircraft tracer lighting up downtown Baghdad. I rushed to the balcony, fitting a wide angle to my camera, in panic, and still totally naked.

The US Air Force was bombing Baghdad.

Now, how to photograph a city in total darkness only faintly lit up by tracer? I held my camera poised on the edge of the balcony, the lens wide open on pause, waiting 15 seconds, 30 seconds, one minute between each frame. It seemed to take so long to get a single picture.

Reuters writer Bernd Debusmann was next to me. We had spent the night at the Palestine Hotel in the city centre, far from the media mob and the security services, who were housed in the Rashid Hotel on the outskirts. Debusmann waited a few minutes, watching the raid and soon asked, 'Have you finished? Time to go to a shelter.' But I needed more time. I did not have enough pictures. Maybe not a single good one. I needed more flares, more light, more time.

And then came my luck, pure luck: the camera was on pause, facing the city centre when, for just a second, a bomb lit a communication centre 100 metres from the Palestine Hotel. I closed the shutter. Had I got the picture? I couldn't tell. Surely it was underexposed; maybe there was nothing on the film. Debusmann was still pressing me to leave. Flares were still flying around. Another couple of pictures and I rushed back into the room, quickly dressed, grabbed my equipment and left the place...

My films of the first bombings of Baghdad were carried safely to Amman by Reuters television producer Sean Maguire. This picture frontpaged many newspapers and magazines, including the International Herald Tribune and Time. I only found this out a week later, when I returned to Amman after an unpleasant interrogation by angry Iraqi officers. But that's another story – with no pictures!

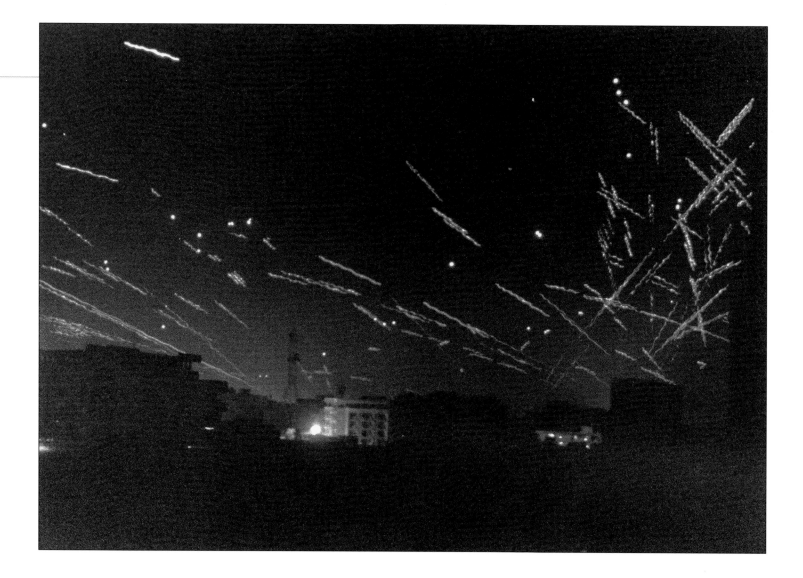

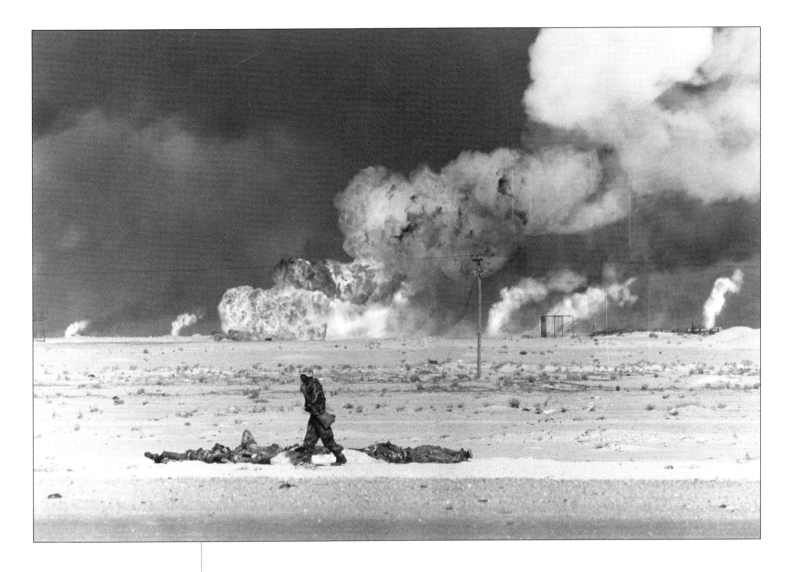

The aftermath of battle, Kuwait
01 March 1991

Andy Clark

This shot is of an American soldier, as he walks past the bodies of Iraqi soldiers near Basra, 20 kilometres south of the border with Iraq. Oil wells were burning in the background. The Kuwait oil company claimed that all Kuwait's 950 oil-producing wells were damaged by Iraqi saboteurs.

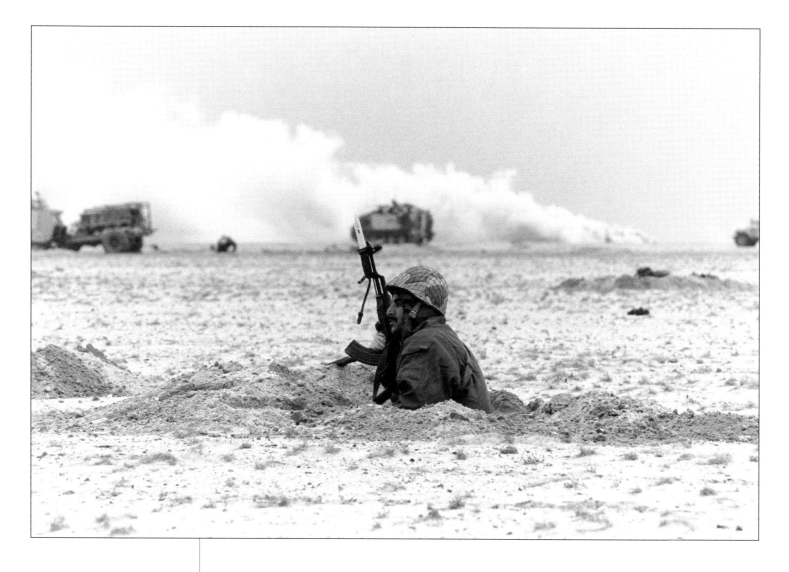

UN troops dig in, Kuwait
25 February 1990

Philippe Wojazer

An Egyptian soldier is dug into the sand during a ground battle in Kuwait.

Dead Iraqi soldiers, Kuwait
28 February 1991

Win McNamee

Two dead Iraqi soldiers lie on the road in front of a destroyed T-72 Soviet-made tank. The soldiers died during a battle against US troops. The road, leading north from Kuwait City, was jammed with destroyed vehicles.

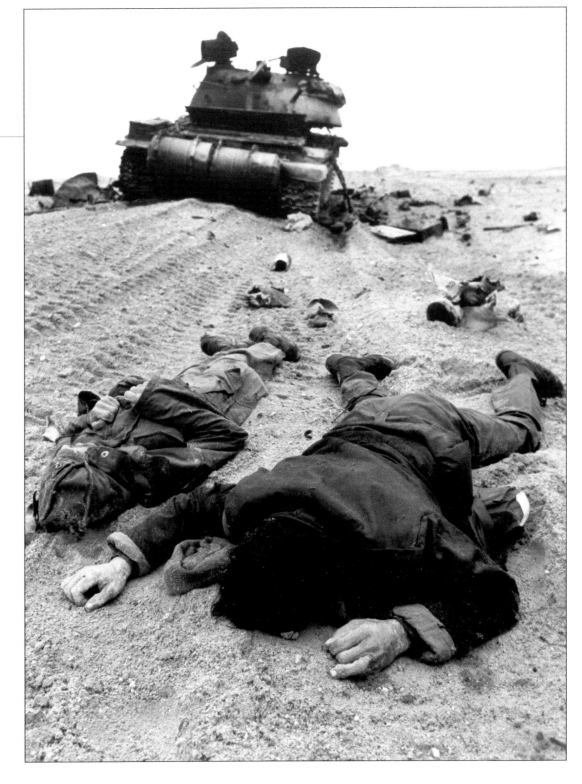

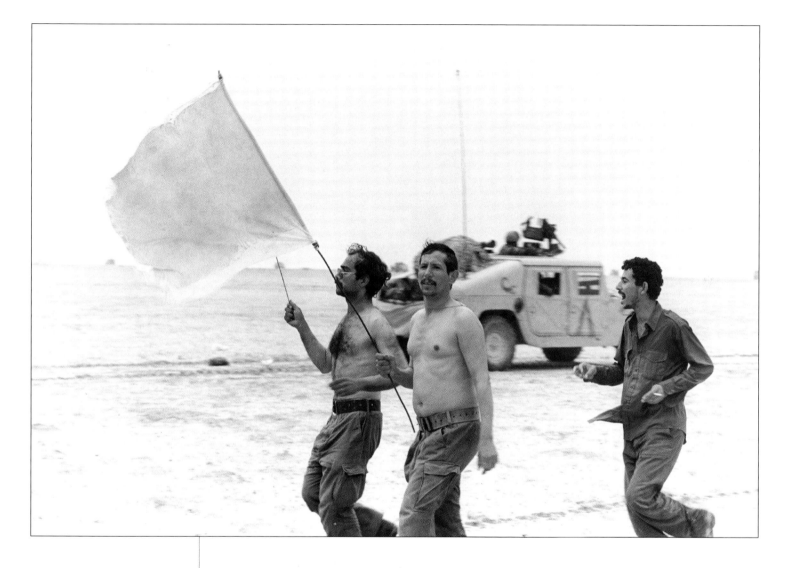

Iraqi soldiers surrender, Kuwait
25 February 1990

Philippe Wojazer

Iraqi soldiers hold a white flag as they surrender to the Egyptian army during a ground battle in Kuwait.

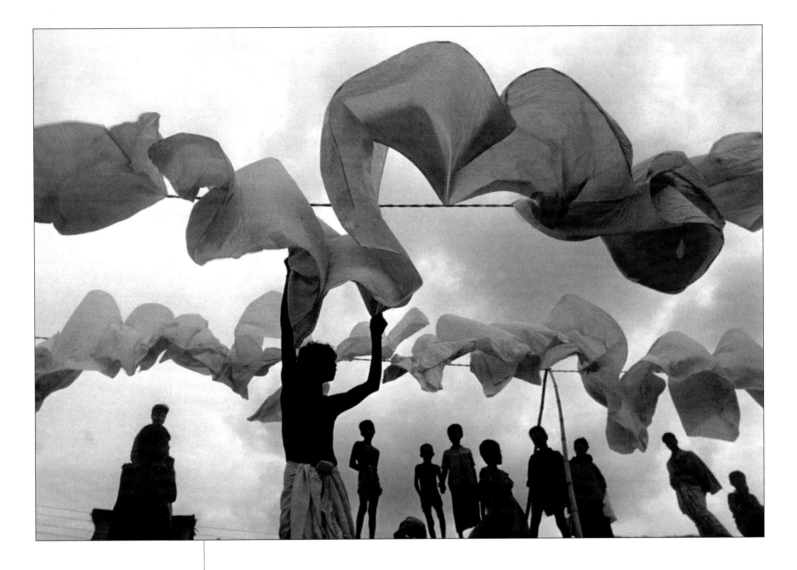

Laundrymen, Dhaka
23 July 1997

Rafiqur Rahman

Strong winds dry clothes hung out by the laundrymen on the banks of the river Buriganga, Dhaka. The laundry workers still use steam irons heated by burning coal.

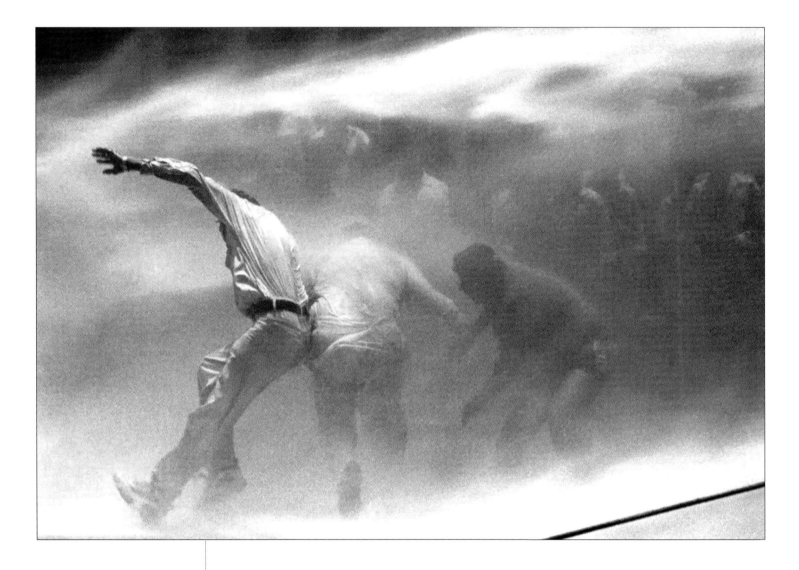

Indian police disperse strikers
23 July 1998

Sunil Malhotra

Police use water cannons to disperse striking medical workers during a demonstration in New Delhi. More than 70,000 workers from state-run hospitals went on strike to demand higher wages.

Australian firefighters combat bushfires
03 December 1997

David Gray

This photograph was taken the day after seven homes in the southern Sydney suburb of Menai were destroyed by a furious bushfire that was fuelled by strong westerly winds and searing hot temperatures. The blaze was continuing to burn out of control, creeping closer to the neighbouring suburb of Lucas Heights, the site of Australia's only nuclear reactor. I managed to get closer to the area by obtaining a ride through a road block in a police car. Only one crew was fighting the oncoming fire at a spot approximately 500 metres from the reactor. The crew was busy constructing fire breaks when I arrived, so my presence was not noticed for quite some time. As the fire roared closer with every gust of wind, two firefighters went down to a clearing, directly in the path of the oncoming flames. The intensity of the heat was becoming quite dangerous when, all of a sudden, a helicopter came flying in very low, dumping its load of water only a few feet away from the startled firefighters. Soon afterwards, at around 5pm, I quickly walked the four kilometres back to my car in order to make local newspaper dealines. The picture was on the wire by 7pm and made the cover of Time Magazine the following month.

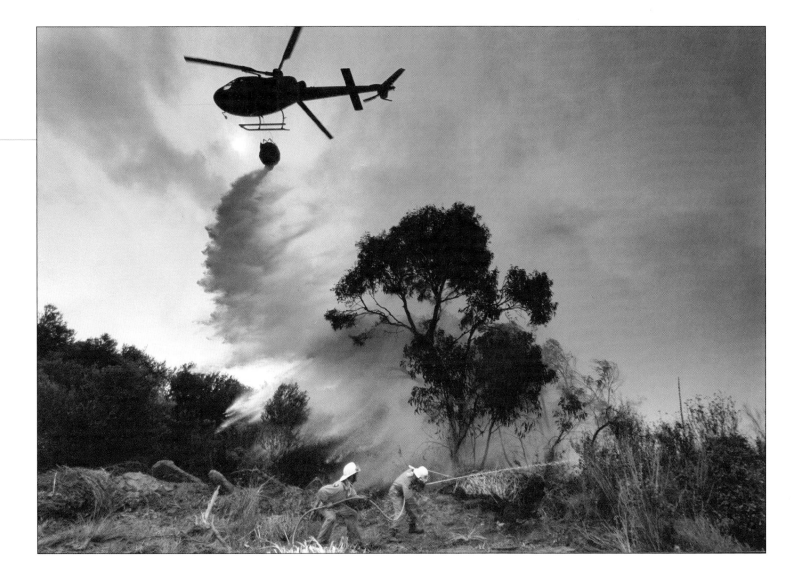

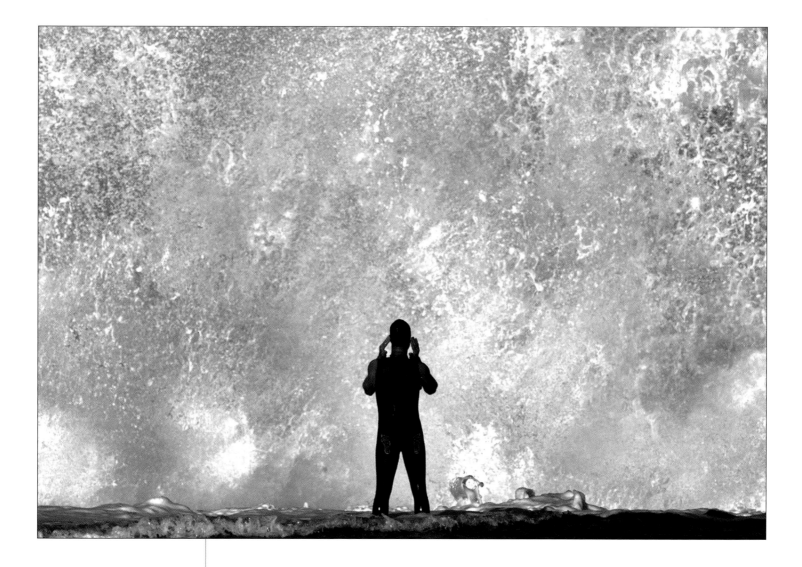

Surf's up in Sydney
16 August 1999

David Gray

A swimmer wearing a wetsuit prepares to dive into the sea from a rockpool as a wave breaks in front of him at Narrabeen Beach in Sydney, Australia. Big wintry seas were pounding Sydney's coastline, causing severe beach erosion and closing several city beaches, with very few regular surfers and swimmers daring to enter the dangerous conditions.

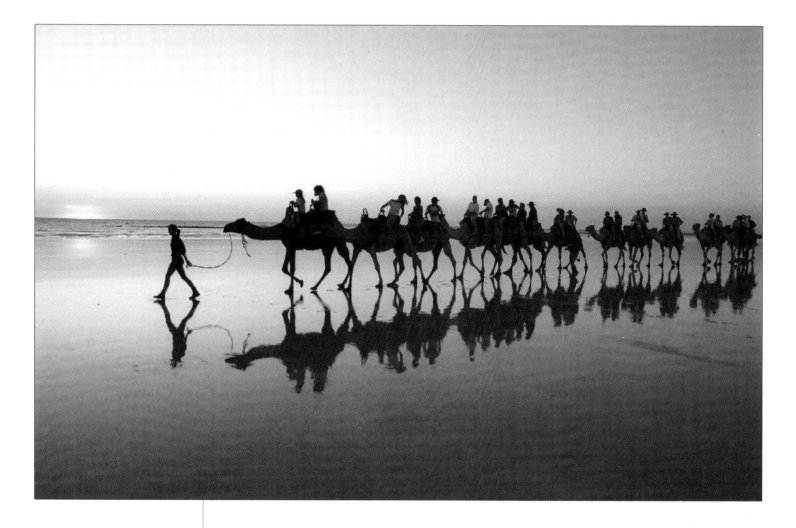

**Camel rides on the
Australian coast**
31 August 1996

Megan Lewis

A camel train carries tourists on a sunset safari along Cable Beach, near the northwest Australian town of Broome. The camels are from stock first brought to Australia by Afghan traders in the nineteenth century, and are a popular mode of tourist transport in the region around Broome, the centre of Australia's growing pearling industry. The area is an increasingly popular destination for travellers, many of whom watch the spectacular sunsets from the white sands of Cable Beach.

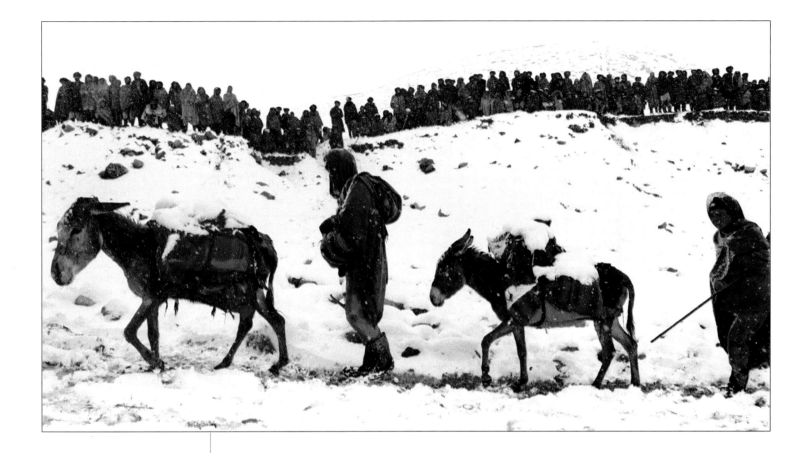

Earthquake in northern Afghanistan
14 February 1998

Shamil Zhumatov

The earthquake in northern Afghanistan on 4 February 1998 killed more than 4,000 people and left some 30,000 people homeless, cold and hungry. Up to 28 villages were badly damaged – and in some cases were razed completely – by the earthquake and the subsequent aftershocks.

This picture was shot during the last of the relief operations. I travelled with two trucks carrying United Nations emergency aid, which left Rostaq for the mountain village of Baghi Hisar. The road went from bad to worse. A few times the trucks came very close to falling into some of the canyons below, and eventually we came to a halt at the bottom of the hill which led up to Baghi Hisar. As the trucks were unable to scale the hill, donkeys had to be enlisted to carry the aid and supplies.

The severe weather conditions froze my professional Canon EOS1. I tried to warm it up in the car cabin, but it was a big mistake – the camera and two of my most useful lenses became foggy. Fortunately I had a spare camera and lens and was able to take this shot.

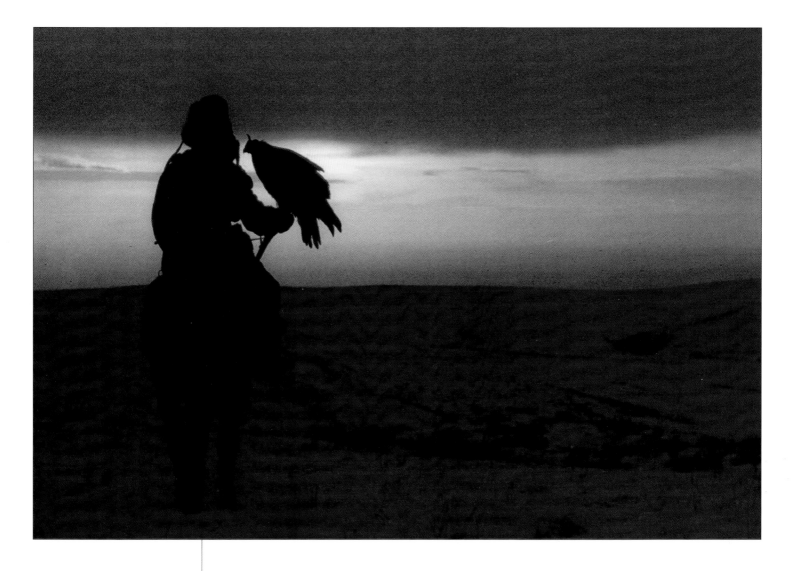

Hunting in Kazakhstan
01 February 1996

Shamil Zhumatov

Hunting with eagles is a very ancient Kazakh tradition, but nowadays most Kazakhs prefer using rifles and cars and very few of the elders remember how to hunt with a bird. It was only after considerable research, in a joint project with Reuters Television, that we found someone hunting in the traditional way.

Our hunter, Abylkhak, took us hunting on the steppe near Almaty. I had had some riding experience before, but spending all day toting cameras on horseback was very fatiguing. The steppe is very bleak – to the extent that when Abylkhak had found a good place to release his eagle to search for small animals, I could find no place to 'park' my horse; there was simply nothing to tether it to – no tree, no stone, no post, just flat landscape covered by snow and patchy, ragged grass.

It was on the way back to the village that I saw the sun setting, and the sky seemed like a huge unreal painting surrounding me. It wasn't a successful day for hunting, but as a photographer I was very happy.

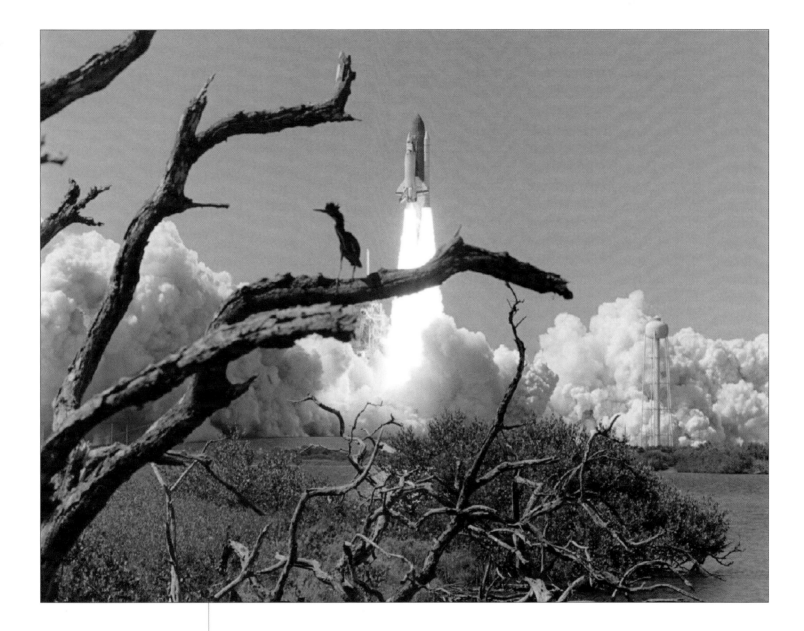

**The launch of the space
shuttle Columbia**
14 April 1997

Pierre DuCharme

This photo shows the space shuttle Columbia lifting off from launch pad
39A at the Kennedy Space Center, Cape Canaveral, USA. It was taken by
an unmanned camera position three-quarters of a mile from the launch,
and triggered by a sound remote. I selected the location so that the dead
tree could serve as foreground; the egret was a fortuitous addition. The
crew of seven astronuauts on board spent 16 days in space on a routine
research mission.

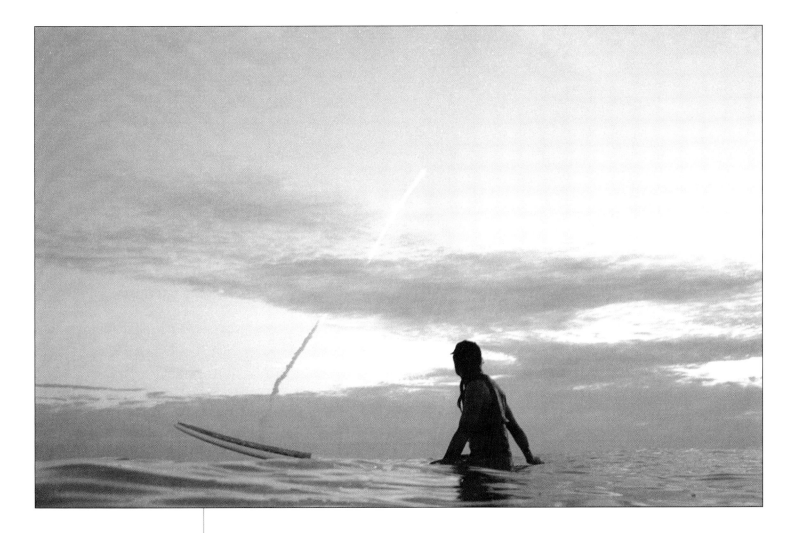

The launch of the space shuttle, Endeavor
19 May 1996

Duffin McGee

Photographing rockets has taken me from Kennedy Space Center in Florida to Baikonur Cosmodrome in Kazakhstan. It is a very challenging task to remain focused and ready for the unexpected, such as a launch failure, or to search for a new angle in telling the story of a rocket launch. This image shows a surfer, Tony Stanzonie, sitting on his board while the shuttle Endeavor lifts off from the Kennedy Space Center in Florida. I feel it's interesting because the viewer assumes the place of another surfer sitting in the ocean on a cool spring morning as the shuttle lifts off.

US Air Force Academy graduates celebrate in traditional fashion
02 June 1999

Rick Wilking

The 944 graduates at the Air Force Academy commencement throw up their hats as Air Force Thunderbirds F15s fly over. US President Bill Clinton, in his speech to the graduates, announced that the US was contributing 7,000 soldiers to a planned NATO peacekeeping mission in Kosovo.

A time-honoured tradition at the Air Force Academy commencement is the president of the US coming to speak, and the hat toss. At the moment the graduates are accepted into the Air Force as officers they throw their hats in the air. An extra surprise was the Thunderbirds aerial acrobatic team coming over the stadium at the same precise moment. Having covered the commencement previously I was ready for the hat toss. The timing of the jets flying over, just as the hats were in the air, was pure luck!

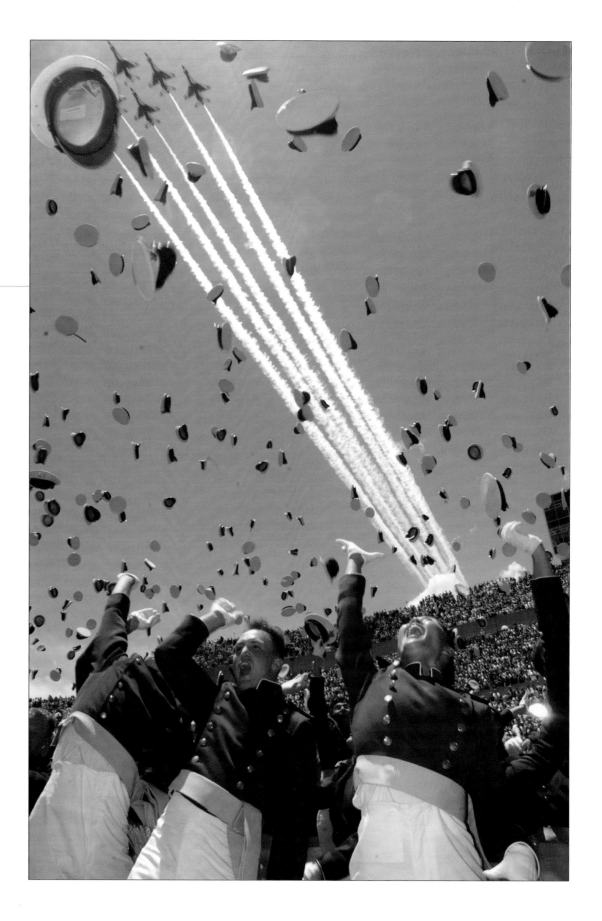

Ray's the roof
26 December 1996

Peter Mueller

I took this picture during a press presentation on the occasion of the opening of the new aquarium at Timmendorfer Strand, on the German Baltic Sea coast.

I was as fascinated as the man in the photograph by the originality of the construction: it was possible to see fish swimming all around and above you.

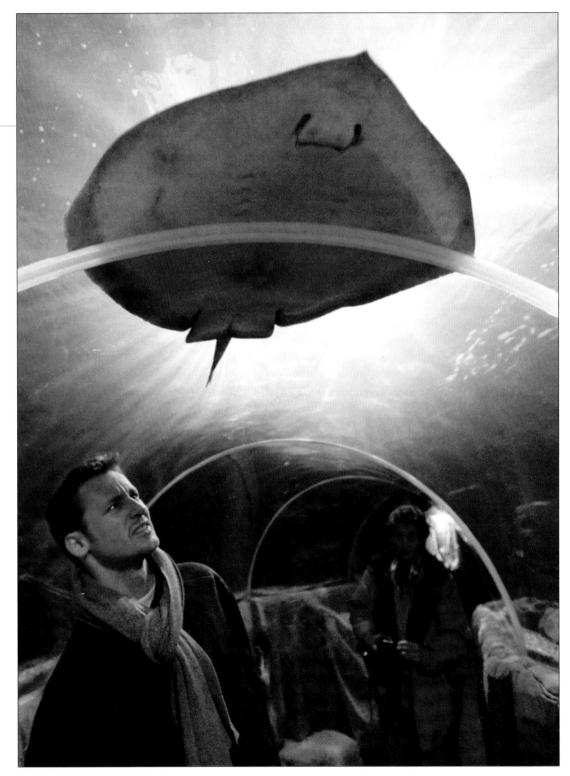

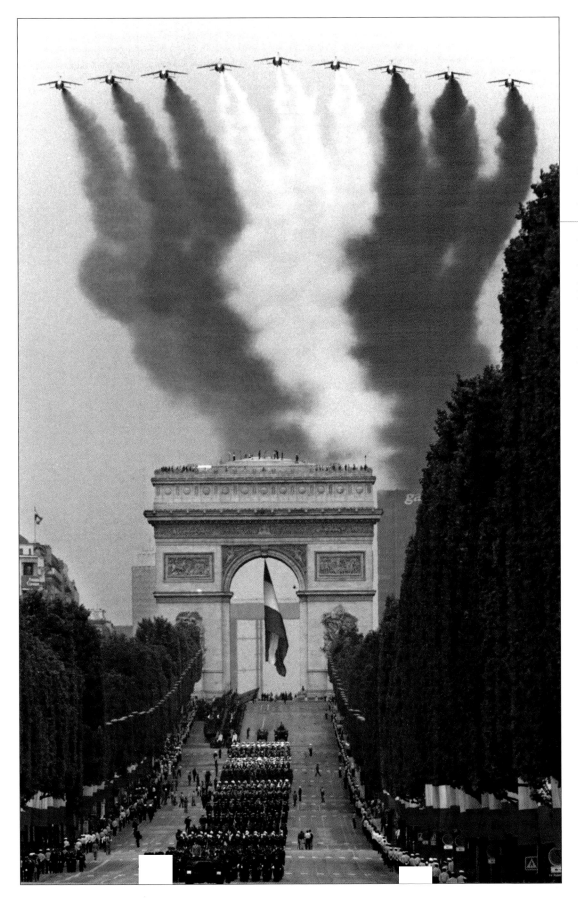

Bastille Day celebrations, Paris
14 July 1999

Jean Paul Pelissier

This photo was very simple: the point of interest in the picture was to be in the axis of the Champs-Élysées and the Arc de Triomphe, but the platform reserved for the photographers didn't allow for that shot. I moved discreetly to reach the area reserved for officials and members of the government and got this picture.

I was in Paris to support the Reuters office there, and was sent to cover the July 14 Bastille Day parade on the Champs-Élysées. The parade was almost over and, as usual, the French Republican Guards were closing it. A lot of photographers had already started to pack their cameras and bags and had ceased to pay attention to the parade. By chance I happened to continue watching events through the viewfinder of my camera – just because it was an entertaining sight, rather than to get any further shots. Suddenly one of the front horses slipped on the cobblestones of the Champs-Élysées and fell to the ground. There was only a fraction of a moment to get this shot, and I just happened to be ready and focused on the right place at the right time.

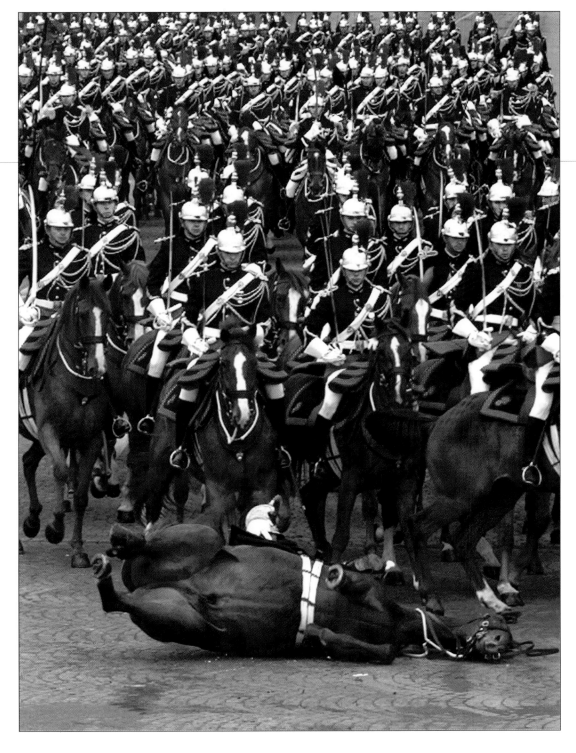

Bastille Day parade, Paris
14 July 1999

Eric Gaillard

Bob Dole's presidential campaign collapses
18 September 1996

Rick Wilking

We were in Chico, California. It was the last stop of the day on the Bob Dole for President campaign. I'd taken plenty of pictures of the candidate over the course of the day and left my film with local support staff to send the pictures out over our network to the newspapers and magazines. Since it was getting close to deadline time for the major US east coast papers I really didn't need pictures from this last rally and I didn't have anyone to support me here in this remote place anyway.

I decided to use my digital camera to record the event just on the off chance some paper might request a picture. But then the unexpected happened: Bob Dole stumbled off the stage, I got the picture of my career, and the digital equipment made the difference.

Dole had bounded onto the stage and waved to the cheering crowd. Suddenly he decided to lean over the edge of the stage to shake hands with one of the well-wishers. I focused my camera on him leaning out and just as I did so he fell four feet onto the ground at the feet of the photographers!

As soon as he got back up and dusted himself off (and I was sure he was OK) I stopped shooting and called Reuters in Washington, DC, to tell the office what had happened. Before Dole was done with his speech I had sent five pictures back to DC using my laptop and a phone line under the stage – just making the first edition deadlines. I didn't know it yet but of the dozens of photographers at the event I was the only one with the pictures of Dole flat on his back the moment he hit the ground. I had positioned myself to the side of the stage, rather than head on, and that been the difference between capturing the picture of the falling candidate, or getting flattened by him!

When we got back on Dole's campaign plane to head to the next stop the Senator came back to see me. He had already heard from campaign staff about my pictures and wanted to see them for himself. He shrugged off how bad he looked lying on the ground but you could see on his face he knew the damage had already been done. The next day his grimacing face was huge on the front of the Washington Post and dozens of other papers, and many now say that picture became a metaphor for his failed run at the presidency.

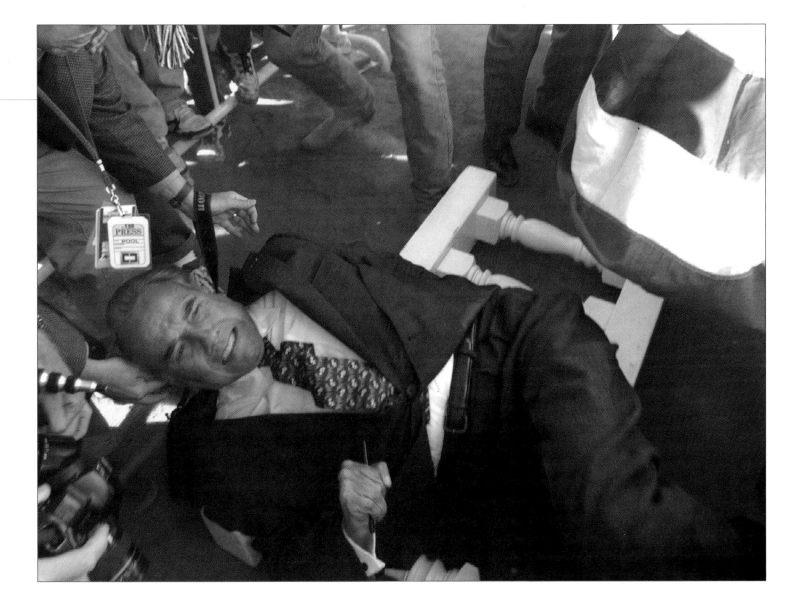

Arafat and Rabin shake hands on the White House lawn
13 September 1993

Gary Hershorn

This photo was taken during a ceremony on the South Lawn at the
White House. It followed the signing of a peace agreement between
Israel's Prime Minister, Yitzak Rabin, and the PLO Chairman Yasser Arafat
– an agreement in which President Clinton and the US political machine
had been instrumental. It was a highly anticipated event and certainly
the biggest news event I had covered. The photo was shot from the main
centre platform and was actually taken with a remote camera. I set up
three cameras on clamps that were triggered using a foot switch as I shot
the event with another camera and lens.

The event happened on a Monday and on the Sunday night I had to
rush to catch a plane to Washington from New York, where I had been
covering the end of the US Open tennis tournament. I remember
worrying about what might have happened should I have missed this
moment if my late flight had been delayed or cancelled.

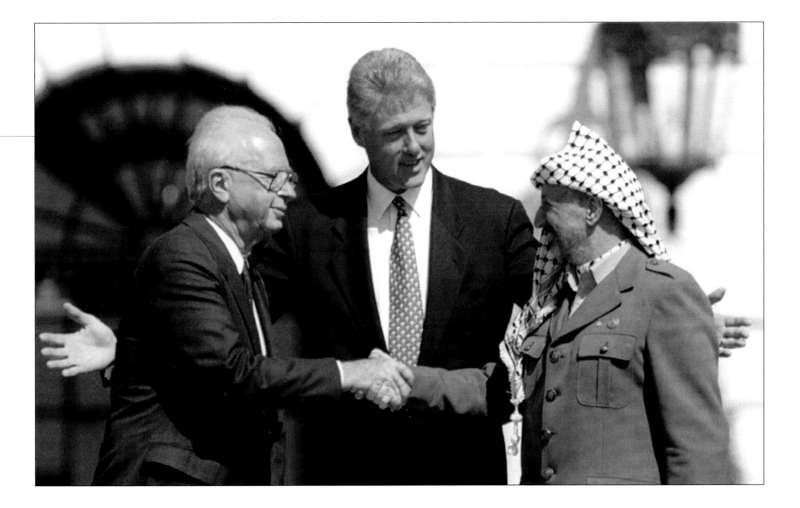

Aryeh Deri resigns from Israel's Knesset

18 May 1999

David Silverman

After covering the run-up to the 17 May general elections, and working almost non-stop on election day, it was the end of 'the day after' in the Reuters office in Jerusalem. Late in the evening the ultra-orthodox Jewish Shas party leader, and political power broker, Aryeh Deri called us to a press conference at the party headquarters just down the road.

With rumours flying about the possibility of his impending resignation from Israel's Knesset (parliament), allowing the Shas to join Prime Pinister-elect Ehud Barak's coalition, I ran down to the press conference with only a few minutes to spare – grabbing the nearest camera on my way.

On arrival I found that Shas activists had removed all Deri's supporters from the hall to ensure an undisturbed press conference. Anxious to hear their leader's words, and to find out if he had actually resigned his seat, some of the party faithful pressed themselves up against the frosted glass doors to get a better look.

Deri stated that he would remain party chairman, but leave political issues to his party comrades. His announcement came a day after the Shas had been the big winner in Israel's general election, taking some 15 per cent of the parliamentary seats. A month earlier, Deri, convicted on charges of bribery, fraud and corruption, had been sentenced to four years in prison.

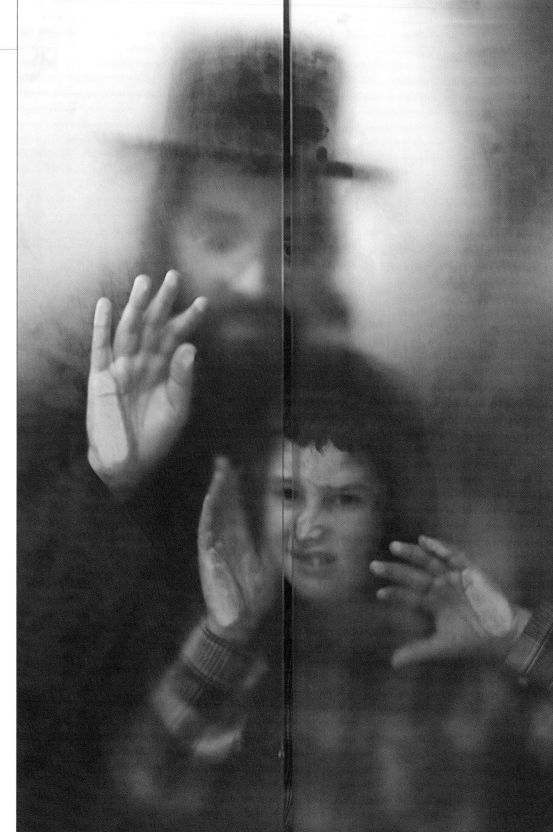

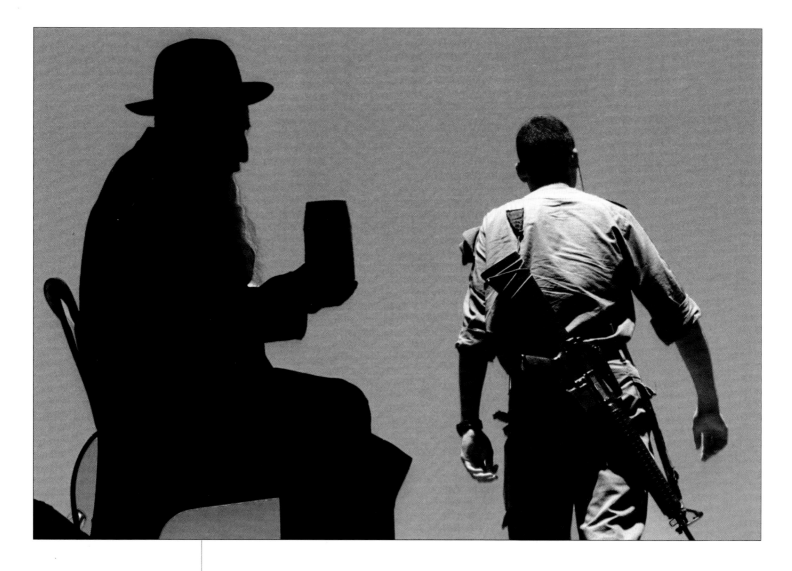

**Modern and traditional
Israel**
27 May 1996

Yannis Behrakis

This picture illustrates the co-existence of the driving forces behind Israel: religion and the military.

I was in Jerusalem, covering the period in the run-up to elections, in which the main candidates were Mr Netanyahu and Mr Peres. Netanyahu supported a conservative, hardline approach towards the peace talks between Israel and the Palestinians, and had support from Jewish religious groups, while Peres was in support of a faster approach to peace and had more modern political views. This picture seems to convey these two elements.

I photographed the old man sitting on a chair from the entrance to an underground pass near Jerusalem's bus station. I wanted the picture to be about contrasts, so was pleased to get the shot of him in the shadow, and the passing soldier against a clean background, and lit by the sun.

Netanyahu won the election.

The Gaza Strip: Israeli soldiers frisk Palestinian suspects
November 1986

Jim Hollander

Reuters received a report that a Jewish man had been stabbed in the Gaza Strip early one afternoon in the winter of 1986. At that time the Gaza Strip was firmly under Israeli occupation and one could enter and drive around Gaza relatively unmolested, except for a slight delay at the Israeli military roadblock at the Erez Checkpoint. There was little else happening on the news front that day so I drove down from Tel Aviv, about an hour's travel time. We didn't have any exact information as to where the stabbing had taken place – but did have reports it was on one of the main roads leading to the centre of Gaza City. I had to discover which main road. As I entered the Gaza Strip and headed towards the main Israeli military/police station located on the main north–south road, I suddenly came across this small group of Israeli soldiers frisking Palestinian men who

had been lined up against a wall. I drove past them, parked and crossed to the far side of street in order to photograph the scene straight on. I also did not want to be so close that the soldiers would either perform for my benefit, or order me to stop photographing, as is often the situation during tense moments in the Israeli–Palestinian conflict. I shot slowly, and just towards the end of my film these schoolgirls appeared from around a corner and began walking past the soldiers and their neighbours, brothers or fathers. I moved a few metres to the left and in towards the street to get a slightly different perspective and to see the girls' faces as they passed. This occurred some ten months before the official outbreak of the 'Intifada', or Palestinian uprising. I still consider this frame the best image I have taken in all my years covering the Israeli–Palestinian conflict since 1983.

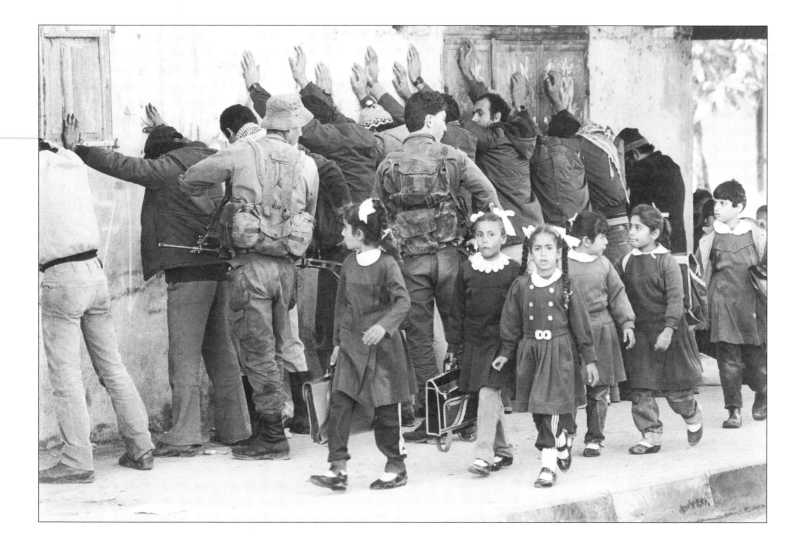

The New Year of 1996 began with the execution of one of Israel's most wanted Palestinian activists, a man known (and feared) far and wide solely by his nickname, 'The Engineer'. Yakhya Ayyash learned and practised his trade as a bomb-maker with expert dedication and was responsible for the death of scores of Israelis in vicious suicide car bombings inside Israel. The Israeli undercover agents were searching for him and he was lying low somewhere in the Gaza Strip.

On January 5 the story broke that Ayyash had answered a call on a mobile telephone and a bomb inside had been detonated through the phone lines. The Israelis were immediately accused of the execution, a charge they have never denied. The funeral was set for the next day and was expected to be huge, as Ayyash was considered both a martyr and a hero to the tens of thousands of supporters of the Palestinian fundamentalist Hamas movement, itself violently opposed to any peace deal being negotiated between the newly liberated Palestinian Authority areas and Israel.

I left Jerusalem early for the Erez Checkpoint crossing into the Gaza Strip where I caught a taxi to the Palestinian mosque where Ayyash's body was being delivered for the first stage of his funeral. I was instantly stuck in a massive traffic jam that paralysed a large part of Gaza City. In the old days I would have driven my own car into Gaza but that all changed about a year after the 'Intifada', or Palestinian popular uprising, which began in 1987. Any car bearing distinctive yellow Israeli license plates

was subject to attack by Palestinians hurling stones. So I was stuck – at the mercy of a Palestinian taxi driver trying his level best to get me to the funeral on time. By way of dirty back alleys and ceaseless horn-blowing my driver pulled up to the mosque just as the coffin was arriving down a main street swirling with dust as hordes of people ran alongside the pick-up truck bearing the coffin.

I looked around and, following a second of panic, realized my best attempt at covering this scene would be if I could make it onto the roof of the mosque. This might provide a good perspective. I rushed up wooden stairs, around some interior halls, and found my way onto the roof. I shimmied through a crowd five deep already positioned on the roof and found my way to the edge overlooking the entrance just as the pick-up bearing Ayyash's body, in a flag-draped plain wooden coffin, pulled up outside.

I didn't even catch my breath but began shooting as the coffin was unloaded and hustled into the mosque. I got off the roof, and, realizing I could not get into the mosque for the funeral, grabbed my taxi driver and headed back to Jerusalem carrying what I knew were a few good frames. Talk about good timing and not wasting time waiting for an event to happen!

This frame won an Award of Excellence in the University of Missouri Pictures of the Year, General News category.

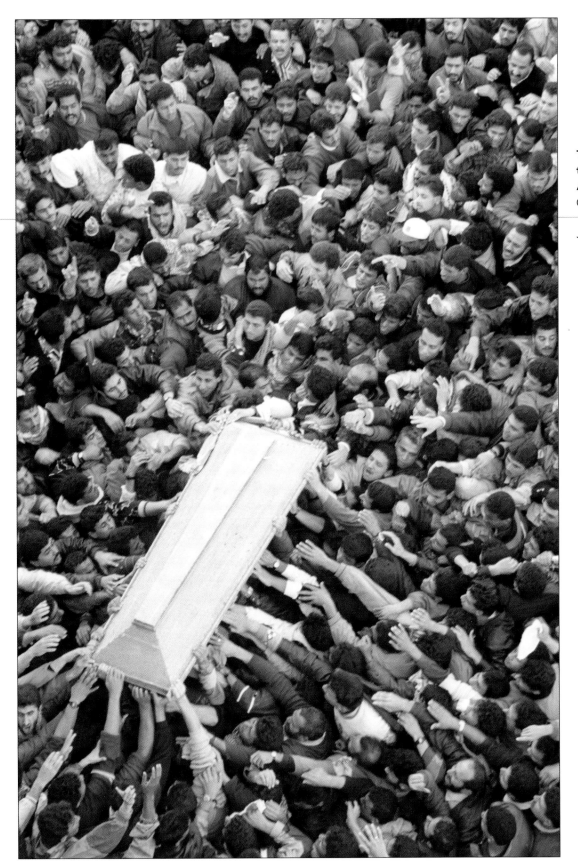

The Gaza Strip:
the funeral of Yakhya
Ayyash, 'The Engineer'
06 January 1996

Jim Hollander

A funeral in Omagh, Northern Ireland
19 August 1998

Ian Waldie

Two days after the event, I was sent to Northern Ireland to cover the aftermath of the massive bomb detonated in the centre of Omagh by a dissident Republican organisation. My colleague Dylan Martinez and I had the grim task of covering 28 funerals in a matter of days. We also oversaw the clean-up operation and the political stories that went along with this devastating incident. Dylan and I split the tasks between us and I was sent to Buncrana to cover the triple funeral of three local boys while Dylan covered other funerals near Omagh.

I had covered the funeral of the three and decided along with the rest of the press corps to allow the burial to be private. The opportunity for this picture came about when I watched the coffins being carried up a hill to the graveyard, one by one. A huge crowd of locals had arrived and gathered on the hill to pay their respects. As I watched, the first two coffins were obscured by the large number of people, but as the last one was carried up the hill, I managed to get a clear line of sight for a few seconds to photograph the coffin amongst the sea of mourners. This picture seems anonymous, and because of that it was the one I liked most of all those reflecting the entire Omagh ordeal – but there is no getting away from the fact that this was a momentously sad occasion.

The Omagh bombing was the worst attack in the history of the Northern Ireland troubles.

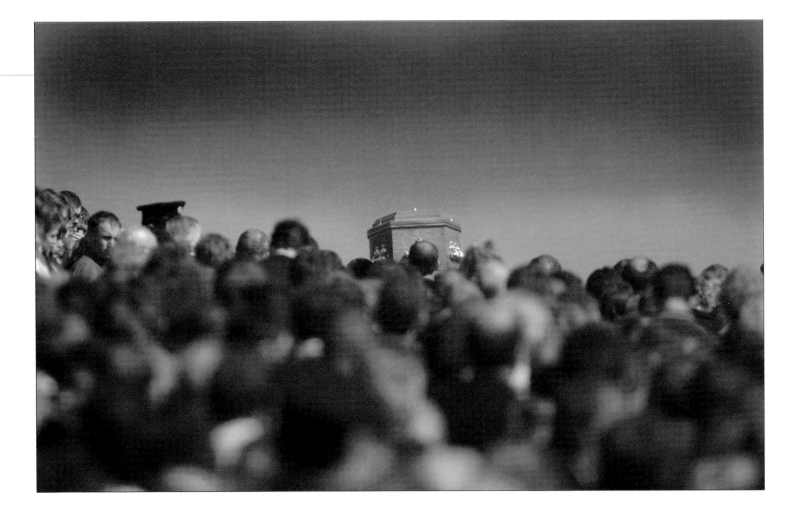

This picture to me sums up the inbred hatred between the two communities in Northern Ireland – a hatred I have experienced many times over my ten year period covering the troubled province, from the late 1970s.

The Irish Garda (police) were escorting Protestant supporters of prominent Northern Ireland Unionist politician Peter Robinson from Dundalk in the Irish Republic. Robinson had made an appearance in court in the town, which borders Northern Ireland, and about 100 of his Protestant supporters had crossed from Northern Ireland to bolster him. This inflamed the Republican majority in the town and led to clashes between the Garda and Republicans, who were trying to break the cordon around the Protestants. As they were nearing the edge of town a crate of petrol bombs was dropped on the Protestants from a first story window, exploding amongst them. The Garda then retaliated against the hundreds of Republican youths who were throwing stones and yelling abuse. This picture shows three youths, one suffering a bleeding head wound after an altercation with the Garda, screaming at the departing Protestants as they run from the town.

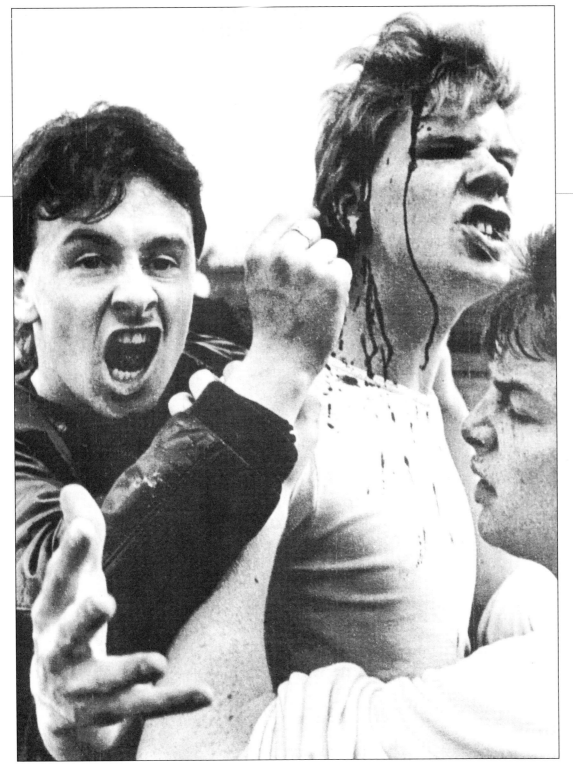

The Northern Ireland troubles
14 August 1986

Rob Taggart

The IRA bombing of Bishopsgate
24 April 1993

André Camara

I used to live by Tower Bridge, south of the Thames, very near the City of London. One Saturday morning – still waking up with a cup of coffee and peeking through the window – I heard a loud bang. That woke me up completely. For the next two or three minutes, as I got myself together thinking about what the bang could have been, the phone rang.

It was Nigel Small from the Picture Desk. He said a huge bomb had gone off in the City and told me to get there. I jumped on my motorbike and went straight to London Bridge, to get to the heart of the City, but it was closed even for pedestrians. After a quick U-turn I was back on Tower Bridge which had just been closed for vehicles, but one could still walk across.

I walked towards the City using the NatWest Tower as my guide. Nigel had told me the rumour was the bomb had exploded there. I walked for a couple of hours, being constantly redirected, or refused access to the scene, by the police. I remember thinking that I hadn't been quick enough.

But then I started to come across shattered windows and glass doors, and remember seeing a photographer very busy taking shots of a bomb-damaged bank about 100 yards ahead of me in the street. I knew then that I must have been very close to the bomb site. Police appeared and began shouting at the photographer and jostling him back down the street. I ducked into a little alleyway right beside me and disappeared. It was a dead-end alley with a few doors into an office building. I had two choices: retrace my steps and be confronted by the police, or try one of the doors.

The first one was open – perhaps because of the force of the blast. As I opened it all sorts of debris fell over my feet and onto the kerb. Inside it looked as if the bomb could have gone off in that very building. My heart went wild: I got a huge adrenalin rush and stepped into the darkness.

The alarm noise was deafening. Alarms were screaming throughout the City, but once inside the office it was even louder. The entrance led to a staircase and I started to climb the steps on all fours, picking my way over the debris – which was strewn everywhere.

I couldn't get onto the first floor as the ceilings had caved in. I could see onto the second floor but fallen concrete and live wires blocked my access.

I decided to try the roof – and it took me a long time to get there. The scene was unbelievable: the City of London looked like you'd imagine Beirut. The bomb had blown up right in front of the office building I was in, and all the surrounding buildings were heavily damaged. I took some pictures, including this one, and sat down for a cigarette. I needed a rest.

Back downstairs and out on the street a couple of police officers came screaming at me asking what I was doing there. I was harshly ordered out and met with more angry police on my way. After seeing the assembled crowd I realised why – I had somehow managed to get on the wrong side of the police cordoning.

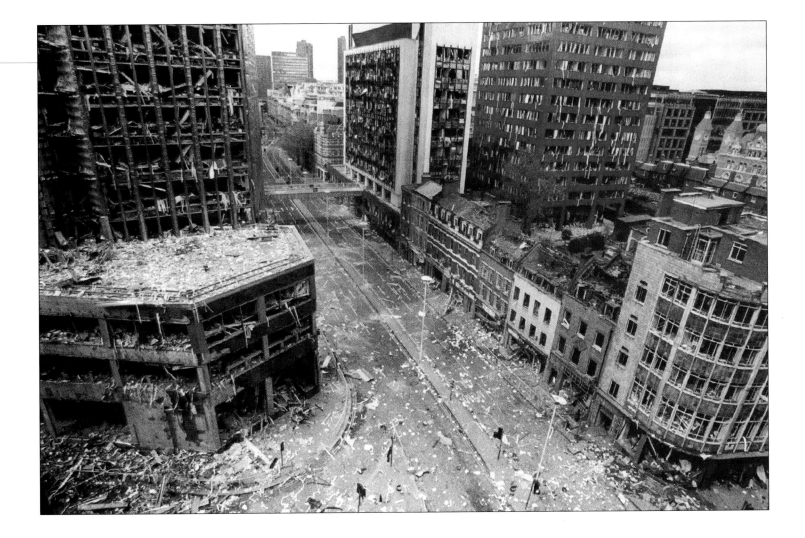

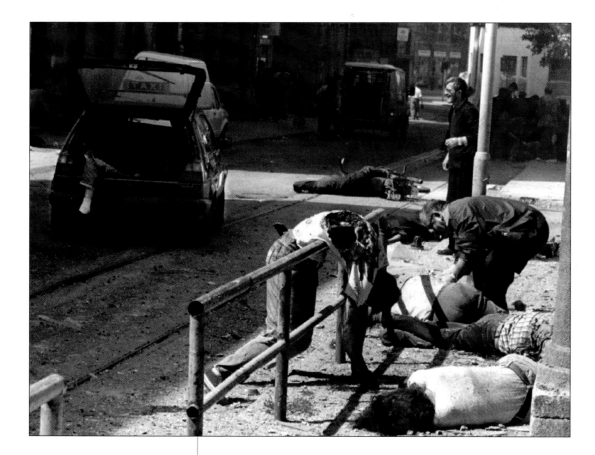

A mortar attack on Sarajevo
28 August 1995

Peter Andrews

This picture was taken on the main street of Sarajevo, just outside the indoor market. The previous three weeks had been very quiet in terms of Serb sniping and bombing activity. People felt relaxed, and the city streets were getting busier, as people felt the end of the war may be in sight.

On this day I was strolling through the downtown area with my Reuters colleague Danilo Kristanovich. We had just walked out of one of the many newly opened coffee bars when the mortar shell struck.

We were no more than 200 yards away from the blast and, as we rushed to the scene, we could see the extent of the damage. Bodies lay all over the place, people were running, screaming – or just standing still and in shock. I don't remember taking pictures and felt as if I was in some kind of a trance. We only stayed for 15 minutes, and then drove a wounded woman to hospital.

This incident led to NATO bombing of Serbian positions surrounding Sarajevo, and hastened the end of war in Bosnia.

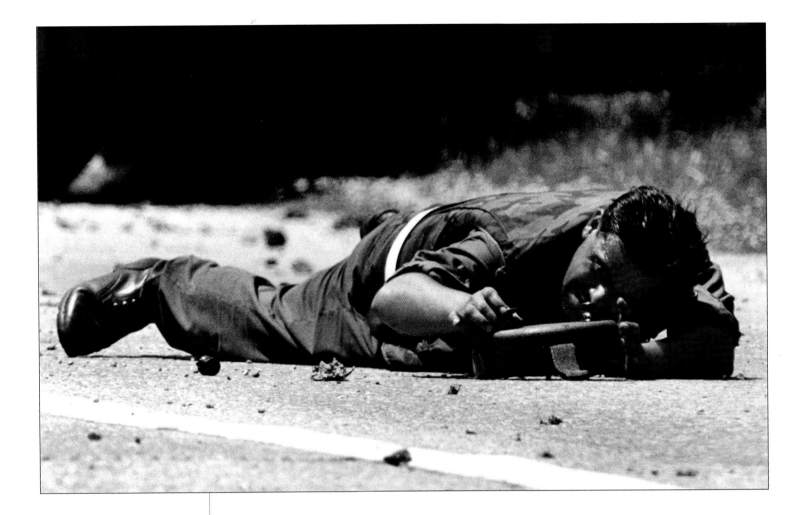

Bomb disposal, Slovenia
01 July 1991

Petar Kujundzic

I took this picture at the very beginning of the conflict between the various Yugoslav republics, when Slovenia decided to secede from Yugoslavia. A Yugoslav army unit was halted near the town of Krsko, on the road between Zagreb, the capital of Croatia, and Ljubljana, capital of Slovenia. Slovenian fighters had planted mines to block the advance of Yugoslav army forces. On my arrival at the spot a Yugoslav Peoples' Army (JNA) bomb disposal expert was defusing anti-tank mines. I took many frames but only in this one could I get the expression on his face. This picture was published widely.

Princess Diana in Pakistan
31 August 1997

John Pryke

This picture was taken in Lahore, Pakistan, while Princess Diana was visiting Imran Khan's Shaukut Khanum Memorial Cancer Hospital.

Myself and visiting colleague Russell Boyce had been on assignment in Pakistan covering the cricket world cup when we were told to cover the Princess' visit. Together we went to the hospital, and along with a number of other photographers from London and Pakistan, were shuffled off to a concert given by young cancer patients at the hospital.

When we arrived at the venue we learnt that we were all to take pictures in a pre-arranged position – meaning that we would all end up with much the same pictures.

Given that there were two of us at the event, I opted to cover her arrival in the hope that I could get a different picture from those in the official position inside. I took up a position amongst the crowd to take my pictures.

Being an unofficial position there were no guarantees that I would be able to get a picture at all, but with two Reuters photographers at the concert it was a risk worth taking.

Princess Diana selected this as her favourite news photograph when, shortly before her death, she was interviewed in a French newspaper.

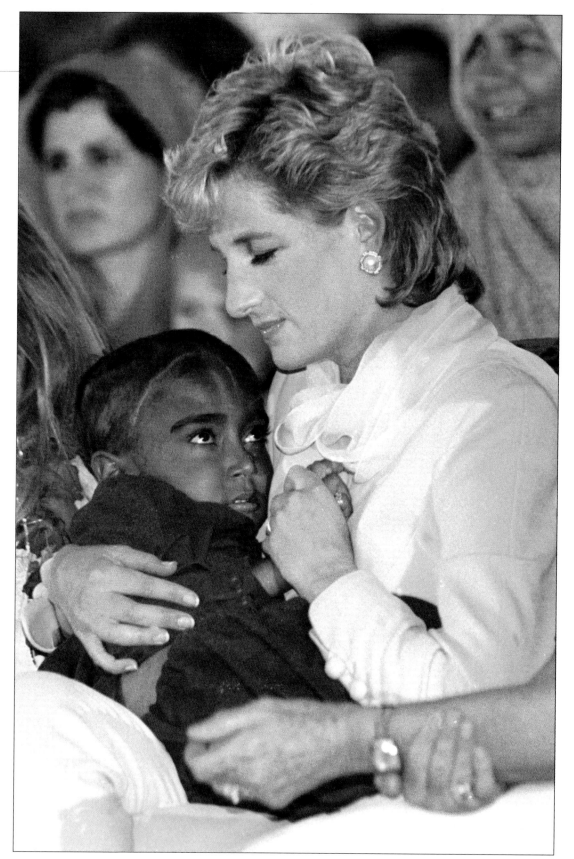

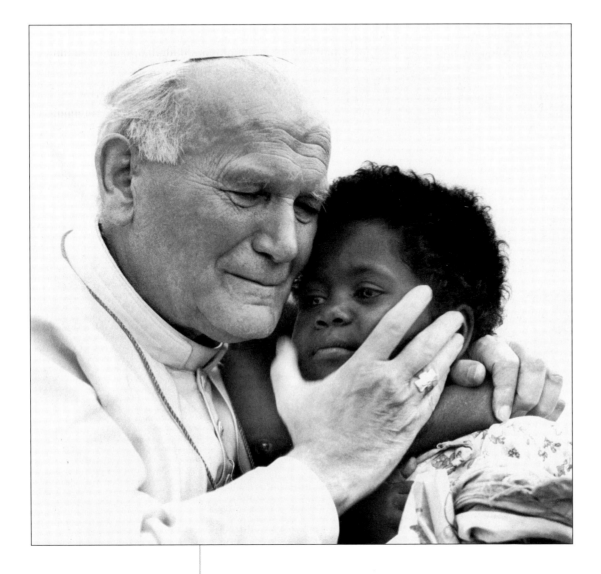

Father and child
06 February 1993

Luciano Mellace

This photo was taken in Uganda, during the Pope's three-nation African tour to Benin, Uganda and Sudan.

In the photograph there are actually two children: one child's eyes can be seen just between the Pope and the child he is hugging. I saw these children during a short ceremony at which the Pope was making a speech. The older one was holding the smaller one, so I assumed they were brother and sister. I was close to the podium and drew the attention of the Pope's secretary, pointing out the two children, and telling him that it would make a great picture if the Pope were to receive them. After a short time the two children were taken up on the podium and the Pope spent two to three minutes greeting and talking to them.

The Queen Mother
05 November 1999

Kieran Doherty

The Queen Mother, unquestionably my favourite member of the Royal Family to photograph, prepares to lay her wooden cross in St Margaret's Churchyard at the Royal British Legion's Field of Remembrance. Her face shows that the memory of such loss has not been dimmed, even in her 99th year. I was able to see her face visibly by shooting from an angle lower than the lectern on which she was placing the cross.

Monica Lewinsky
28 July 1998

Tim Aubry

This photo of Monica Lewinsky was taken on a very busy news day in Washington. Most of our staff and contract photographers were on assignment at the White House and the Capitol for other news events, when word of Ms Lewinsky's immunity deal came to the desk. With very little notice, and being short of photographers, I scrambled to the lawyer's office. It was a mob scene – with press and a lunchtime crowd of curious bystanders everywhere. Ms Lewinsky's handlers asked for some space to bring her into the building, but the crowd did not move much so when she was escorted in it was a scramble to hold a position and get some images.

Following the meeting with her lawyers, she left by a rear entrance to avoid the crowds. Her lawyers came out and briefed reporters but Ms Lewinsky never reappeared. This immunity deal cleared the way for Lewinsky to testify and led towards impeachment proceedings against President Bill Clinton.

Clinton and Yeltsin, Helsinki

21 March 1997

Rick Wilking

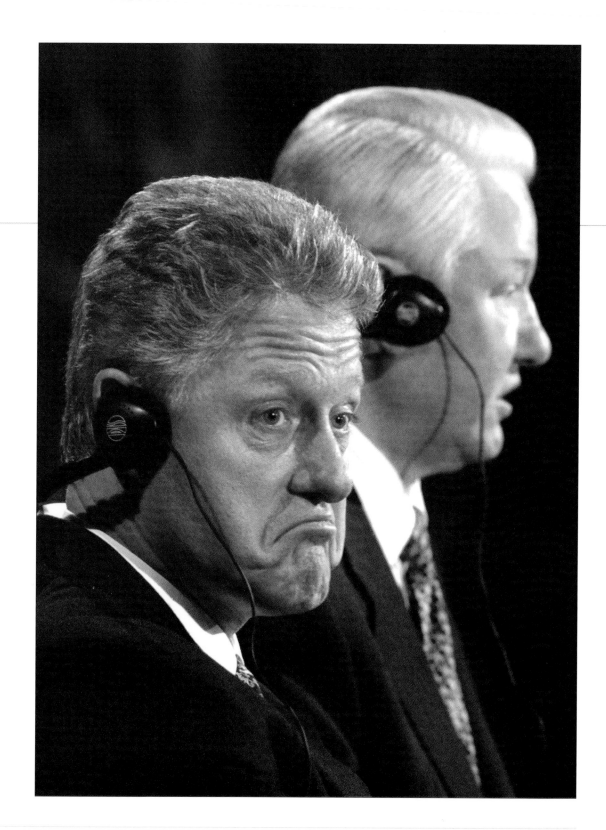

US President Bill Clinton pulls a glum expression after his translation device fails briefly at the start of his joint press conference with Russian President Boris Yeltsin. The two had just signed a joint declaration on NATO expansion.

In a summit meeting shortened and moved from Moscow to Finland, after President Clinton tore his knee and had to use a wheelchair, the closing press conference was full of surprises. Most of the press was lined up at the back of the room for pictures of the event, but I slid onto the side behind Clinton's staff. When the press conference began and Yeltsin began to speak Clinton's translating headset failed. He looked over at his aides for assistance and I had my picture.

Comrades in arms
18 April 1986

Gaby Sommer

Soviet leader Mikhail Gorbachev was guest speaker at the 11th German Communist Party Congress in East Berlin. When he finished his speech all the delegates stood to applaud him. The photographers from the western media were a long way from the dais – so far in fact, that I had to use my longest lens, a 600mm telephoto lens with a 1:1.4 converter, which increased the focal length to 840mm.

I had supported this heavy lens, as I always do, with a monopod instead of an unweildy tripod. When Gorbachev's speech ended I felt instinctively that something would happen between Gorbachev and German communist party leader Erich Honecker.

Although standing quite tall I had to stand on tiptoe, holding my camera well above the heads of the cheering delegates to get a photograph of this sudden bear-hug and kiss. I had the lens prefocused and shot the scene without looking through the viewfinder.

Fellow photographers from other agencies missed the shot because they had their cameras fixed to tripods. They may not even have seen what was going on.

Suspects in the Stephen Lawrence murder trial
30 June 1998

Paul Hackett

In 1997 a black teenager called Stephen Lawrence was stabbed in south London by a gang of white youths. Nobody was convicted of the crime, but five young men were dubbed the 'prime suspects' and were called to appear before the Macpherson inquiry into the murder. The public inquiry had become a high profile investigation into racism, in particular police racism, in Britain. It attracted an angry crowd, which gathered outside the building to protest against apparent mishandling of the case and vent their anger on the five suspects.

This picture was taken on the second day of the suspects' appearance, and the crowd had grown increasingly hostile. We knew the five suspects were due to leave the building, but were unsure of which exit they would use. I expected the police to take them out through the back, to avoid the angry crowds, but a Reuters colleague alerted me to the fact that they were coming out through the front doors. I ran around to the front with my step ladder, got into a position, and minutes later the suspects appeared. The crowd began throwing eggs and other missiles and fighting broke out as they tried to get over the police barricades to attack the suspects. I stood on my ladder long enough to get ten frames before I was knocked off it by the crowd.

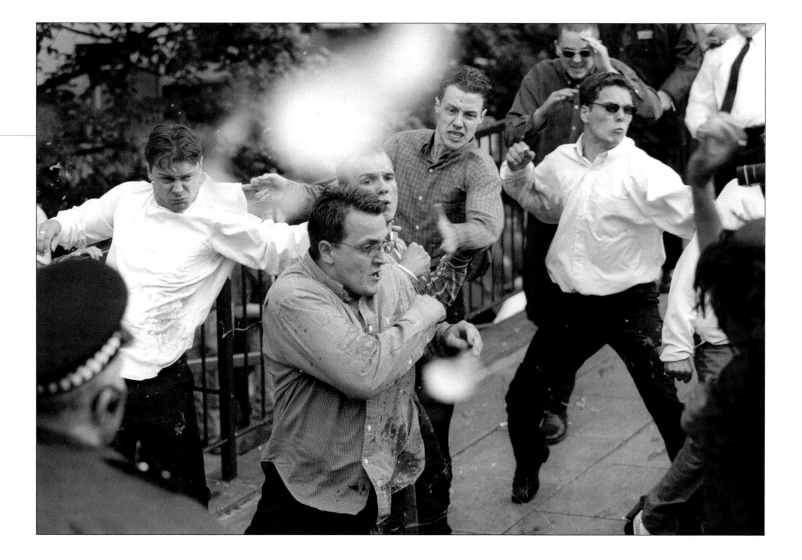

Prison riot, Buenos Aires
02 April 1996

Enrique Marcarian

I was covering a story about the prison conditions in Argentina, which had led to nationwide riots by over 5,000 prisoners, and to the taking hostage of 20 civilians. I arrived at Caseros Prison, Buenos Aires, to get some good images, and began to walk around it. The prison is a very tall concrete-finished building and prisoners were peering through holes they had smashed in the walls. I then saw a man pushing his body through this tiny opening, arms first, and felt he was reaching out for the things that all human beings should have by right: air, light, freedom.

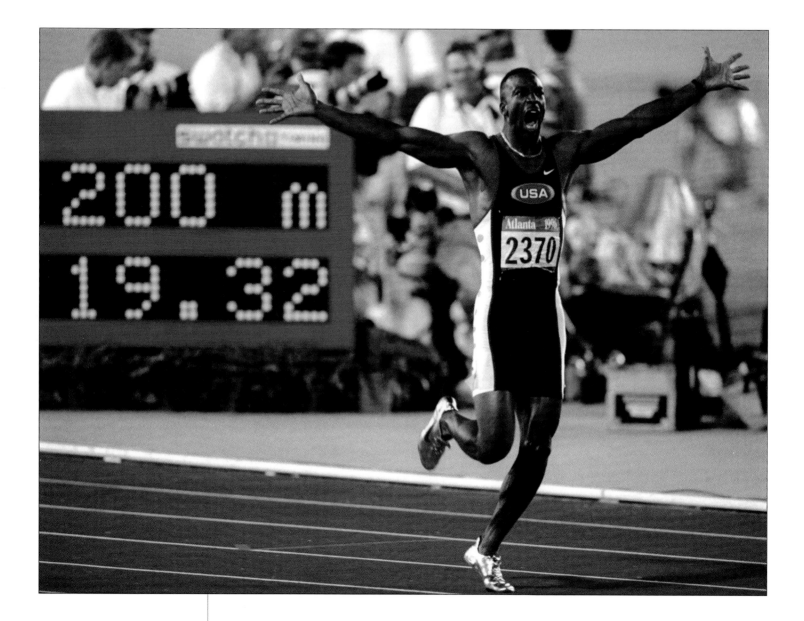

**Michael Johnson clocks
a new world record**
01 August 1996

Mike Blake

In the run up to the 200 metre final at the 1996 Olympics in Atlanta Georgia, everyone expected Michael Johnson to win the race and take gold. However, when he crossed the finish line, clad in his gold shoes, and shattered the world record, it became an Olympic moment.

We had a number of Reuters photographers covering this race and my angle was to shoot the finish from the side in the hope of catching Johnson running past the clock at the finish. I could not have hoped for things to work out better. The picture was developed and transmitted from a small bureau we had set up under the Olympic Stadium, not far from the finish line. At big events Reuters photographers gather from all parts of the world, we work as a team, and our goal is to get our best pictures out quickly.

The 1999 European Cup Final
26 May 1999

José Ribeiro

My fellow photographer Desmond Boylan was in Belgrade covering the Kosovo crisis, so the picture editor in Madrid, Enrique Shore, called me in to replace him. One of my first assignments was to cover the final of the European Champions League, between Manchester United and Bayern Munich. I was using a digital camera and filing pictures immediately – almost in real time. But during the second half my computer battery went down and I had to leave the pitch to change it. When I came back I saw Teddy Sheringham waiting for a pass, focused on him – and got this shot. I filed it so quickly that I was not sure how good it was until, only an hour later, I saw it on the editor's desktop.

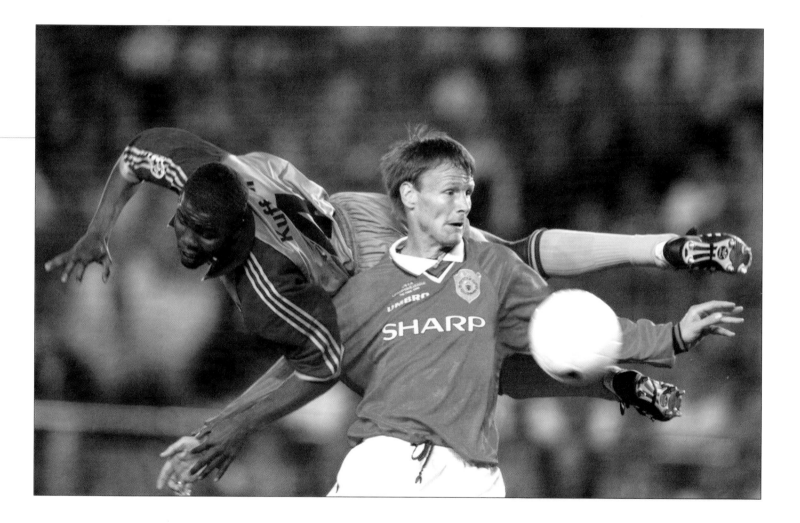

Wayne Gretzky holds the Stanley Cup
31 May 1987

Gary Hershorn

This photo was taken in Edmonton, Canada after the Edmonton Oilers won the NHL championship. Being Canadian I always looked forward to covering the hockey championship. And being Canadian I was always assigned to cover it. For me, covering the great Wayne Gretzky for 20 years was one of the best things about being a photographer. My career paralleled his as a player. After the championship was won the NHL always presented its trophy, the Stanley Cup, to the captain of the winning team. In Canada this is always one of the highlights of the year and also one of those events that always plays on the front pages of newspapers. The procedure for a photographer was always the same: use a wide-angle lens, sharpen your elbows, hope when the cup was lifted the player didn't turn away from you, and all the while try to maintain your balance whilst jostling for position on a sheet of ice!

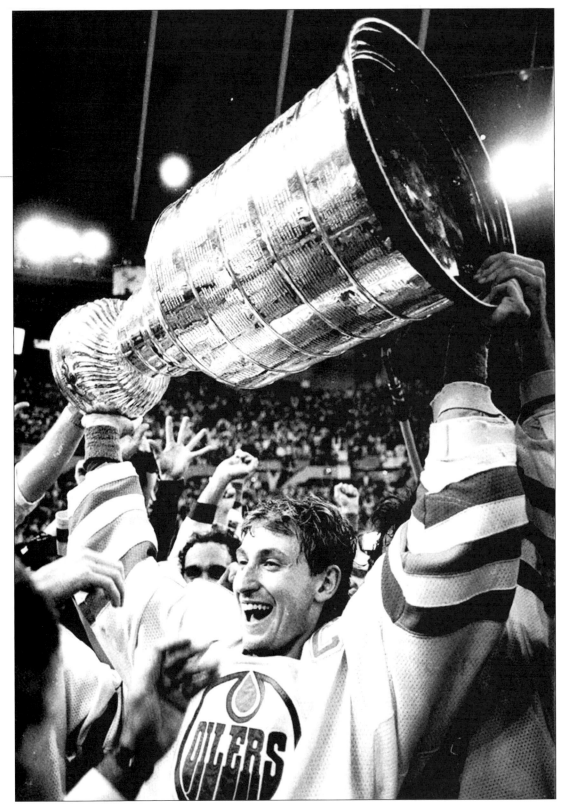

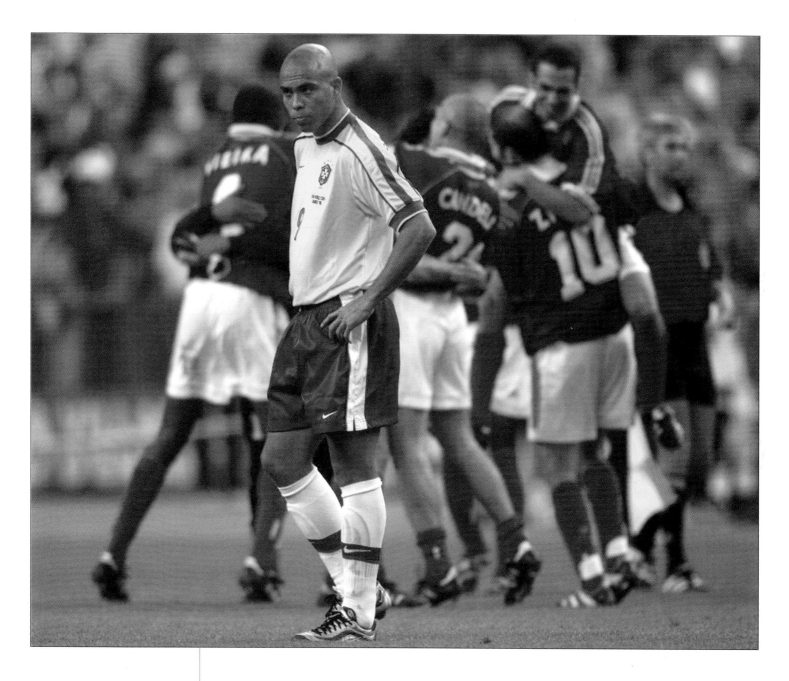

France beat Brazil to the World Cup
12 July 1998

Desmond Boylan

As the final whistle goes, Brazil's Ronaldo walks past French players as they celebrate their World Cup victory. The match was played in the newly built Stade de France, Paris. France beat the reigning world champions, and four time winners, 3-0 to win their first World Cup.

Ronaldo, touted as the world's greatest player, was controversially pulled from the Brazilian starting line up amidst reports of tendinitis and fatigue. Following disputes within the Brazilian camp he was reinstated only 45 minutes before kick-off.

An Indonesian marine witnesses unrest in Jakarta
14 November 1998

Jason Reed

During November 1998, and following the ousting of unpopular long-term president Suharto in May of that year, Indonesian leaders were planning for the first democratic elections in over 30 years in this country of 200 million people. Thousands of student demonstrators, who had earlier in the year successfully pressured Suharto to step down, were again urging for their voices to be heard on the make-up of Indonesia's political future. Clashes on the streets between riot police and students again flared – and led to several deaths as students tried to march to the nation's parliament where the make-up of its democratic future was being drawn up. The parliament compound was guarded by Indonesia's elite marine corp, who were the last line of defence between the militant students and Indonesia's policymakers.

This picture was taken after I negotiated with the military to get inside the compound, since I had already covered the clashes on the streets and was looking for a fresh angle. The marine in the picture was one of many on standby for more violence late on that night, and stood for just a few moments in front of this illuminated billboard advertising the parliament meeting. One of the spotlights put just enough available light on his face, giving the picture some depth and preventing the picture from becoming a flat silhouette. I believe the simple composition and dramatic lighting make this picture stand out.

The world's biggest flag, Turkey
19 May 1998

Fatih Saribas

On 19 May 1998, as part of the celebrations during the Commemoration of the Youth and Sport holiday in Istanbul's Ali Sami Yen Stadium, the world's biggest flag was unfurled.

It measured 52 x 78 metres and weighed over a tonne, and it took 400 students to display it. They were dwarfed by the giant size of the flag as they ran to unfold it over the entire pitch.

Oil spill in Turkey
30 December 1999

Fatih Saribas

A helpless cormorant is covered by oil leaked from the Russian tanker 'Volganeft 248', which split in two and sank off Istanbul, after it ran aground in the Marmara Sea off Istanbul during a violent storm which pounded the northwest of the country. The tanker was carrying 4,300 tonnes of heavy fuel oil which spilled on the shore after the accident.

MRTA guerrillas training in the Amazon, Peru
23 February 1998

Mariana Bazo

While the Japanese Ambassador's residence in Lima was occupied by members of the MRTA (Tupac Amaru Revolutionary Movement), who held more than 100 hostages, Reuters got an exclusive interview with members of the movement.

This interview took place at an MRTA training camp in the middle of the Amazon jungle. Access was extremely difficult: we drove for a whole day, and walked through muddy fields and flooded land for another day. Rain was everywhere. The MRTA training camp was 'clandestino', or underground. No reporter or photographer had been there for almost ten years.

I wasn't allowed to shoot any pictures while the rebels weren't wearing scarfs to cover their faces. They only time they allowed me to photograph them without their red scarfs was during a 'camouflage' exercise when they covered themselves in mud.

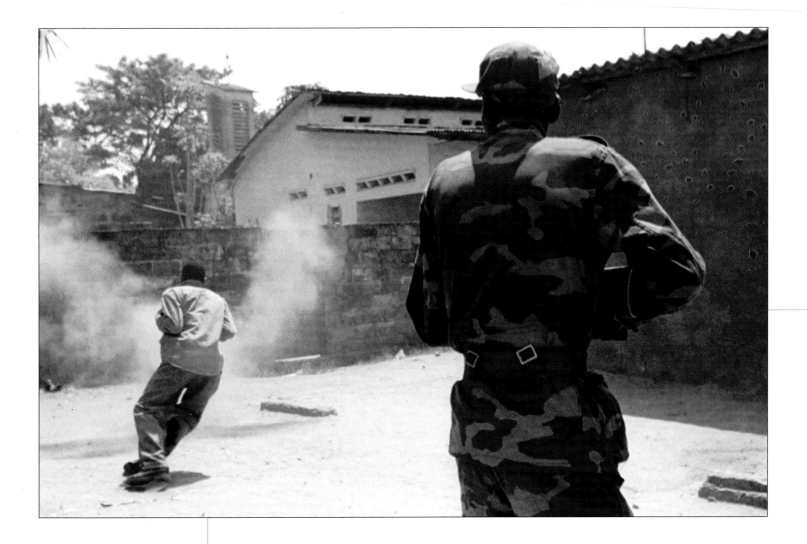

**Street execution in
Monrovia, Liberia**
08 May 1996

Corinne Dufka

Springtime in Liberia, 1996. The rival militias of Charles Taylor's National Patriotic Front of Liberia (NPFL) and Roosevelt Johnson's Krahns mounted running battles throughout the capital city, Monrovia. Children and youths giving themselves names such as Colonel Fire in the House, Major Blood and Lt. Double Trouble glided through the streets armed with AK-47s, pistols and kitchen utensils. By the end of this latest flashpoint in Liberia's seven year civil war, many people would be dead and the seaside capital city would lie in ruins.

It was one of those wars no-one, much less the frontline protagonists, could really explain. I came across countless victims of senseless violence, like the nameless man we photographed being shot in a gutter. From what we gathered he'd crept out of his house in the morning to search the empty streets for something to eat. The frontlines changed sometimes two or three times a day, so when caught by a patrol of armed NPFL men, he was probably confused and screamed out, 'I'm a Krahn, I'm a Krahn'.

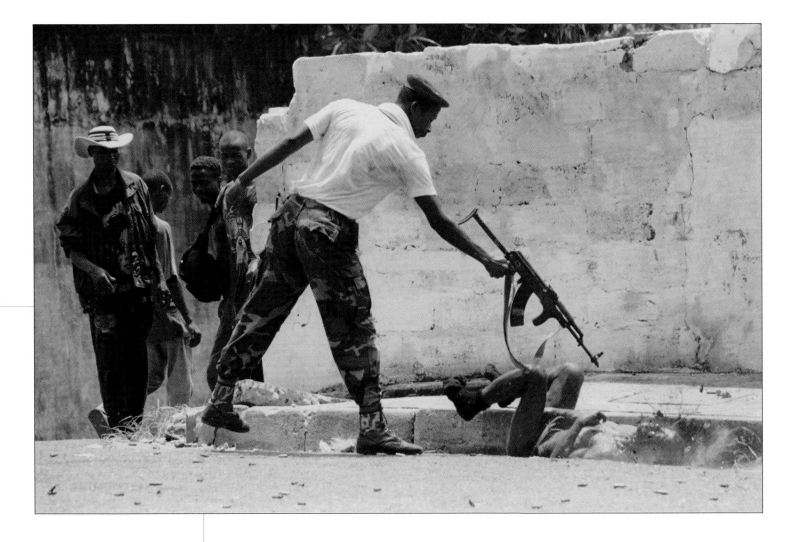

The admission was all the NPFL needed to brand him an enemy. Within eight minutes he had been told to run, shot in the back, then dragged down the street and stripped down to his socks and underwear. As the fighters prepared to go, a young one with a long kitchen knife pointed at 'the enemy' writhing in pain in the gutter. As the boss man finished him off we could hear gunfire and looked up to see the Krahn militiamen inching up the street. There was commotion and within seconds we were all scrambling over walls and down alleyways to escape. The militias moved on to their next battle, we hurried back to develop our film and a family waited for the unknown man lying dead in the gutter to come home.

The burnt body of a Tutsi, Kinshasa
27 August 1998

Peter Andrews

This photo was taken in Kinshasa, at a time when rebels opposed to the rule of Laurent Kabila, President of the Democratic Republic of Congo, and backed by Rwandan and Ugandan forces, were advancing on the city. The population was hearing constant reports about the coming threat of the rebel forces. They began hunting down anyone they suspected of being a rebel or a Tutsi.

On this day we were taken around the city in a car by a group of soldiers. It was one of the most horrible days I have lived through; we saw at least ten people being burned alive. The crowds were out of control: everybody was suspected of belonging to the enemy. Members of the media, especially, were targeted. If it was not for our escort we ourselves could easily have been killed.

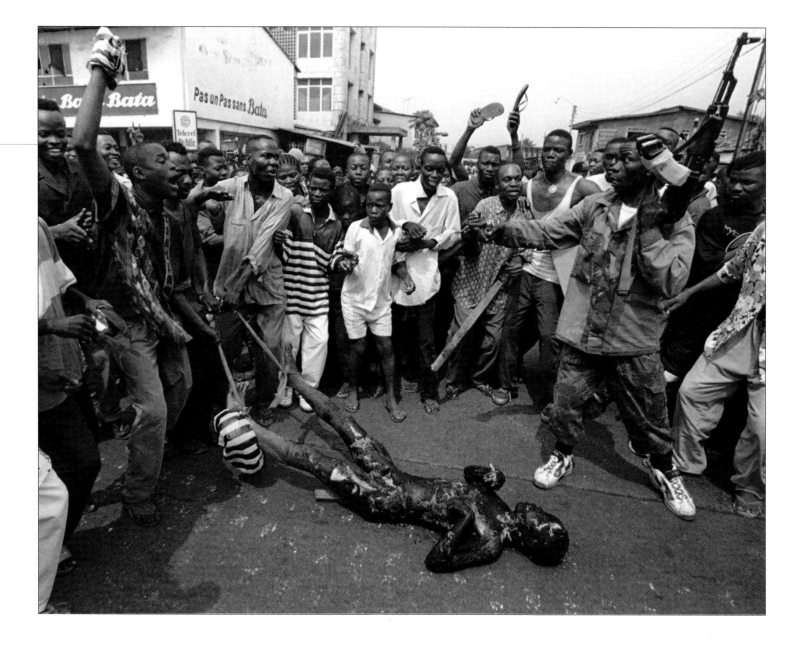

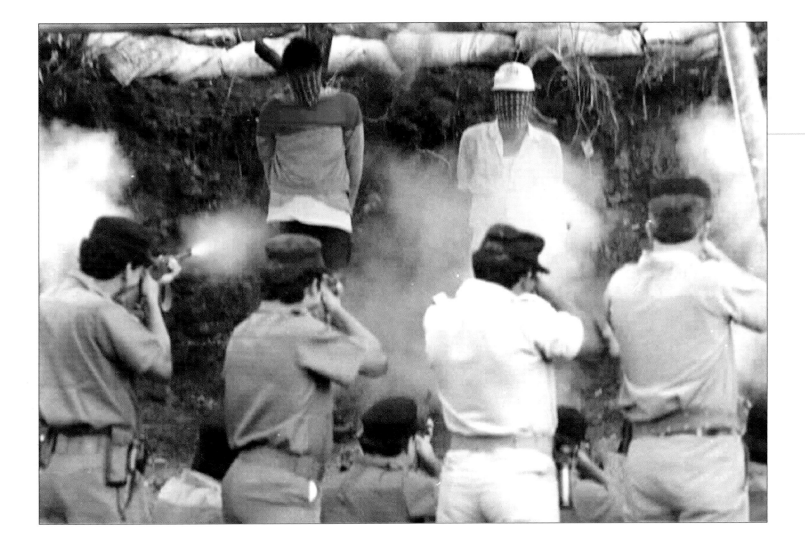

Execution of two convicted Guatemalan men
13 September 1996

Kimberley White

I witnessed these two men, who were convicted of raping and murdering a four-year-old girl, being executed by firing squad. This was the first state execution in Guatemala for 13 years.

The execution took place behind a jungle prison at dawn. The men walked to their deaths without any outward sign of emotion. They were blindfolded with green and white handkerchiefs and tied with string to tree trunks under black plastic sheeting.

However, a forensic doctor determined that a volley of shots from the 16-man firing squad had failed to kill them. The coup de grâce was a pistol shot to the head of each administered by the prison director.

In 1996 the fundamentalist Taliban were knocking at the gates of Kabul, the Afghan capital, and were poised for a victory against the northern opposition alliance.

On 26 September the Bureau Chief of Pakistan's English daily, The News, asked me to accompany him to Kabul just in case the Taliban took the capital that day. Once over the border into Afghanistan it was a very dangerous drive from Jalalabad, capital of Afghanistan's eastern province, to Kabul, as the road was littered with anti tank mines.

Whilst on the road we heard that Kabul had fallen into the hands of the Taliban, and when we got there the capital wore a deserted look. Only a few people could be seen in the streets. Just as we took a turn towards the Ariana chowk (square) we saw the bodies of former Afghan President, Dr Najibullah, and his brother hanging from a pole. The Taliban, under their very strict version of shariah, disapprove of the taking of pictures – but I had some luck, managed to take the picture, and rushed back to Pakistan the same day.

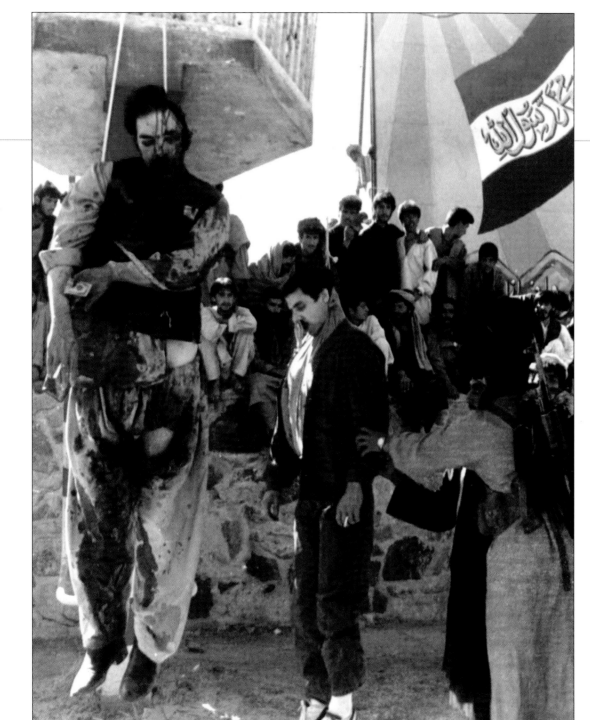

The bodies of the former Afghan President and his brother
27 September 1996

Syed Haider Shah

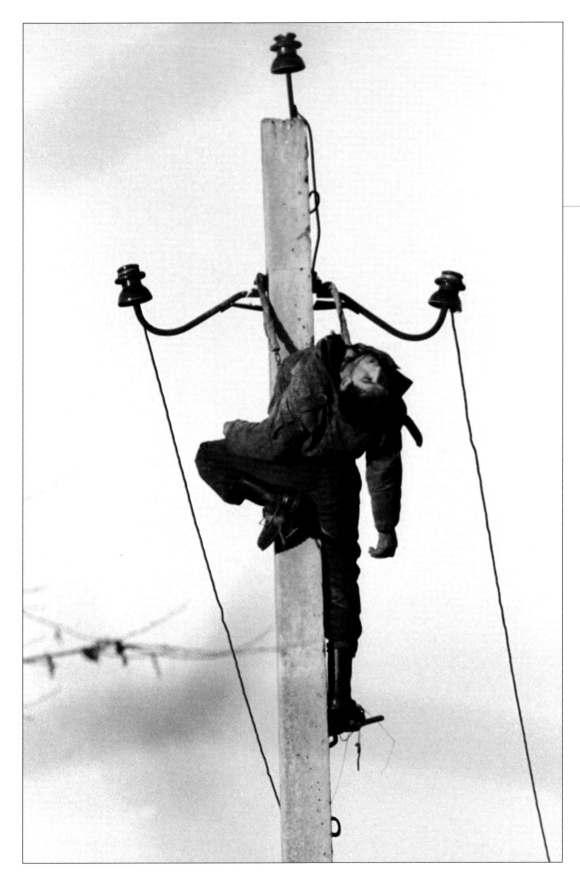

A Chechen man killed by an electric shock
06 December 1999

Vladimir Suvorov

A Chechen man, killed by an electric shock while trying to disconnect and steal copper wire, hangs on a telegraph pole in a field in the Nadterechny region of Chechnya.

That day Russia's military had issued an ultimatum for all Chechens to leave their beseiged capital, Grozny, within five days or face an unrestrained onslaught by artillery and air.

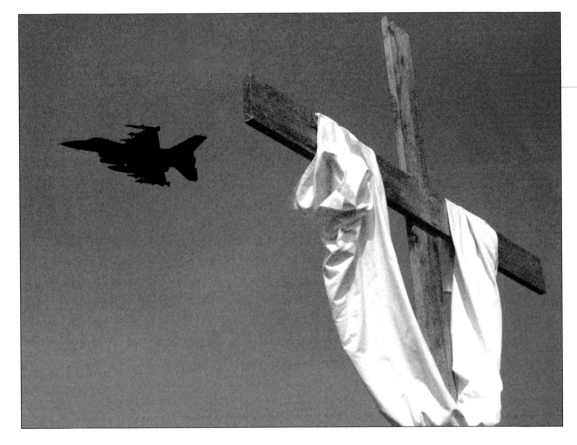

War and peace
04 April 1999

Stefano Rellandini

This picture shows a USAF F-16 fighter taking off from Aviano air base in northern Italy, over a cross erected for Easter by a pacifist group outside the base. On the previous night, a vast fireball had lit up the Belgrade sky, as NATO intensified its campaign on targets in northern Yugoslavia.

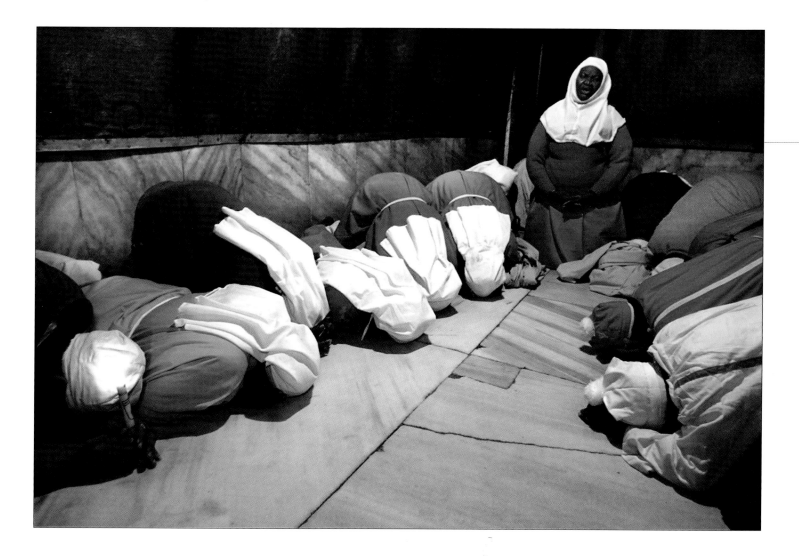

**Bethlehem on
Christmas Eve**
24 December 1999

Jim Hollander

A group of Christians from Lagos, Nigeria prostrate themselves on the marble floor inside the grotto of the Church of the Nativity as they recite prayers on Christmas Eve. The grotto is a small cave-like area underneath the main church.

On Christmas Eve in Bethlehem an annual procession takes place at 1pm – consisting of choir boys, the Patriarch of the Holy Land and hundreds of Palestinian 'Scouts' in their pressed dress uniforms, beating drums and even playing bagpipes. There are usually hundreds, if not thousands, of Christian pilgrims on hand – as well as a huge assortment of reporters, television crews and stills photographers. It is usually cold and damp and when the procession gets underway in Manger Square for the short march to the Church of the Nativity there is much pushing and jostling between the press photographers and security officers as each try to keep close to the assembled hordes. I broke away from the press pack and went into the 'grotto', or cave, underneath the Nativity Church about one hour before the procession. Pilgrims flock to the grotto to see, touch, kiss and pray over the silver star inlaid in the marble floor, marking what is traditionally the exact spot of Jesus' birth. It is a very small area, dimly lit only with candles and several oil lamps hanging from the curved ceiling. In the back of the room these colourful pilgrims sat in a semi-circle softly singing Silent Night. When they finished I asked one priest where they were from and sensed they would not mind if I photographed them. They didn't object and I was able to document their prayers until the end. When the lead priest had finished a woman priest took over and recited prayers in a singsong manner as they bowed to their Lord in one of the most reverential of places. Several other photographers did wander down to the grotto and witnessed this touching religious prayer, but most of the press pack were still outside watching the crowds form for the official procession.

These Cambodian Buddhist monks were on their way to attend a ceremony remembering the Cambodians who were killed at Cheung Ek during the genocidal Khmer Rouge regime of 1975–79. Cheung Ek is a former killing fields site, and now a memorial, just outside Phnom Penh. In total, over 1.7 million people are said to have died under the Khmer Rouge.

Monks always attend religious and memorial ceremonies in Cambodia and these monks had just stopped to wait for the rest of their group to catch up before entering the gates of Cheung Ek. Shooting through a fence I tried to photograph the monks individually as they walked across the flooded rice paddies, but rice and grass prevented a clear reflection so I settled on a group shot.

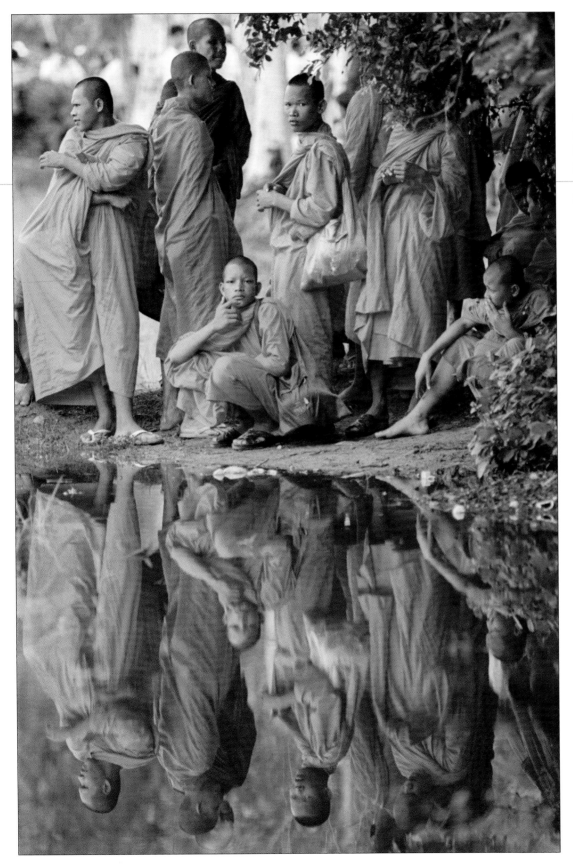

**Cambodian monks
remember victims of
Khmer Rouge**
20 May 1999

Darren Whiteside

Who's the fairest?
25 September 1998

Daniel LeClaire

Flamingos crowd together in a restroom at Miami's Metro Zoo. More than 50 of the birds were herded into the building for protection from Hurricane Georges, which made landfall in the Florida Keys. The zoo lost most of its birds in a 1992 hurricane, so officials moved the birds as a precaution.

**A gymnast at the
Asian Games, 1998**
13 December 1998

Tom Szlukoveny

I love sports photography because it is 'black and white': if you get the crucial picture of the event you are good, if you miss it you are not. All sports photographers know the feeling of being hot – when you have one of those days when you can't do wrong. Everything is happening in front of you, you happen to be facing in the right direction and your reflexes are in top shape; you simply can't miss. Mind you there is the downside to this – often on only the next day, when, confidently arriving at the same type of event, you simply couldn't take a really good picture if your life depended on it.

Luckily I had a good day at the 1998 Asian Games, and ended up with a number of good shots from the rhythmic gymnastics event, which is one of my favourite sports to photograph. This shot shows the Chinese gymnast Zhou Xiaojing. She appears to be headless as she bends backwards during her clubs routine. She too had a good day – and went on to take gold.

Russian High Fashion Week, 1996

01 December 1996

Cyril Iordansky

The picture was taken during the High Fashion Week organised in Russia every year. The week, in fact a contest, featured the work of several renowned French and Italian designers and of some talented Russians. At the end of the week the best Russian designers were presented with awards. As it was one of the first big scale fashion events in Russia, it was an interesting news item to cover.

The wedding dress shown in this picture was created by Irina Selitskaya, a Russian designer already fairly well known at that time – but not as famous here as Yudashkin or Zaitsev. The picture is interesting because of the impact of the white semi-transparent bridal veil covering the whole model. It also offers an original take on Russian style, which is traditionally associated with matrioshkas, the Kremlin and sarafans...

New York Yankees celebrate winning the World Series
26 October 1996

Jeff Christensen

The legs of a New York Yankees player stick out from the pile of his teammates as they celebrate their World Championship victory against the Atlanta Braves. The Yankees won the game 3-2, and the Series four games to two.

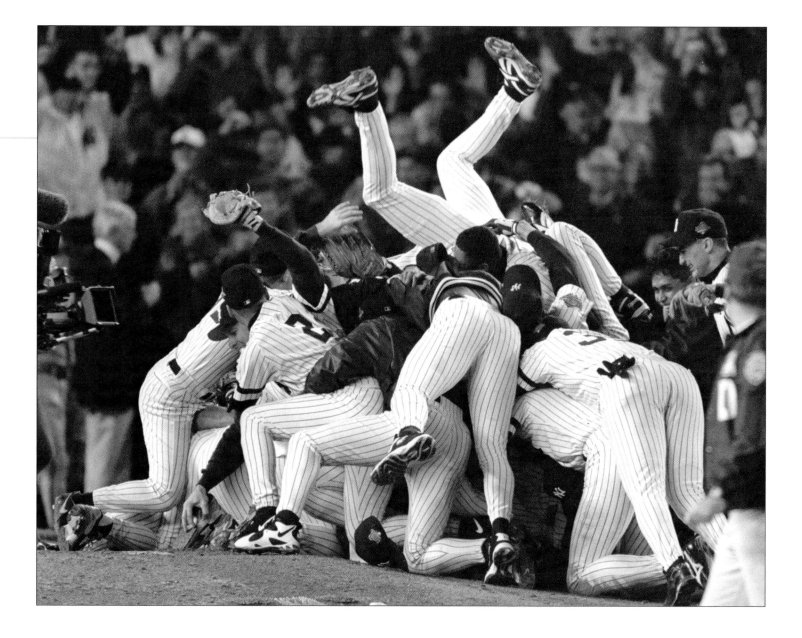

Flea in your ear
25 June 1996

Laszlo Balogh

Anthony Keidis, lead singer of the band The Red Hot Chili Peppers, performs during a concert in Budapest.

Royal Ascot
17 June 1999

Kieran Doherty

Looking at the balcony of the Royal Enclosure at Ascot Racecourse there were countless opportunities for run-of-the-mill feature pictures of dazzling ladies in fantastic hats. By using a slow shutter and a zoom burst I was able to inject some dynamism and colour into what would have otherwise been an ordinary frame.

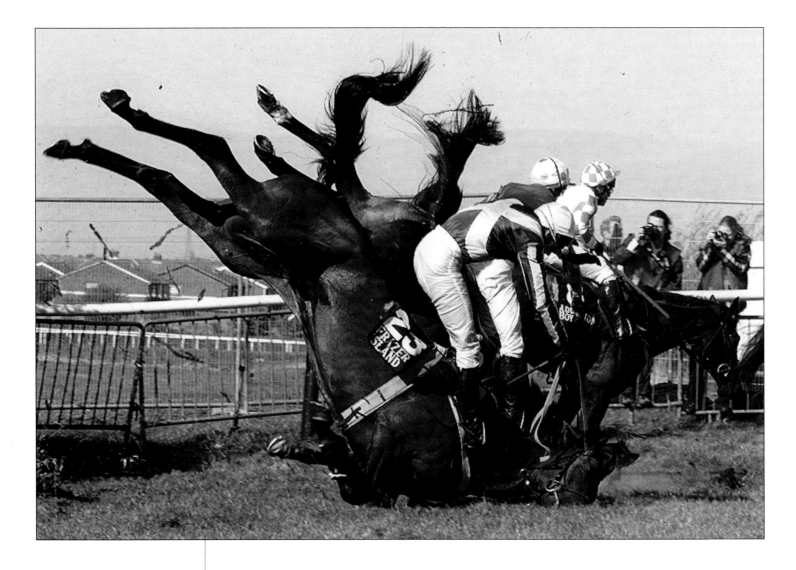

Becher's Brook, the English Grand National
10 April 1999

Ian Hodgson

The Grand National is the world's most famous steeple chase and in recent years has fallen foul of several phenomena, including a false start, a terrorist bomb threat and animal rights protestors. On this occasion, the story that made the headlines was the pile-up at Becher's Brook which resulted in the death of the horse Eudipe. It wasn't until the riders came round for the second time that three of the horses stumbled on landing. Frazer Island landed nose first, throwing jockey Richard Guest from the saddle. Eudipe, partly concealed by Frazer Island, also took a heavy fall and was injured so badly it had to be put down. The race was won by the Irish horse Bobbyjo, ridden by Paul Carberry.

It was the second time I had covered the Grand National for Reuters and I wanted a picture which symbolised the race for me. Other Reuters photographers were covering the winning post and winner's enclosure, so I needed to get a strong action picture. As Becher's Brook is the most notorious fence on the course, I decided that was the place to be. Fortunately for me, the decision paid off and I was in the perfect position to capture the dramatic and tragic moment when the three horses fell to the ground.

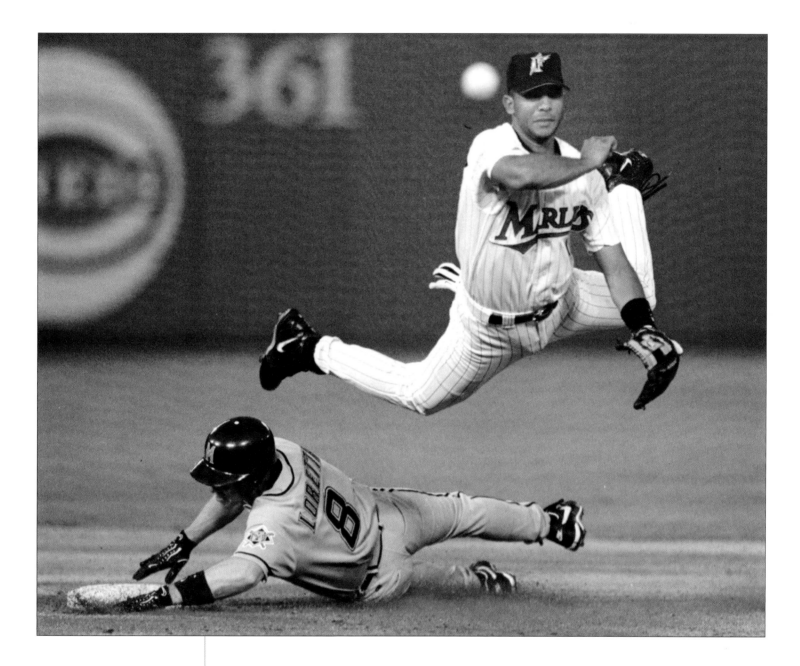

Short stop
03 May 1999

Colin Braley

Florida Marlins' shortstop Alex Gonzalez soars over a sliding Milwaukee Brewers' Mark Loretta, foiling the third inning doubleplay as Gonzalez's throw to first was late.

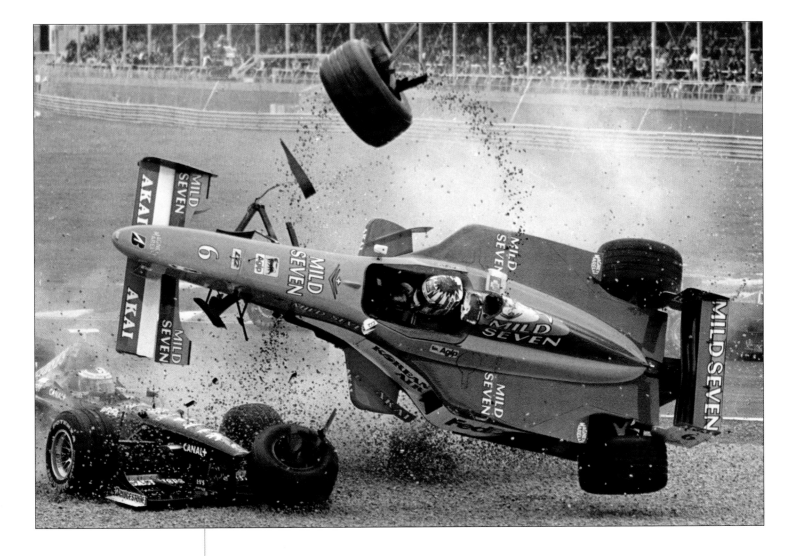

Stopped short
07 June 1998

Peter Jones

An hour before the start of the 1998 Canadian Grand Prix I walked out to the first turn to pick up film from the photographer at that spot in order to get an early picture out for papers in Europe. Infield of Turn 1 I found a place to stand on the steps of the photographers' platform and waited for the start of the race.

The green lights signalled the start of the race and the cars screamed down a short straight before the first turn. I followed the leaders though the turn and swung my camera back again. Seconds later Alex Wurz, in the Benetton Mecachrome, caught a tyre and his car flipped over. It slid across the track upside down, reached the gravel run-off and flipped, doing a 270 degree roll before coming to the ground right side up.

Wurz climbed out of his car and checked on driver Johnny Herbert whose car also left the track. Then they both ran to the pits for their backup cars and joined the re-started race from the back of the pack. Wurz finished the race in fourth place. After the dust settled I immediately rewound the film and put it in my pocket.

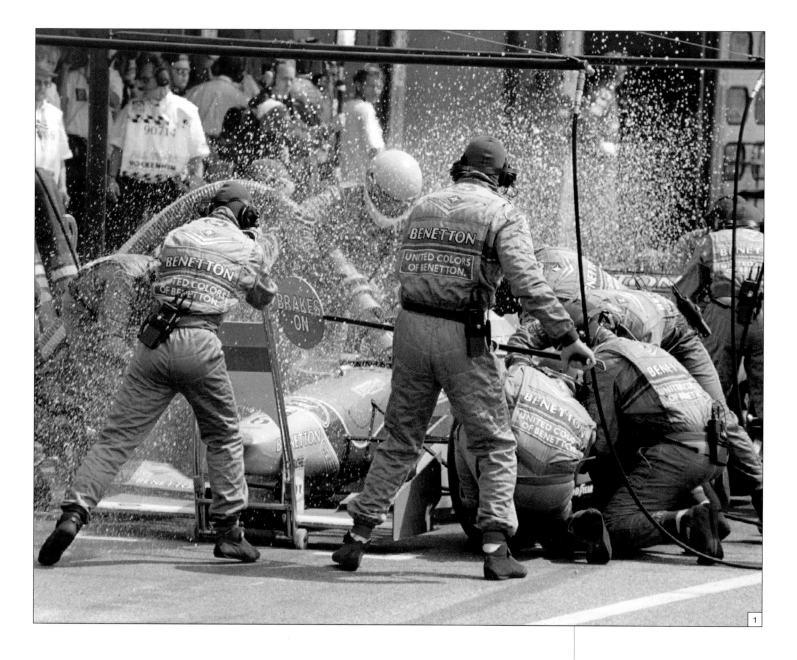

**Jos Verstappen's
Benetton goes up in
flames**
31 July 1994

Joachim Herrmann

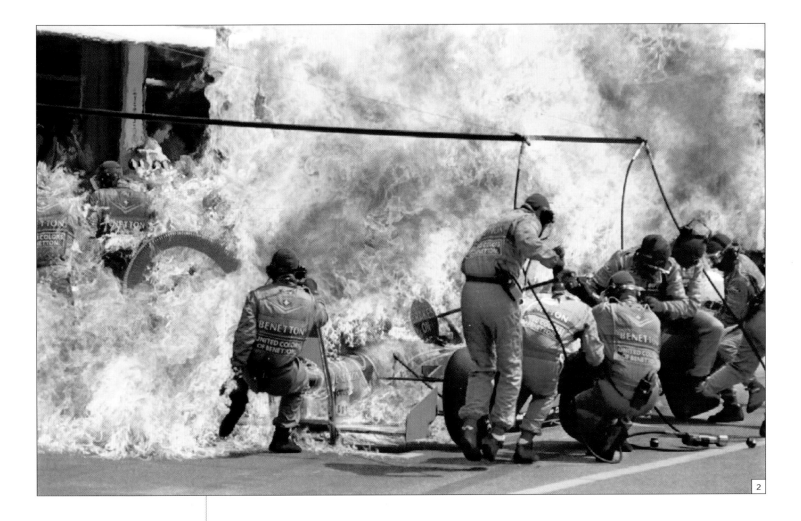

2

The 1994 Formula One Grand Prix in Hockenheim, Germany, was, to my knowledge, the first time provision had been made for a special position for a few photographers on the pit wall – in the thick of the action, immediately between the paddock and the race track.

As I saw a Benetton Ford arriving for refuelling on the fifteenth lap I looked through my 80-200mm lens to see if it was Michael Schumacher, who had won six of the first seven races, and, following the death of Ayrton Senna at Imola earlier in the year, was clear favourite for the championship. However, it turned out to be Jos Verstappen. As I tried to shoot a normal refuelling situation, I saw petrol spraying around the car and a sudden conflagration. I pushed the button on my camera and after four or five seconds had passed I had this dramatic series of photographs: the petrol around the car, the car in flames, the fire being extinguished and Jos Verstappen getting out remarkably unscathed. Unsurprisingly the car was retired. Schumacher retired with engine trouble five laps later, and Gerhard Berger recorded Ferrari's only win of the season. However, Schumacher went on to take the championship – by one point from Britain's Damon Hill.

After this incident new and more stringent refuelling regulations were established.

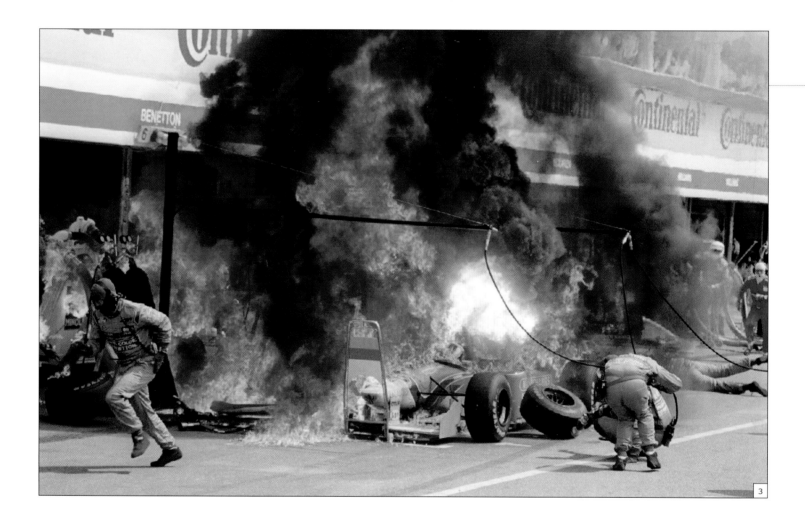

3

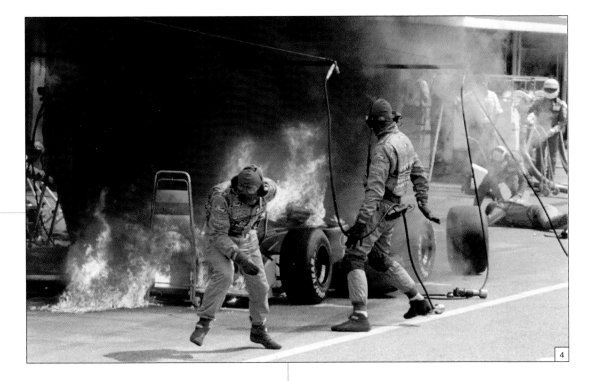

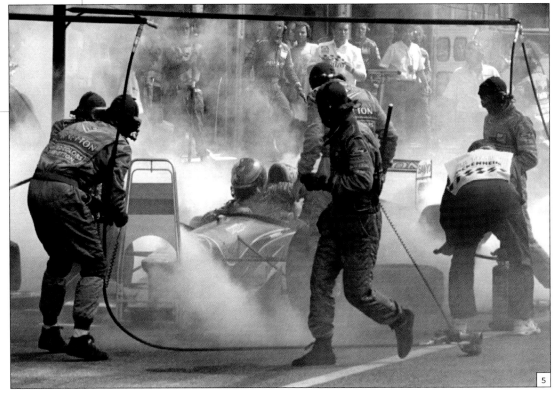

Jos Verstappen's Benetton goes up in flames

31 July 1994

Joachim Herrmann

European Swimming Championships
21 August 1997

Desmond Boylan

To get this shot I focused closely on a single swimmer, the Swiss Dominique Diezi, competing in the women's 100m backstroke. I waited until she was coming up for air, but shot just before she did so using a very high shutter speed. She clocked 1:05.24 and finished eighteenth.

Painting the town red
28 August 1996

Desmond Boylan

Tomato battlers swim in the pulp of tomatoes during the local festival in the village of Bunol, near Valencia. People hurl some 100 tonnes of tomatoes at each other during the fight, which is the biggest tomato battle in the world.

Once I arrived in Bunol I found a position in a house on the second floor. When the battle started, I shot some pictures from a window, then went down to the street when I saw people swimming in the tomato pulp. People immediately threw tomatoes at me, and soon I was covered. I had one camera wrapped in plastic except for the lens, and paper to clean the lens in a sealed pouch. When I saw people swimming in the tomato pulp I went down to their level and shot this picture.

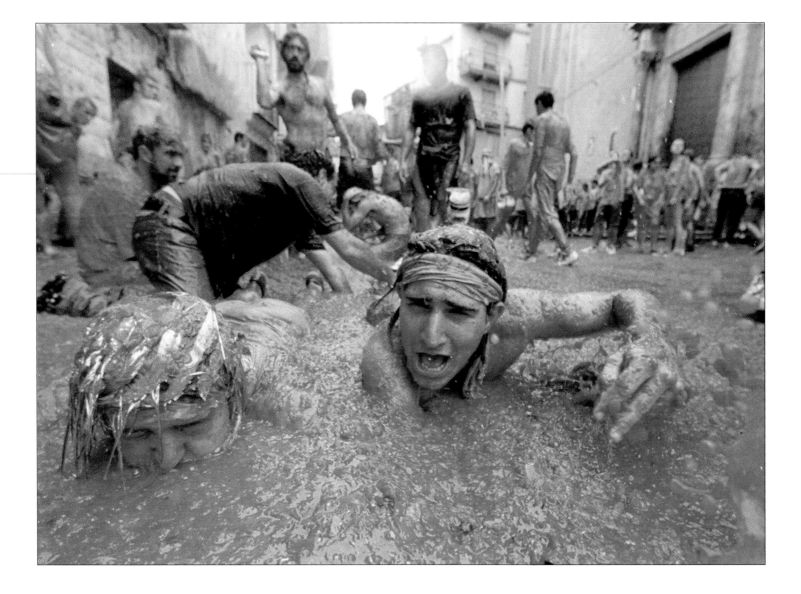

Each year in Cuellar, Spain, bulls are let loose at dawn to run through fields before riders on horseback herd them into town for the running of the bulls. Before entering the town two bulls split from the rest and charged towards some spectators standing in a field. With virtually no protection apart from a few shrubs, the spectators scrambled up an electrical pylon. One of the loose bulls appeared over the hill and charged.

As I was on vacation the longest lens I had was a Nikkor 180mm F2.8 (in those days there was only manual focus) and I had already shot two rolls of 400ASA film with my Nikon F3 when the bull charged. The only roll I had left in my bag was an Ektapres 1600ASA colour negative which we used for shooting night sports. I was standing in the middle of a field, some 50 metres away, with nowhere to take cover. I had no idea where the loose bull was but I had to get closer to get a shot. The 1600ASA film did the job: despite the grain the quality holds up well due to the great optics of the old Nikkor lens. This is one of my favourite pictures. The precise moment of the bull in mid air as it charges, combines with the form of the spectators crammed up and inside the pylon, as well as the nice clean background – a frame where all the right ingredients came together for one fleeting moment.

Raging bull
15 September 1990

Paul Hanna

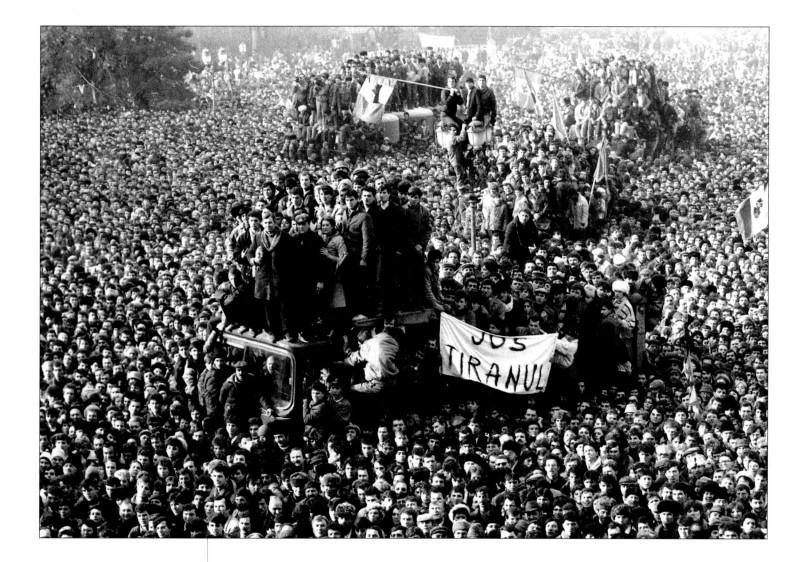

**Uprising against
Ceausescu**
22 December 1989

Radu Sigheti

On 22 December 1989 Romania was at boiling point. It seemed that almost the whole population was protesting against the dictatorship of Nicolae Ceausescu. Thousands of people were walking towards the city centre where, only a day earlier, security forces had arrested and killed protestors. The army was deployed on the streets to protect the Communist Party Central Committee building. I went out in the morning without my camera, afraid that I could be arrested if some militiaman or plain clothes secret policemen saw me taking photos. I returned home to collect a camera after I saw army tanks returning to their barracks and the hordes of people crowding towards the centre of the city. Back at the Communist Party building I was in time to see Ceaucescu's helicopter leaving – and, almost simultaneously, protestors entering the building. In the square people were looking up towards the balcony from which Ceaucescu had made his last speech, and from which some people were waving flags with the communist emblem cut out. Nobody was making the victory sign, and everyone was worried about what might happen next, afraid of a reaction from Ceausescu's special forces. It was such a different and unusual scene, and atmosphere, that I remember taking the photo and thinking, 'Oh man, this is history!'

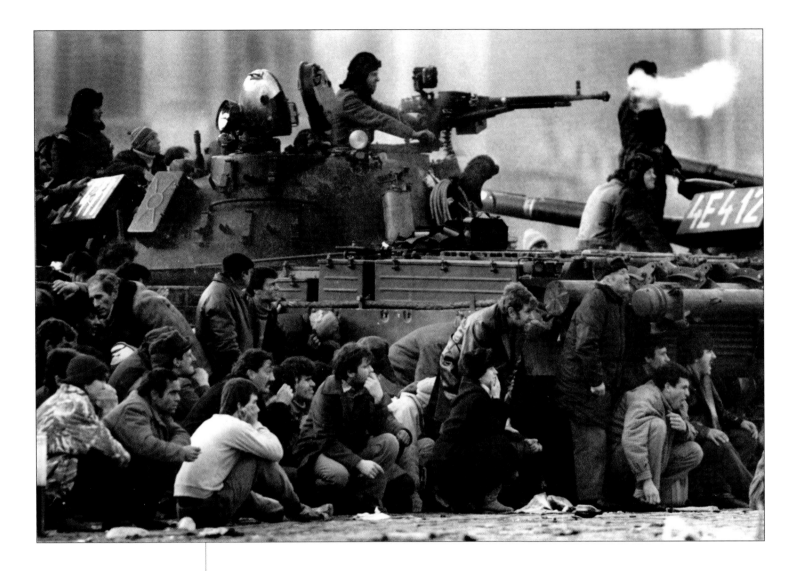

**The overthrow of
Nicolae Ceaucescu**
23 December 1989

Charles Platiau

After sitting at the Paris picture desk watching Romanian dictator Nicolae Ceausescu's last speech live on TV, my boss, Mallory Langsdon, decided to send me to Bucharest. I rushed to the airport without even making a stop at home to collect some clothes, and boarded a French humanitarian flight. However, we would never have been allowed to land in Romania so we headed for Sofia in Bulgaria. That night, with the help of some US dollars, I managed to persuade a taxi driver to drop me at the Romanian border. From there I hitchhiked to the outskirts of Bucharest and took the metro to Republican Square. I arrived in the thick of heavy fighting – between supposed supporters of Ceausescu and anti-regime soldiers. I shot the fighting with the long lens I was more accustomed to using when covering a soccer game. Residents were watching the fighting from the relative protection offered by the tanks. On Saturday 23, and on the days following, I saw soldiers and spectators being killed in friendly fire and by stray bullets – but I never saw up close a single pro-Ceausescu sniper. This picture, quite unreal, fronted most of Sunday's worldwide newspapers. Two days later Ceausescu was executed. Two weeks later I was back shooting soccer games in French stadiums.

Passive resistance, Beijing
05 June 1989

Arthur Tsang

A Beijing citizen stands passively in front of a convoy of tanks in the Avenue of Eternal Peace. The tanks did not slow down but did move around him before taking up position in another area of the city. The man was not injured.

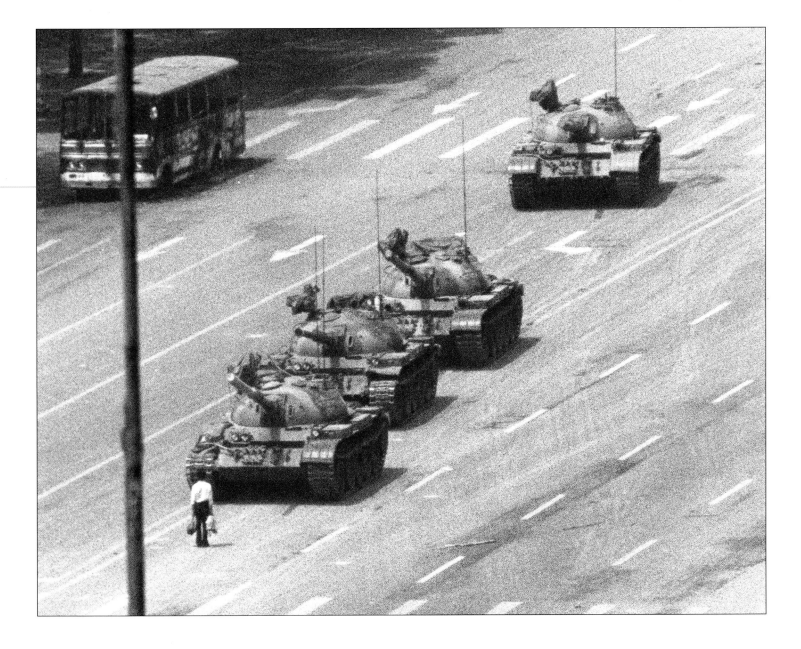

**Opening ceremony,
World Gymnastics
Championships, 1999,
China**
Andrew Wong

08 October 1999

These Chinese dancers are
performing during the opening
ceremony for the 34th World
Gymnastics Championships in
Tianjin, China.

Ceremonies in China are usually
very colourful and beautifully
done. However, most Chinese
officials have very little concern
regarding the needs of
photographers, and restrictions are
very tight.

On this occasion I wanted to get a
better angle, decided to try my
luck, and, though I lacked the
right security passes, wandered up
to the top tier of the stadium,
avoiding any security personnel.

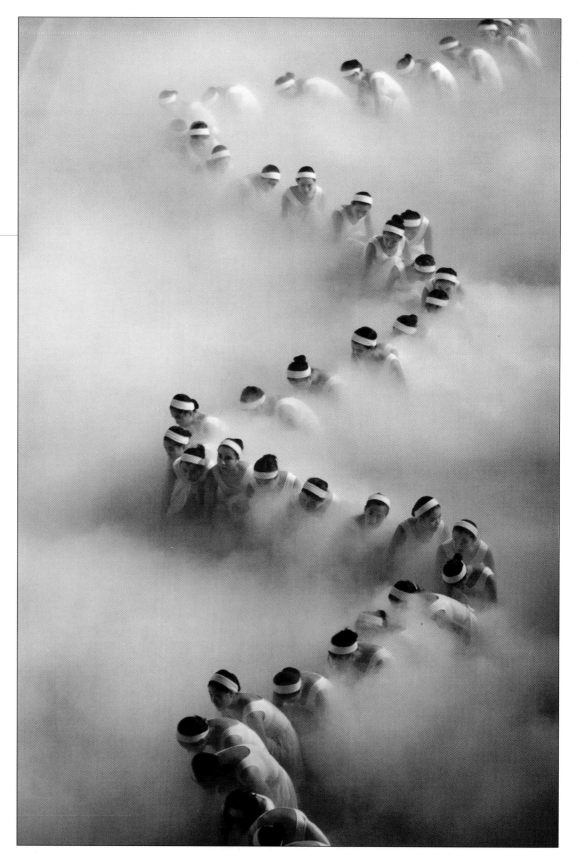

A Vietnamese ballerina rehearses under the shadow of 'Uncle Ho', Hanoi
16 September 1995

Claro Cortes

A young Vietnamese ballerina rehearses in Hanoi, the communist capital of Vietnam, near a huge bust of revolutionary leader Ho Chi Minh – popularly known as 'Uncle Ho'. The photograph was taken during one of the many fashion shows and beauty contests that started to be frequently staged as the country gradually opened up to the outside world. I had covered several beauty events in Hanoi and they had all begun to look the same. To get a new take on the subject, I asked the organizers if I could get access to the backstage. I got my green light and patiently watched and took photographs of behind the scenes action.

Models were nervously fitting their gowns, perfecting their walks, putting on their make-up, etc. Then I saw this petite ballet dancer practising alone backstage. I followed her and started shooting. I played with the exposure, shooting with flash and with available light. A slow speed with ambient light caught her pirouetting near the statue of 'Uncle Ho'. The slow speed gave it a feeling of movement and grace which helped portray the fluidity and feeling of her moves. Ho Chi Minh's statue also helped to establish the background – setting the picture in Vietnam.

Tonya Harding
23 February 1994

Enrique Shore

It was a very intense moment, when the time came for US figure skater Tonya Harding to take to the ice in competition, during the Lillehammer Winter Olympics. Hers was a story that had attracted much attention after allegations that, only seven weeks previously, she had been behind an attack on her archrival, and fellow US skater, Nancy Kerrigan, in a deliberate attempt to jeopardise Kerrigan's chances of competing. As Harding got into the ice rink she prayed for a second, and I took this frame, which luckily also had the Olympic Figure Skating icon in the background. Despite skating well Kerrigan finished second behind the Ukrainian, Oksana Baiul. Harding could only finish out of the medals, in fourth.

Since the beginning of the Olympics I had been working mostly inside, editing the story, but when our team got reinforced that day I was able to go out and shoot at the last moment. This was very fortunate, because Reuters photographers covering this event from the other side of the ice rink were not able to capture this shot.

Diego Maradona
02 June 1986

Gary Hershorn

This photo shows Argentine soccer great Diego Maradona being fouled in a 1986 World Cup soccer game in Mexico City. Maradona was the big star of the tournament and led Argentina to the championship. This game, against South Korea, was played in front of a huge crowd in Mexico City's Olympic Stadium.

I was working in Canada when I was asked to go to the World Cup. Soccer is not a big sport for photographers working in North America – I had never really covered soccer up to that point in my career and didn't cover it again until the World Cup in the USA in 1994. I was based in Mexico City for the whole of the 1986 tournament and was lucky enough to cover all of Maradona's games.

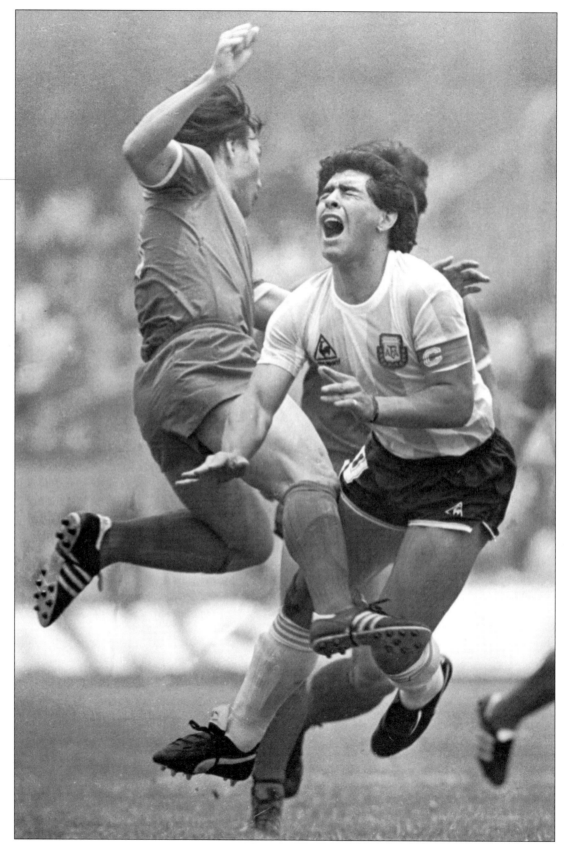

Andrei, a young child who was abandoned by his HIV-infected mother, cries in an infection hospital in the city of Ust-Izhora, some 30 kilometres from St Petersburg. There are 30 such children within the hospital, all of whom have been abandoned by their parents. They each stay for 17 months, during which time doctors determine whether or not they are infected with the virus. The green marks on Andrei's face are disinfectant.

**Infection hospital,
Ust-Izhora, Russia**
01 September 1999

Alexander Demianchuk

Survivors of a mudslide, Guatemala
27 August 1998

Eliana Aponte

This picture shows Guatemalan women grieving for their relatives, who died the day before when a mudslide buried four villages and killed at least 22 people in Santa Cruz del Quiche, a remote northern region of Guatemala. Dozens more, mainly women and children, were still missing, at the time I took this photo. This is the one picture, of all those I have taken in Guatemala, that means the most to me. Every element in the photograph is of mourning. It conveys a deep-rooted despair, natural to every disaster, and yet ... the image focuses on the women and their plight: they are Guatemala's pillars, surviving and continuing in the face of harshest adversity.

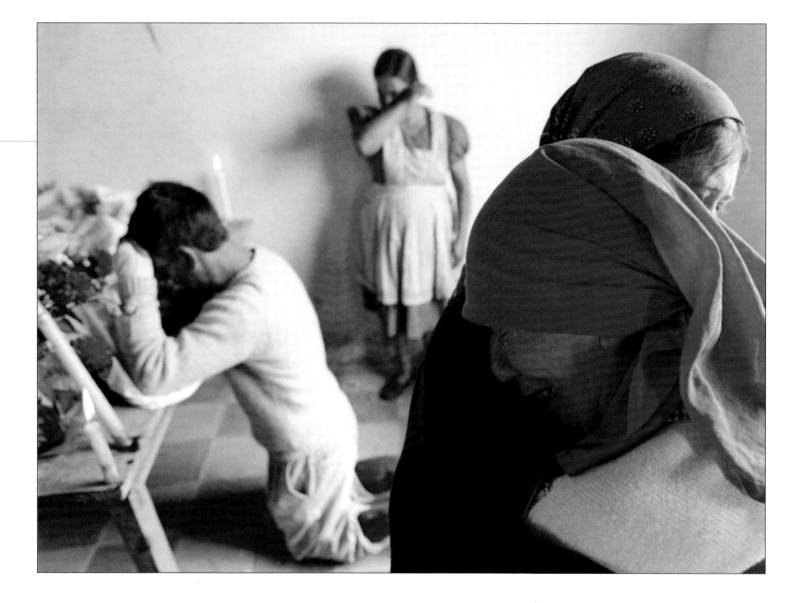

A mental institution in Stimlje, Yugoslavia
18 April 1999

Goran Tomasevic

Inmates sit in their room at a mental institution in the town of Stimlje, some 40 kilometres from Kosovo's capital of Pristina. Yugoslavian authorities said the inmates were suffering due to poor conditions, and a lack of food and medical supplies brought on by NATO's bombing campaign.

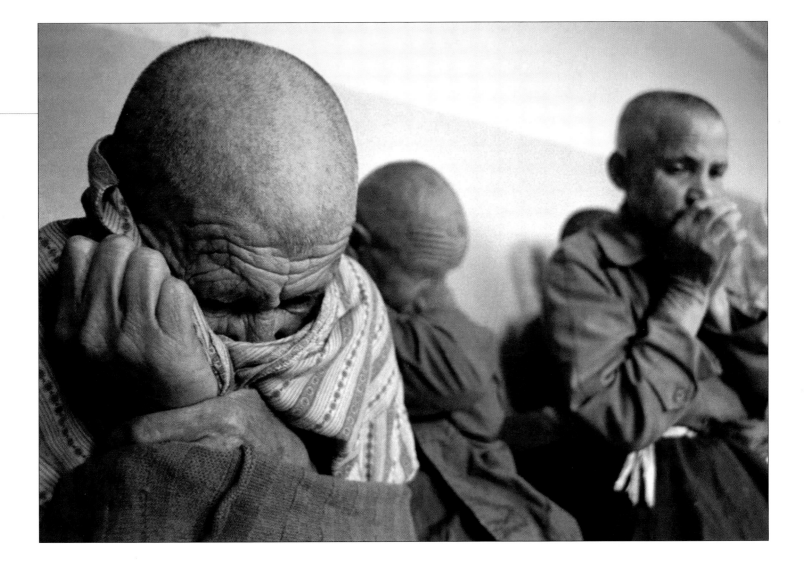

The funeral of Versace
22 July 1997

Stefano Rellandini

Princess Diana comforts pop star Elton John as he weeps openly at a memorial mass for Italian fashion king Gianni Versace in Milan. Scores of international celebrities converged on Milan to pay their last respects at the city's ornate gothic Roman Catholic cathedral.

OJ Simpson and family
16 March 1994

Fred Prouser

The premiere of Naked Gun: 33$^{1/3}$ in March 1994 was very much like every other premiere that I had covered since joining Reuters in 1992. Cast members, invited celebrities and other guests were arriving at once. The two leads, Priscilla Presley and Leslie Nielsen, were the main newswire shot. As supporting cast members arrived, they were routinely photographed. OJ Simpson arrived with his children and a tall blonde, whom I did not recognize. I shot tight on him and then shot the whole group – taking a total of five to six frames. When the premiere ended I transmitted the leads, and shots of a few other celebrities, but passed on sending the Simpson photo as he was just a supporting cast member.

The negs were then filed away according to my usual practice.

Nicole Brown Simpson was found murdered in June 1994 and I covered the story as it broke. A few days later, at an entertainment assignment, other photographers were talking about having photographed OJ Simpson and his ex-wife Nicole back in March, at the premiere of Naked Gun: 33$^{1/3}$. It was then that I clicked: I went through my files, located the negs I had shot, and sent the two best on the Reuters wire. In the early days of the murder story Reuters was the only wire service to provide this family photo.

A hard reign
07 June 1999

Jeff J MItchell

Britain's Prince Charles reacts to torrential rain while on a visit to the Forth and Clyde canal in the Maryhill district of Glasgow.

Helmut Kohl reviews the Scots Guards
29 April 1996

Kevin Lamarque

The German Chancellor, Helmut Kohl, reviews members of the Scots Guards outside 10 Downing Street. He was on a one-day visit to Britain for talks with Prime Minister, John Major, on the European ban on British beef.

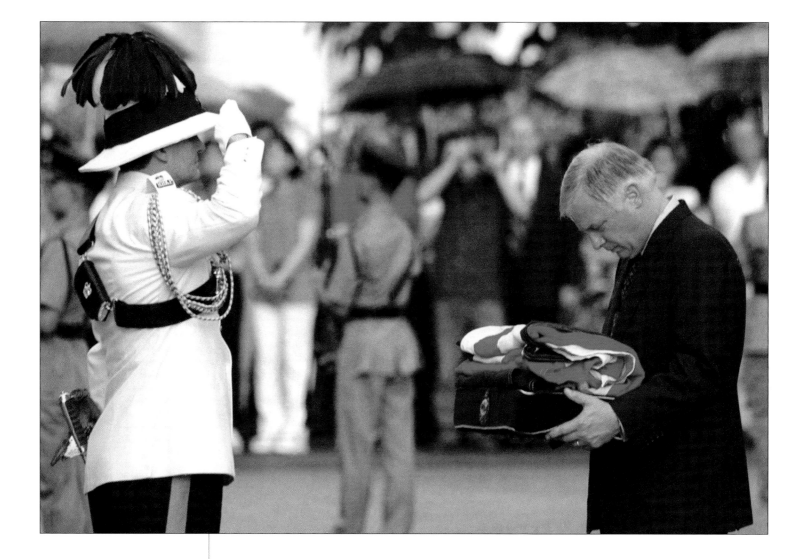

The handover of Hong Kong
30 June 1997

David Gray

This picture shows the last Hong Kong Governor, Chris Patten, receiving the British flag from an aide de camp at Government House on the last day of 156 years of British rule in the now Chinese province. The body language of Patten whilst holding his country's flag seems to symbolize the sadness felt by many at the handing over of the small British territory to the Chinese. Taking the picture proved difficult due to the low light caused by the torrential rain that periodically interrupted the ceremony. In addition, I required a fairly long lens to cover the distance from the designated photo position to the area in which the handover would take place. And, due to the confines of the designated photo position, and the amount of attendant press, much jostling occurred during the moment.

US marines evacuate foreign citizens from Albania
16 March 1999

Yannis Behrakis

An Albanian man carrying a child staggers forward through a blizzard of sand kicked up by a US marine CH53 Super Stallion helicopter as it lands at Golame beach, near the port town of Durres. US marines poured out of the helicopters as they landed, in order to guide to safety American, Turkish and Italian citizens fleeing the chaos of Albania. Many frantic Albanians also attempted to escape their country by jumping on board, and marines used rifle butts to beat them off.

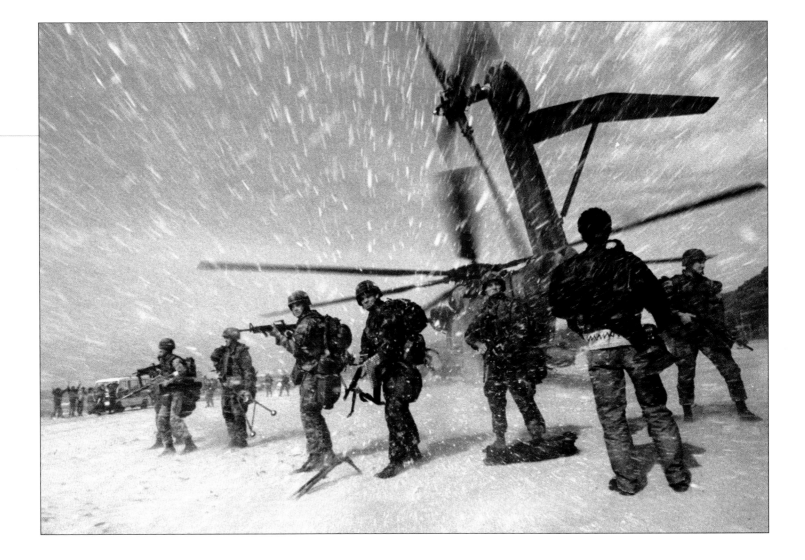

Elite French troops storm a hijacked plane
26 December 1994

Eric Camoin

Algerian fundamentalist terrorists had hijacked a plane at Marseille's Marignane Airport. This photo shows the anti-terrorist elite force, GIGN, storming the Air France Airbus as it stands on the runway.

At 3.30am the Reuters agency had called me asking for photos of the anticipated GIGN raid. I travelled to the airport and sat down to wait. At 3pm we saw the first sign of action, when the plane moved in the direction of the control tower. All the waiting journalists followed, but I was dissatisfied with our view of the plane.

I climbed a nearby building, and from the roof I had a great viewpoint. After a little while the anti-terrorist force moved into position, and I was able to shoot the action as events unfolded.

The 160 passengers and 12 crew were successfully liberated and the four hijackers were killed. I was the only person to get photographs.

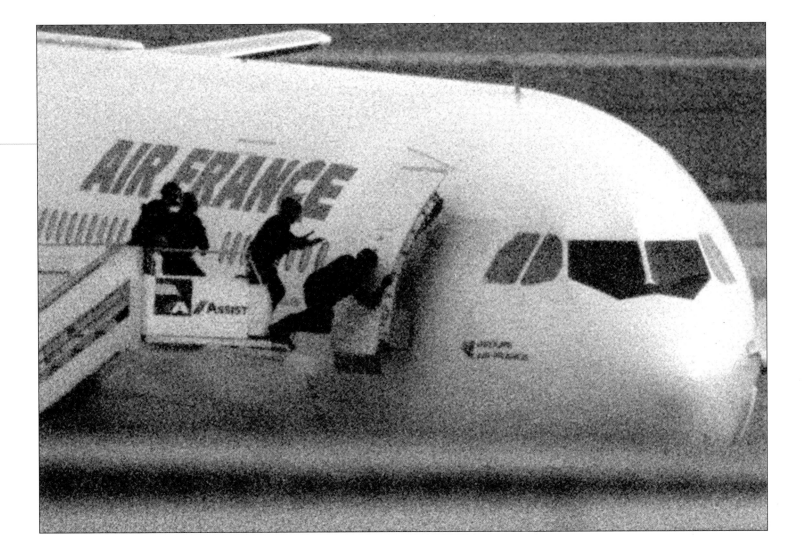

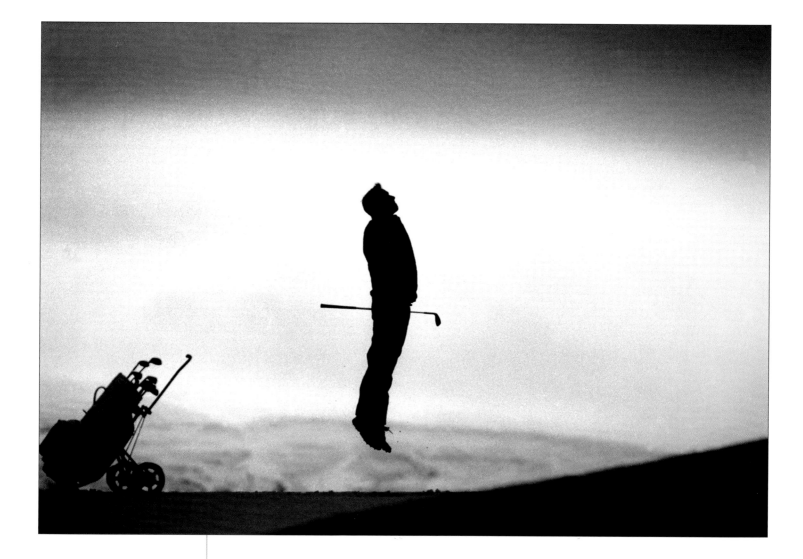

Spring greens
April 1993

Ian Waldie

News-wise, it had been a slow week in Scotland when this picture came about. I went out roving, looking for a picture. I particularly wanted a picture to illustrate the first day of spring, which fell on the next day. I went to the nearby Crowood Golf Club in Glasgow, where the club pro was out on the course practising, and asked him if I could photograph him. I managed to capture this picture of him leaping to follow the progress of his shot – but, unfortunately, most newspapers failed to link my springing golfer with the first day of the new season.

Mika Laitinen
16 March 1995

Andy Clark

During the World Nordic Ski Championships at Thunder Bay, Northern Ontario, a very unusual warm spell descended on the area – bringing temperatures above freezing and sunny skies. After several days of these conditions most of the snow in the fields surrounding the competition area had disappeared. I wanted to try to illustrate this fact but found it difficult since plenty of snow remained within the competition area itself. I decided my best opportunity was to climb the skijumping hill. After trekking through the very deep snow and heavy undergrowth surrounding the jump I found a good spot, looking down from which one could see the skijumpers pass over the snowless fields below. I was able to get the perfect shot when it was the turn of the current skijumping world champion, Mika Laitinen, and the sun was beginning to set.

Three-legged race
06 August 1997

Petar Kujundzic

Bernard Barmasai (left) and Moses Kiptanui (right), both of Kenya, cross the finish line as they take second and third place behind their compatriot Wilson Boit Kipketer in the 3,000 metres steeplechase final at the sixth IAAF World Athletics Championships in Athens.

I was in Athens as part of the Reuters team covering the sixth IAAF World Athletics Championships. I took this picture from my position and immediately thought I had something interesting – as it looks as if these two guys have one body, three legs and two heads.

Arantxa Sanchez Vicario
27 July 1996

Michael Leckel

I covered the entire tennis tournament at the Atlanta Olympics in 1996, from the first round to the finals. Coverage was quite a rush in the first rounds, since I was on my own and had to shoot up to 12 matches a day, some of them taking place simultaneously on different courts.

This match was in round three, between Spain's Arantxa Sanchez Vicario and Brenda Schultz-McCarthy of the Netherlands, on court one of the Stone Mountain Olympic tennis venue. The match was briefly suspended due to rain after three games, but resumed later as weather conditions improved. This shot was taken as Sanchez Vicario had to cross the court to reach a ball from her opponent, missed it, and was unable to stop herself crashing into the spectators' stands.

This picture required a huge amount of background work with officials for permission to get down to a tiny viewing window underneath the pool. For four days I ran around talking to numerous people about finding 'the man with the key', but when I finally found him, he said I must speak to someone else who was 'not available this week'. However, my persistence finally paid off when by chance I ran into the official chief of the pool complex, who said at first that admission to the viewing window was not allowed, but eventually relented, and agreed to allow me entrance as long as I didn't tell anyone else. So, at a designated time the next day, I met him and we walked through a maze of tunnels lined with pipes to a window that was about the same size and thickness as the aeroplane window I had looked through when I landed at Kuala Lumpur airport. Shooting through this window, the timing of the divers entering the water required an alert trigger-finger, along with a fast shutter-speed to capture the rippling effect you can see on the diver's skin. The diver pictured is the English competitor in the ten metre platform diving event, Sally Freeman.

A diver practises for the 1998 Commonwealth Games in Kuala Lumpur
16 September 1998

David Gray

On 23 March 1999, during the Kosovo crisis, and a couple days after NATO's ultimatum to Yugoslav President Slobodan Milosevic, we got the expected call for a 'media op'. It came from the US 6th Fleet Command (in charge of US naval operations in the Adriatic). The next morning we were airlifted onto the USS Philippine Sea, an American ship under NATO command. Shortly after arriving on board we were informed by the captain that a strike was imminent and were told that they were 'spinning up the missiles' – military jargon that meant the missiles were being programmed with their attack coordinates.

Just after dark photographers and TV crew were fitted with life vests and hard hats and accompanied to the aft section of the boat. NATO's strike on Yugoslavia then started with the Tomahawk missiles being fired. On the first night I photographed most missiles digitally, with my Kodak DCS520, so that I could e-mail the pictures from the boat to London once the media embargo was lifted.

This picture was taken on the second night of strikes. I decided I would try a time exposure since a blur effect could give more impact. I put my Canon EOS 1-N on a small tripod and exposed for eight seconds on different missile launches. The film was sent from the ship to Bari, Italy, by helicopter the next morning. There, Reuters stringer Mario Laporto picked it up and took it back to the hotel to develop, edit, and transmit to London.

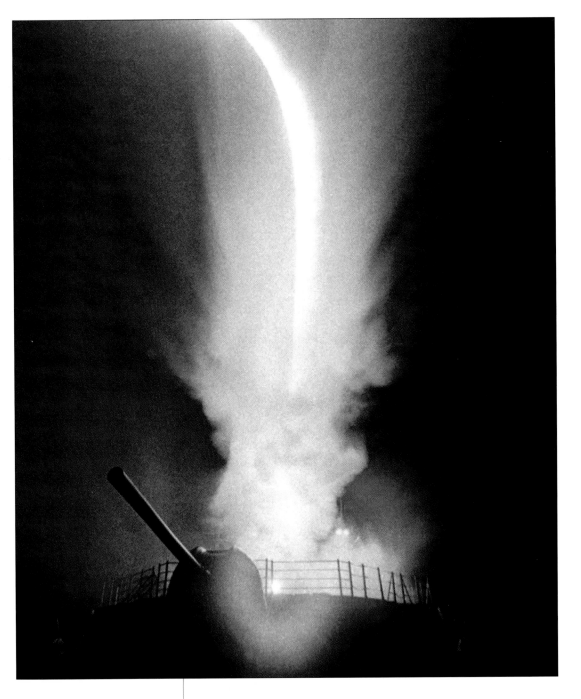

NATO launches attacks on Yugoslavia
26 March 1999

Paul Hanna

Lightning over Johannesburg
July 1989

Ulli Michel

Southern Africa experiences some of the most violent thunderstorms in the world – and it was one of these storms I witnessed from my house in Johannesburg.

While sitting in my garden late on a Sunday afternoon, I could see dark clouds gathering over the city's Hillbrow district. I quickly got my camera and started to take long exposure pictures of this breathtaking natural display. By this time the daylight had gone and the lightning became even more impressive.

I exposed two rolls of film and out of curiosity I decided to go back to the office and develop them immediately. Not knowing what I had captured, I could not believe my luck when I discovered this frame, with the fork of lightning cutting across the Hillbrow skyline and hitting the big TV tower.

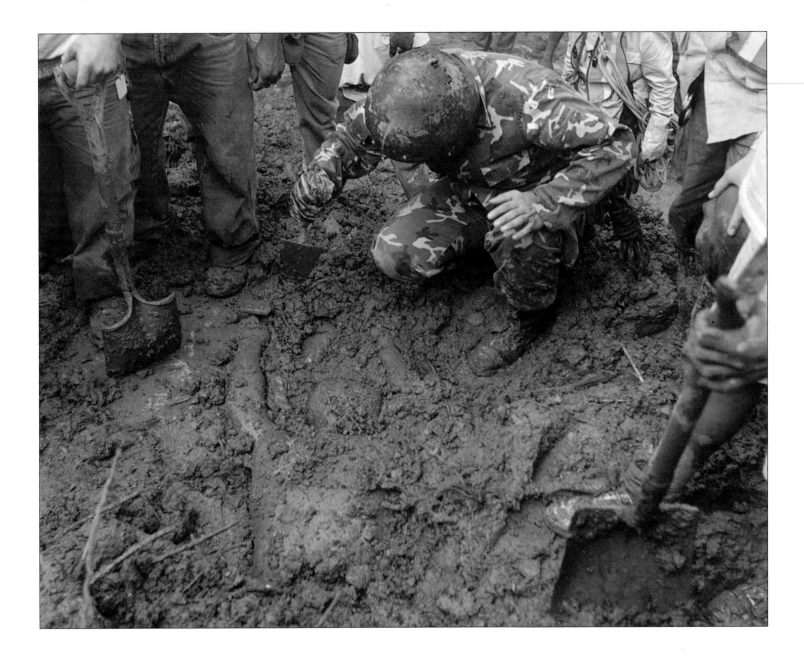

This page: The mud-caked body of Nestor Diaz, 29, lies face down on what was the floor of his humble shack in a hillside Caracas slum. Diaz and 11 members of his family were engulfed by a wall of mud that swept down from the mountainside amid torrential rains.

I came across this scene after walking for hours through the rubble and mud left in the landslide's wake. A crowd of people using picks, shovels and their bare hands were removing the tons of earth covering the corpse. The scene resembled an archeological dig as rescue workers and neighbours pulled baby clothes, pictures and personal papers from this mud-engulfed bedroom.

Victims of flash floods in Venezuela
December 1999

Kimberley White

Flash floods and mudslides along the Caribbean coastline of Venezuela in December 1999 took the lives of up to 30,000 people and left tens of thousands homeless. It was the country's worst natural disaster in over 50 years.

This page: This shot shows a woman being carried on a stretcher through waist-high seas to board a Venezuelan frigate that has edged onto a Caribbean beach to evacuate flood survivors. After taking several shots of the long lines of people queueing up to board the waiting ship I waded out through crashing waves, along with terrified evacuees, to take this photo from the prow. When I tried to leave the ship I found that it had already set sail and had to remain on board until we docked at an evacuation centre several miles along the coast. To reach the beach in the once-prosperous resort of Caraballeda I had ridden on the back of a motorbike through rivers and over hills of mud and boulders, barely able to see ahead or breathe because of the clouds of dust and stench of dead bodies.

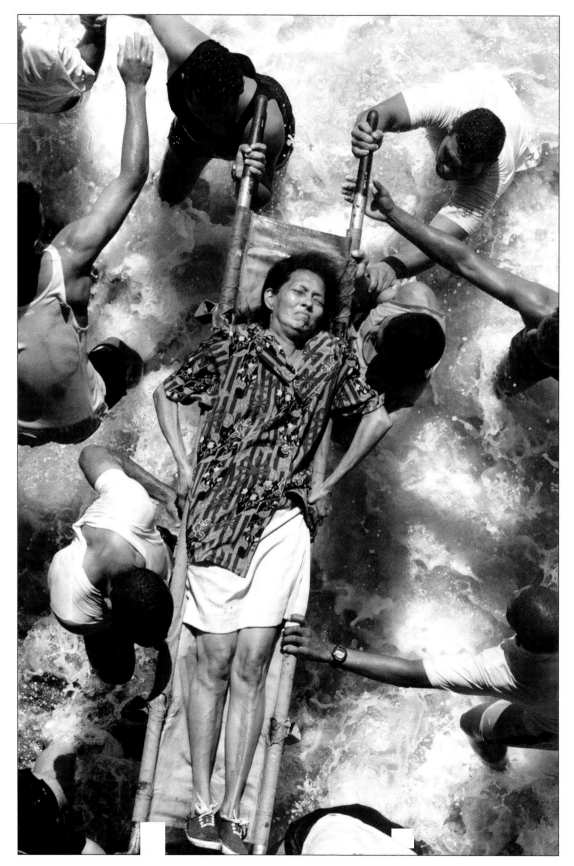

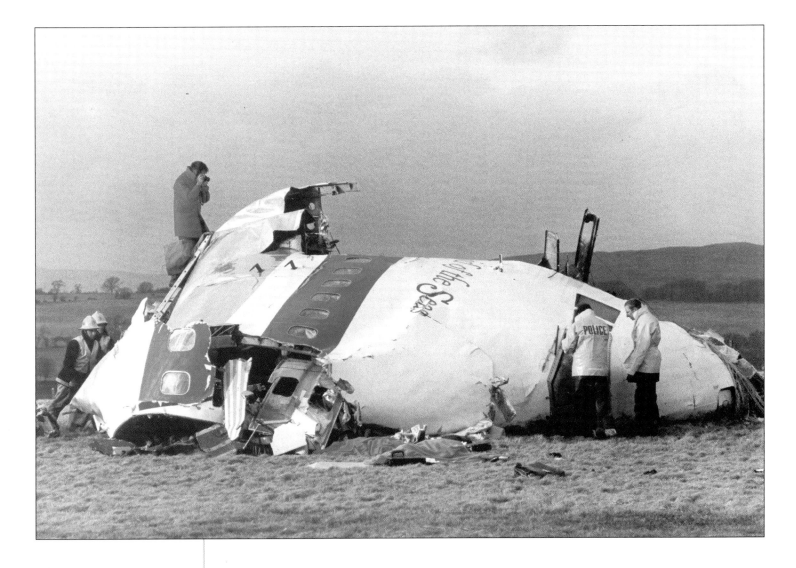

Lockerbie
22 December 1988

Rob Taggart

It was the week before Christmas and I was putting on my coat to leave the office in London at about 8pm when the first reports of a plane crash in Scotland came in. Once it became apparent what had happened I arranged to pick up my colleague Nick Didlick en route and drive to Lockerbie. Not observing the speed limit we were among the first London-based media to arrive in what had been, only a few hours before, a small sleepy Scottish border town.

We got into the town around 2am, before it was completely sealed off, and I will always remember the scene. Walking through the town it was impossible to put a foot down without stepping on wreckage, debris, or worse and the silence of rescuers, townsfolk and media – most of us in shock at the scene we were witnessing – resulted in a very eerie situation. The area where the bulk of the aircraft hit, and where houses had stood a few hours earlier, was a huge crater. The next morning the nose cone was found intact just outside the town.

The sinking of The Herald of Free Enterprise
11 March 1987

Etienne Werner

This photo shows a woman who lost a relative during the Zeebrugge ferry disaster throwing flowers into the sea in the spot where the ferry sank.

The Millennium Wheel, London
12 October 1999

Kieran Doherty

London is famous for its landmarks and skylines, and the Millennium Wheel is a dramatic new addition. As I was driving on the north side of the River Thames I noticed the colour of the sky against the wheel and stopped to take this picture. Without some form of contrast in size between the people on the bridge and the wheel, this picture would have been pointless, and there was only one spot where the angle was correct for getting people in the frame. I had to wait about an hour for the figures on the bridge to be free of passing traffic. The fact that one passer-by put his hands in the air was completely fortuitous.

Stonehenge
18 December 1999

Paul Hackett

I'd been sent to cover the sunrise over the stones, and myself and other journalists were met by representatives from the National Trust at the local train station at 4am. They were meant to be escorting us to Stonehenge in a bus, along with a delegation of druids, but by 4.15am we still hadn't set off, and then we started getting calls on our mobiles from other journalists already at the site, telling us that travellers had stormed the stones. A bit of a panic broke out as everyone was frantic to get there, but the roads were all sealed off by police. The National Trust bus eventually got us most of the way there, and then we had to sneak past police and cut across fields on foot. I was worried that the sun would have risen by the time I arrived, but I got there just in time, and shot the travellers standing on the stones as the sun came up.

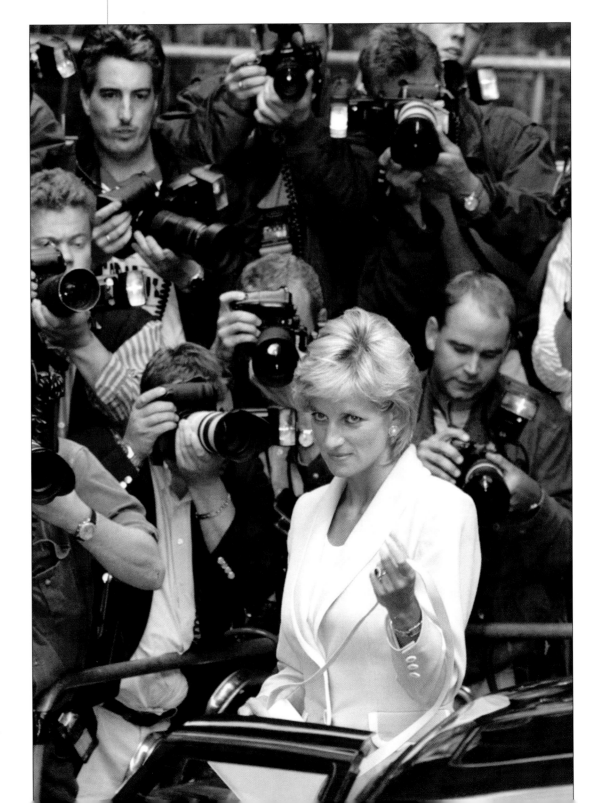

Princess Diana surrounded by paparazzi
28 August 1996

Ian Waldie

Previous page: The news story that went along with this picture was that Diana and Prince Charles were in the midst of being separated. This photo was taken on the day the decree absolute, ending their 15 year marriage, was issued. Diana was visiting the English National Ballet, of which she was patron, and a vast pack of paparazzi photographers had turned out. As the story of media intrusion was running alongside the separation story, before she was due to depart, I decided to move position and try for a picture of the Princess surrounded by the press pack.

I had been told to be present for this job the previous night, as interest in the Princess was extremely high. I arrived there at 5.30am where there were already about 40 paparazzi who had been waiting there overnight – even though the Princess wasn't due until 1pm. We were all camped out on stepladders – the only way to cover a job with so many photographers and so little space.

One further point of interest aroused by this photo was the fact that the Princess was still clearly wearing her engagement ring – even after the split with Prince Charles had been made public.

Peter Andrews

was born in Kano, Nigeria in 1961, grew up in Poland from 1966, and emigrated to Canada in 1980. He became a photographer in 1984, following study at the University of Ottawa. In 1989 he returned to Europe to work for AP, and joined Reuters in 1991 during the first coup in Moscow, after which he worked in the former Soviet Union and in Bosnia. In 1996 he moved to Johannesburg as Chief Photographer for Southern Africa, and in 1999 became Chief Photographer for Eastern and Southern Africa, based in Nairobi.

Eliana Aponte

was born in Bogota, Colombia in 1971. She graduated in journalism at Bogota's Externado of Colombia University, switching careers when she took a Reuters-taught photojournalism course at the university. She has worked for Colombian magazines and newspapers, and for Agence France Press in Panama. Eliana has been a contract Reuters photographer, based in Guatemala City, since 1997.

Tim Aubry

is presently Editor-in-Charge of Assignments for North America, based in Washington, DC. He began his career with Reuters News Pictures in 1988 following more than six years with the Associated Press. He has a degree in photojournalism from Bowling Green University in Ohio, is married and has three children.

Heinz Peter Bader

was born in Vienna in 1966 and has been working for Reuters since March 1992.

Mariana Bazo

Was born in Lima, Peru, in 1964. She studied history, then started working as a photojournalist for a national newspaper in Peru. She worked for Reuters as a stringer during the most active years of the Shining Path. She got the Willie Vicoy Reuters Fellowship in 1993 and spent a year studying at the University of Missouri, USA, before becoming a Reuters staff photographer in 1994.

Yannis Behrakis

was born in Athens. He studied photography at the Athens School of Arts and Technology (AKTO). He joined Reuters as a photo stringer in Athens in 1987, and as a full-time staff photographer in 1989. He has covered major news stories in the Middle East, Somalia, Northern Africa, southern Europe, and the Balkans. He has also covered major sports events in Europe and the USA.

Natalie Behring

was born in San Francisco in 1972. She is a freelance photographer based in Beijing, and has been working with Reuters since 1997.

Fabrizio Bensch

was born in Berlin in 1969 and has worked for Reuters since 1992.

Mike Blake

has been a Reuters staff reporter for the last 14 years. Based in Vancouver, Canada, he spends a large portion of his year on the road, covering all sports – from hockey, to football, basketball, skiing, golf etc. The Olympics in Atlanta were his fifth games – following his coverage of three winter games and the summer olympics in Barcelona in 1992.

Desmond Boylan

was born in London in 1964. For six years he worked as a Reuters photographer, based in Madrid, and has worked for the Associated Press for three years.

David Brauchli

was born in Boulder, Colorado, in 1964. He completed a degree in Photojournalism and went to work for Reuters in Hong Kong, later moving to the London photo desk. After 18 months there – during which time he covered the fall of the Berlin wall – David moved to Prague. He left Reuters in 1991, and has since worked for AFP and AP, in Russia, Yugoslavia, Somalia, Chechnya and South Africa.

Andre Camara

Andre Camara was born in 1969 in Sao Paulo, Brazil. He completed a photography course when he was 13 and when he was 15, he got his first job for a national newspaper "Jornal do Brasil" – while still at school. He moved to London with the paper in 1989. He has worked for AP and worked for Reuters from 1990 to 1994.

Eric Camoin

was born in 1967 in Marseilles, France. Since 1987 he has worked for many publications and agencies, and he began working with Reuters in 1990.

Christian Charisius

was born in 1966 in Freiburg, and has been working since 1989 as a freelance photographer. From 1989 to 1995 he was based in Munich, working in reportage and portrait for several magazines, in advertising, and as a stills photographer. In 1996 he travelled through Spain, France and Belgium and later moved to Hamburg, where he started working as a stringer for Reuters in 1997.

Andy Clark

was born in Toronto, Canada in 1952. He began his career in news photography in 1970, with Canadian Press. After a year with the Hamilton Spectator he joined UPI, leaving in 1985 to join Reuters in Ottawa. After only a few months Andy left to work as photographer for the Canadian Prime Minister Brian Mulroney. He returned to Reuters in 1987, working in Brussels and London. In 1990 he moved back to Canada as Chief Photographer.

Paolo Cocco

was born in Rome in 1970 and started taking pictures when he was 15. Two years later he started his first job as an assistant to a wedding photographer, and took on his first photojournalism assignment on a 1990 trip to South Africa. He had his own photo agency for two years and began working for Italian and French magazines. Paolo started working with Reuters as a stringer towards the end of 1994, and was hired as a staff photographer in 1998.

Claro Cortes IV

was born in Manila in 1960. He has worked for Reuters in Asia since 1988. In 1987 he was the recipient of the first Willie Vicoy Reuters Fellowship at the University of Missouri, USA.

Jack Dabaghian

is a Frenchman who was born in Beirut in 1961. He began his career in April 1983, when a bomb devastated the US Embassy in Beirut. Aged 22 he became a war photographer for UPI, fronting the New York Times and Newsweek. Jack joined Reuters in 1985, and transferred to Paris in 1987. He has covered the Gulf War, the Gaza Strip and had assignments in Africa. He was awarded the Missouri School of Photojournalism Award of Excellence for his work in Rwanda.

Lou Dematteis

was born in San Francisco in 1948, and was based there working for UPI from 1981-84. In 1985 he moved to Managua, Nicaragua, where he worked as a freelance photographer for Reuters, Time, Newsweek and The New York Times. Between 1985 and 1990 he was a staff photographer for Reuters, covering the Contra War in Nicaragua, El Salvador, Haiti, Honduras and Panama. In 1990 he returned to San Francisco.

Alexander Demianchuk

was born in Kovel, in the Ukraine, in 1959. He has worked for Reuters since 1991, before which he worked for local St Petersburg newspapers.

Patrick de Noirmont

was born in Paris in 1949. He has worked as a photographer/editor with UPI, AFP and Reuters (1972-99), in Europe, the US, the Middle East, Africa and Asia.

Nick Didlick

started his career working for small Canadian newspapers. In 1979 he signed up with United Press Canada, then, in 1985, joined Reuters in Brussels – before transferring to London as Deputy Chief Photographer for the UK and Ireland. He was the Reuters Journalist of the year in 1988 and was twice nominated for a Pulitzer award (once for a picture from the Heysel stadium disaster included in this book).

Kieran Doherty

was born in Dover, England, in 1968, and has worked for Reuters since 1993.

Larry Downing

first worked as a professional photographer on a newspaper in Los Angeles, then had three years of wire staff work at United Press International in Washington DC, before spending 15 years at Newsweek Magazine covering the White House. He became a staff photographer at Reuters in 1999, again covering the White House.

Corinne Dufka

was born in 1957 in the USA. She worked in San Francisco before beginning to take pictures in El Salvador. She joined Reuters in 1989 and worked as a photojournalist in Central America from 1989-92, in Bosnia from 1992-94, and in Africa from 1994–99, when she took a sabbatical from Reuters to work as a researcher with Human Rights Watch: Africa Division. She is currently based with HRW in Sierra Leone.

Eric Gaillard

was born in Nice in 1958. After studying law, he worked as a stringer for AFP in Nice for 5 years, joining Reuters in 1985 as staff photographer in Nice, and covering the French Riviera and Monaco principality. He has covered many major international events, including the Winter Olympics in Norway and Japan, the Czech and Romanian revolutions, the Gulf War, and the wars in the Congo, Bosnia and Kosovo.

David Gray

began his career as a cadet with News Limited Australia, moving to the Canberra Federal Parliamentary Press Gallery in 1991. He worked as sports photographer for The Australian from 1993-95, moving to Reuters in 1996. He has covered many news and sporting events throughout Asia and Australasia. He won the 1998 Australian Walkey Award for best sports photograph, and won best news photograph in the 1999 Australian Photojournalist Awards.

Paul Hackett

began his career in Birmingham, before moving to Scotland on Sunday. In 1991 he won the David Hodge Young Photographer award, and in 1993 joined the Herald in Glasgow. He moved to Reuters in 1996, and won the British Picture Editors' Guild Photographer of the Year and the British Nikon photographer of the Year awards in 1999.

Paul Hanna

used to follow his father to photo assignments and started studying photojournalism in high school. After settling in Madrid in 1987, he started working for Reuters as a stringer in 1989, covering Spain, Portugal and a few foreign assignments. In 1992 he was hired as photographer and desk sub-editor in London and in 1996 moved to Rome as Chief Photographer, Italy.

Joachim Herrmann

was born in Zell am Harmersbach, Germany. He went to photo school in Freiburg and became a freelance photographer. In 1987 he worked as a staff photographer at Offenburger Tageblatt, joining the Hamburg office of Deutsche Presse Agentur (DPA) as a stringer in 1988. In 1990 he joined Reuters and worked at the Frankfurt and Bonn offices, before moving to Berlin in September 1999.

Gary Hershorn

was born in 1958 in London, Ontario, Canada. After getting a picture published in the student newspaper at York University, Toronto, he became hooked on photography. He freelanced for a local Toronto paper and began working at United Press Canada in 1979. In January 1985 he was hired by Reuters News Pictures in Toronto as Chief Photographer for Canada, transferring to Washington in 1990.

Ian Hodgson

was born in Wakefield, England, in 1964. He worked as a freelance photographer for local newspapers in West Yorkshire, joined Wilkinson Press Agency in Bradford in 1988, then took a staff position on the Gloucestershire Echo in Cheltenham. In 1990 he moved to Birmingham to work for the Daily News and later became Picture Editor on the Birmingham Metro News. He started working for Reuters in May 1992.

Jim Hollander

was born in 1949 in the United States. In the mid 1970s he moved to Spain and began his career as a photojournalist. In 1980 he joined UPI and moved to Brussels. Following coverage of the war in Lebanon in 1982 he was transferred to Tel Aviv as UPI Chief Photographer, and then joined Reuters in 1985. Since then he has been Chief Photographer, Israel, and has documented the Israeli-Palestinian conflict.

Cyril Iordansky

was born in Moscow in 1965. In 1987 he started working for Russian press agency, Novosti, later working freelance for magazines including Paris Match, and the Russian edition of Harper's Bazaar. He is currently a picture editor at Reuters Moscow.

Peter Jones

has worked as a staff photographer for Reuters since 1991, and has been based in Ottawa and Toronto.

Petar Kujundzic

was born in the Yugoslav capital of Belgrade in 1959. He has worked for Reuters for over 10 years, and has been a professional photographer for over 20 years. When war broke out in the former Yugoslavia he was in charge of coverage and also covered the political turbulence in Eastern Europe. He now runs the pictures operation in Serbia, Kosovo, Macedonia and Montenegro.

Jerry Lampen

Was born in Rotterdam in 1961. He began his career in photography in November 1981 at a local agency in Rotterdam, covering news stories and sports. In August 1985 he got a staff job at United Photos, in Haarlem, Holland. He left the agency in December 1997 to return to Rotterdam where he has worked with two picture agencies, and commenced working with Reuters, covering sports and general news stories.

Michael Leckel

was born in Vienna in 1961. He studied journalism and political science at the University of Vienna and started work for the Austrian Press Agency (APA). He switched from writing to photography and began freelancing in 1985. From 1989-92 he was pictures editor at APA. From 1992 he has been Chief Photographer for Reuters in Austria and has also covered news and sports events for Reuters abroad.

Enrique Marcarian

Staff photographer Enrique Marcarian has worked with Reuters since 1993. He was born in Rosario, Argentina, and has worked as a photographer for the sports magazine El Grafico, and the Buenos Aires daily, Cronica.

Dylan Martinez

was born in Barcelona to Argentine parents in 1969 and moved to the UK a year later. He began taking pictures for music magazines and record companies and then moved on to Sygma and the Sunday Mirror. He started to freelance for Reuters in 1991 and made staff in 1994. He worked in Asia, based in Vietnam, from 1996-8 and is now back in London.

Duffin McGee

says his career as a photographer grew out of a desire to make photographs as a child: "It always interested me and when I had the chance to learn the craft I jumped into it. Over the years I have found that photojournalism has given me many challenges and taught me a lot about myself as a photographer and a person."

Ulli Michel

began his news photography career in 1983 with Deutsche Presse Agentur. After two years there he joined Reuters as a staff photographer in Bonn and Hamburg, moving to Brussels in 1986. Ulli was Chief Photographer in Johannesburg from 1988, and in 1991 he became Asian Deputy Picture Editor in Hong Kong. He was based there for two years before further stints as Chief Photographer in both Bonn and Moscow. Since 1997 he has lived in London and worked as Global Pictures Editor.

Peter Mueller

was born in 1968, in Bad Homburg, near Frankfurt. Whilst still at school, he took pictures for a local newspaper and later became a freelance photographer for a Frankfurt newspaper. In 1993 he covered the deportation to Beirut of the Lebanese former hijacker Abbas Hammadi for Reuters Germany. After that he worked constantly for Reuters. In 1995 he moved to Hamburg, and is now responsible for northern Germany.

George Mulala

From 1988 to 1990 George served as a provincial news reporter in Mombasa. He got hooked on photography when he moved to AP in 1991. During this period he covered the Somalia crisis, the Rwandan genocide and resulting refugee problem in the Great Lakes Region, and the struggles and destruction in Burundi. In 1995 he joined Reuters and now covers sub-saharan Africa.

Claudio Papi

was born in Rome in 1953. Since 1968 he has lived in Turin, where he started shooting sports pictures for a small regional publication. He started working for United Press International on a stringer basis in the 1970s, and stayed on to work for Reuters after they bought out UPI in 1985. At present he works mainly for Reuters and Italian agency Olympia.

Jean-Paul Pelissier

was born in Marseilles in 1959. He completed a Diploma in sociology in 1985, and commenced work with Reuters in 1986. He covers news and sports in France, along with international events such as the elections in Algeria, the Rwandan genocide, and the Kosovo crisis.

Charles Platiau

was born in 1959 in Saint-Omer, France. He worked as a freelance sports photographer from 1979 to 1983, becoming a full-time stringer for AFP and UPI in 1984. He has worked full-time for Reuters since 1985.

Oleg Popov

was born in Sofia, Bulgaria, in 1956. He studied journalism at Sofia University, and has worked as a photographer for the Bulgarian Telegraph Agency and as Chief Photographer for Sport Weekly Magazine and Narodna Mladezh, a Bulgarian daily. Oleg has been working for Reuters since 1990, and became a staff photographer in 1994. He has covered wars throughout the Balkans and in Chechnya, and many international sports events.

Fred S. Prouser

was born in Mississippi in 1951. From 1975 he worked as a freelance news photographer with UPI and Associated Press, and, in partnership with wife Rose, in Prouser Photographic. They moved to Los Angeles in 1992, where Fred began working as a contract photographer for Reuters, and was hired as a staff photographer in January 2000.

John Pryke

was born in Brisbane Australia in 1965 and started work as a cadet on The Daily Sun and Sunday Sun. He won the Nikon Cadet Photographer of the Year award in 1985, and, in 1989, was the Australian Photographer of the Year and Sports Photographer of the Year. Whilst in Brisbane he worked as a stringer for Reuters, later becoming a staff photographer based in Sydney.

Wolfgang Rattay

was born in Bad Ems, Germany, in 1960. At 17 he started work as a photographer for a local newspaper in Koblenz. In August 1980 he shot his first wire photo for Associated Press then worked freelance for them until April 1985 when he joined Reuters News Pictures as the company's first employee in Germany. A year later he was appointed Chief Photographer, Germany. Wolfgang moved to Berlin in September 1999.

Jason Reed

was born in Sydney in 1970. In 1990, during his first year in college, he joined Reuters News Pictures. In 1994 he moved to Reuters Asia in Hong Kong, where, in 1997, he witnessed the handover of the British colony to Chinese rule. He moved with Reuters to Singapore where he continued working, until, in July 1999 he became Photographer, Thailand, with additional resposibility for picture coverage in Myanmar, Laos and Cambodia.

Stefano Rellandini

was born in Milan in 1963. He started work at a Milan photographic studio. He moved from there to the sports agency Pentaphoto. Stefano covered the Alpine Ski World Cup for 10 years, as well as cycling, formula one, track and field, and tennis. He started stringing for Reuters in the mid '90s when he covered Italy's premier cycling race, the Giro d'Italia and the death of Versace. Since 1997 he has worked on a stringer basis as Reuters' Milan photographer.

José Ribeiro

was born in Lisbon in 1960. On completion of his studies he worked in advertisement photos, before, in 1987, he started working as a stringer on daily Portuguese newspapers and as a telephoto operator for the Portuguese agency, LUSA. During the 90s he worked for PUBLICO, LUSA, Epoca magazine – and joined Reuters in 1996.

Damir Sagolj

was born in Sarejevo in 1971. He worked with the Paris-based Sipa press agency for several years, before joining Reuters in 1996, as their Bosnian photographer.

Fatih Saribas

was born in Gaziantep, Turkey, in 1957. He has worked for Turkish newspapers and as a photo stringer for AP and UPI. Fatih joined Reuters in 1985 and has covered events in Turkey, the Middle East and Europe, such as the Romanian revolution, the death of Khomeini, the Gulf War, and European football championships. He is now based in Istanbul and runs the pictures operation in Turkey.

Syed Haider Shah

was born in Peshawar, Pakistan, in 1954. He started working as a photojournalist for national dailies from 1974, also working as a freelance stringer for Reuters. He was one of the few photographers who accompanied the Afghan Mujahideen inside Afghanistan during and after the Soviet invasion in 1979 and his photos were published around the world. He now works full-time with a national English daily, The News.

Enrique Shore

was born in Buenos Aires, in 1956. He started working as a news photographer during 1978 and freelanced until 1981, when he got a scholarship to study photojournalism in the US. He returned to Argentina and worked as a photographer for the National Commission on the Disappeared. He then worked as Reuters photographer for Argentina, Uruguay and Paraguay, and in 1989 moved to Madrid, as chief Photographer for Spain and Portugal.

Radu Sigheti

was born in Bucharest in 1959. He worked at the photo studio of Romania's biggest printing house from 1980 to 1989, spent 10 months working for Romania, a monthly magazine published for embassies abroad, and joined Reuters in October 1990.

David Silverman

was born in Johannesburg, South Africa, in 1962. He emigrated to Israel in January 1983. After studying photography at the Camera Obscura visual arts college in Jerusalem and Tel Aviv he served as a photographer in the Israeli army for two years. In 1991 he began work for Reuters in Jerusalem, leaving the company in December 1999 to be with his family in England.

Gaby Sommer

was born in Wiesbaden, Germany, in 1959. She worked in Frankfurt as a stringer for AP from 1980-83, when he became Germany correspondnt for the French photo agency, GAMMA. In 1985 she joined Reuters, working out of the Berlin Office as a photojournalist in both West and East Germany. Since 1989 she has been a self-employed freelance photographer specialising in photography of business and economics. She is based in Cologne, Germany.

Ralf Stockhof

has been working as a freelance sports photographer since 1985, and with Reuters since 1996. He has won several national and international photo awards, including European Press Photo of the Year.

Tom Szlukoveny

was born in Budapest, Hungary. He worked for the Globe and Mail in Toronto, Canada, for ten years before joining Reuters as a photographer, based in Vienna, in 1990. He was Chief Photographer in the former Soviet Union from 1993-96, moved to London as an Editor in Charge/Senior Photographer, Europe, in 1996, and has been working from Singapore as Deputy News Pictures Editor, Asia, from 1998.

Rob Taggart

was born in Auckland, New Zealand, in 1954. He joined Reuters Pictures on day one – 1 January 1985. In 1970 he began his career as a cadet photographer at the New Zealand Herald in Auckland, leaving in 1975 to travel. In 1976 he started work for a small Fleet Street picture agency. From 1982 he freelanced for AP, UPI, and a variety of UK national newspapers before joining Reuters.

Goran Tomasevic

was born in Belgrade in 1969. He began working as a photographer in 1991 for the daily newspaper, Politika, based first in Belgrade, and then – during the wars in Slovenia, Croatia and Bosnia – throughout the former Yugoslavia. He had a lot of contact with Reuters during this time but serious cooperation with the agency began in 1996 when he worked for them during the anti-Milosevic demonstrations.

Ian Waldie

was born in Nambour, Australia, in 1970. He worked as a cadet on local newspapers while studying applied photography, then moved on to The Brisbane Courier Mail in 1989. In 1993 he began freelancing for Reuters, as their Scottish stringer – becoming a staff photographer, based in London, in 1996. Ian has gained many awards – including Sports Photographer of the Year in the Scottish Sports Council Awards, Photographer of the year in the British Picture Editors Awards, and Photographer of the Year in the Nikon UK Press Photography Awards.

Kimberly White

was born in Kansas City in 1966. She started selling photos in 1993, while working with human rights groups in Guatemala. A one-off assignment for Reuters convinced her to move into news photography. She worked for Reuters in Guatemala for four years, then in 1998, she took a staff position in Caracas, Venezuela.

Darren Whiteside

was born in Toronto in 1965. He has worked with Reuters since 1995, and is based in Phnom Penh, Cambodia. Some of the most interesting places he has worked are Somalia, Japan, Afghanistan and East Timor.

Rick Wilking

was born in Madison, Wisconsin, USA, in 1955. His first job as a photographer was for UPI in Denver, Colorado. He moved to Brussels in 1982, and was promoted to be UPI's Chief Photographer, Switzerland in 1983. He joined Reuters in 1985, and was made Senior Photographer for Reuters in Washington DC in 1989. Rick resigned from Reuters and in 1998 moved back to Denver where he is a freelance photographer.

Andrew Wong

was born in Hong Kong in 1962. He worked with UPI News Pictures before joining Reuters in 1985. Since then he has worked in Asia and Europe and is currently Reuters Chief Photographer in Beijing.

Shamil Zhumatov

was born in Almaty, Kazakhstan, in 1971. He studied journalism at Kazakh State University and, from 1987, worked as a photographer for the Kazakhstan newspaper, Leninskaya Smena, leaving in 1990 to work as photographer for the Kazakh State Information Agency (the TASS department in Kazakhstan). Since 1994 he has been with Reuters, covering Kazakhstan, Kyrgyzstan, Tajikistan, Turkmenistan and Uzbekistan.